MASTERPIECES FROM THE NATIONAL GALLERY OF IRELAND

Masterpieces

from

The National Gallery of Ireland

A LOAN EXHIBITION AT
THE NATIONAL GALLERY, LONDON
27 MARCH — 27 MAY 1985

THE NATIONAL GALLERY OF IRELAND 1985

First published 1985, by
The National Gallery of Ireland, Merrion Square West, Dublin.
© The National Gallery of Ireland, 1985

British Library Cataloguing in Publication Data
National Gallery of Ireland
 Masterpieces from the National Gallery of
 Ireland : 27 March — 27 May 1985 : The National
 Gallery, London.
 1. Painting, European —— Exhibitions
 2. Painting, Modern —— Europe —— Exhibitions
 I. Title
 759.94'074 ND454

 ISBN 0-903162-18-0
 ISBN 0-903162-19-0 Pbk

Photography by Michael Olohan
Design, origination and print production by
Printset & Design Ltd., Dublin.
Colour separation and platemaking by
Kulor Centre Ltd., Dublin
Printed in Ireland by
Ormond Printing Company Limited, Dublin.

COVER: *Portrait of Katherina Knoblauch* (detail) by
 Conrad Faber (Cat. no. 20).

Contents

	PAGE
Preface	vi
Foreword	vii
Introduction	ix
Catalogue	1
Acknowledgements	2
Paintings in the Exhibition	3
Bibliography	89
Index	96

Preface

In the 1850s when preparations were being made for the opening of the National Gallery of Ireland, in order to augment the small number of paintings then owned by the Dublin Gallery, the National Gallery London generously agreed to lend a group of pictures on a long-term basis to Dublin. During the seventy or so years while those paintings were in Dublin, the National Gallery of Ireland built up its own collection and now, almost one hundred and thirty years later, is pleased to be able to reciprocate London's generosity by lending an exhibition to The National Gallery.

The Governors and Guardians of the National Gallery of Ireland were honoured and delighted by the National Gallery's invitation to send this exhibition; and they were gratified that the choice of paintings, made by Michael Levey and Alistair Smith, should be so discerning as to reflect the very special character of the collection in their care. That character is derived from the fact that, while great 'names' are represented in Dublin, a large number of pictures, although of very high quality, are at the same time very unusual and often by painters whom even specialists do not know. In their sensitive appreciation of this fact Michael Levey and Alistair Smith have, therefore, not asked for *all* of Dublin's *obvious* masterpieces; and nor is their choice based on 'names' alone. Had that been the case such beautiful or unusual paintings as those by Passeri (Cat. no. 7) or van Hasselt (Cat. no. 32) would have been excluded.

The planning of the Exhibition has afforded us in Dublin the opportunity of friendly co-operation with our colleagues in the National Gallery London and we are grateful for the help of the Head of Exhibitions, Alistair Smith, the Registrar, Margaret Stewart and the Press Officer, Sarah Brown. By encouraging the Governors and Guardians to lend the Exhibition I was aware of the burden of responsibility that would fall to my colleagues in making the Exhibition a reality: all the paintings have been treated in the Conservation studios by Andrew O'Connor and Sergio Benedetti; the Assistant Director, Raymond Keaveney and the Exhibitions Officer, Kim-Mai Mooney have been responsible for the arrangements with regard to loans; and Raymond Keaveney, Adrian Le Harivel and Michael Wynne have shared with me the researching and writing of the Catalogue. It is a pleasure to record appreciation to all of these for the willingness with which they carried out their tasks.

In 1858 a deputation from the Board of the National Gallery of Ireland attended on the Chancellor of the Exchequer, Benjamin Disraeli for the purpose of seeking additional funds for the Gallery. Mr. Disraeli greeted them with the words, 'It affords me very great pleasure to receive a deputation from Ireland on a subject so agreeable....' It is the hope of the present-day Board of the National Gallery of Ireland and myself that the British public will find *our* 'deputation', — *Masterpieces from the National Gallery of Ireland* as agreeable as Mr. Disraeli found that of our predecessors.

HOMAN POTTERTON
Director
National Gallery of Ireland
March 1985

Foreword

Gratitude must be the first word when one National Gallery permits another to play host for a few weeks to some of its masterpieces. We in London are profoundly grateful to our colleagues in Dublin — to, above all, Homan Potterton, the Director of the National Gallery of Ireland, and to the Board of Governors and Guardians — for allowing us to borrow and display a notable group of their paintings, ranging widely in school and period but united by quality.

The exhibition brings to Trafalgar Square work by several fine artists not represented in our permanent Collection — among them, Castiglione, Bellotto, Frans Post, Gérard and Nolde — and some outstanding examples by famous figures like El Greco, Titian and Poussin, which extend significantly our own holdings of their art.

So much for the immediate and narrow view of this exhibition. For those who cannot visit, or have not bothered to visit, the National Gallery in Merrion Square, a choice selection has been brought to London for their delectation. But it is very much a selection, governed by reasons of conservation and space, as well as taste; and my strongest hope is that it will serve to stimulate appetite and appreciation and that more people will be encouraged to visit Dublin and the National Gallery of Ireland, to discover the full range of a great — and growing — collection. They will also discover, incidentally, a city of beautiful architecture.

The National Gallery of Ireland was established in 1854, exactly thirty years after the National Gallery in London, also by Act of Parliament, and was similarly built up by a mixture of discriminating purchases and generous gifts and bequests. There have been many links, in terms of people and paintings, between the two institutions over the years, but none perhaps closer and warmer that at the present time, when the National Gallery in London may boast that it was sufficiently discriminating to employ the current Director of the Irish National Gallery in the years immediately up to his appointment.

It is a particular pleasure therefore to thank him for his friendly response to the proposals for loans made by my colleague Alistair Smith, Head of Education and Exhibitions, and myself, and for all the scholarly work carried out on this catalogue by him and his staff. I must also record a debt of gratitude to everyone involved at the London end, beginning with Alistair Smith and including our Design Department. Fortunately, it is far too early to sum up the achievements of Homan Potterton at the National Gallery of Ireland, but I feel honoured and delighted that our Directorships have had such a happy coincidence and that the National Gallery in London should now be privileged to show some of the treasures accumulated by Dublin.

MICHAEL LEVEY
Director
National Gallery, London
March 1985

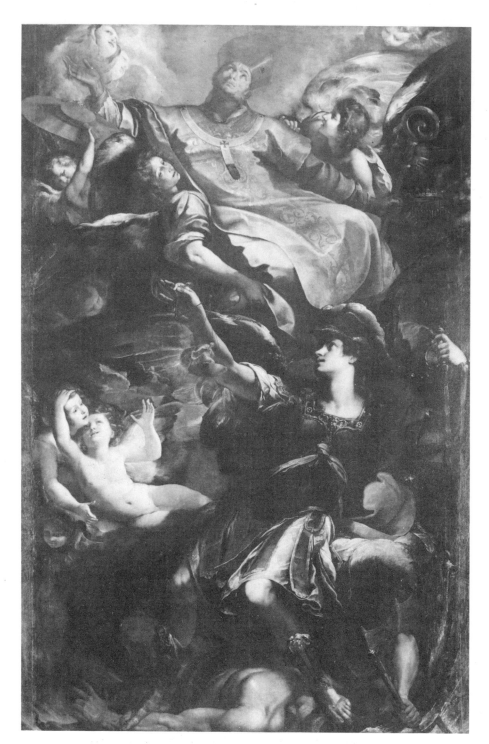

Fig. 1
THE APOTHEOSIS OF ST. CHARLES
BOROMMEO, WITH THE ARCHANGEL
MICHAEL by Giulio Cesare Pro-
caccini (1570-1625). 384 × 250
cm. *One of sixteen paintings purchased
at the inception of the National Gallery of
Ireland. The Carmelites of S. Maria in
Traspontina, Rome, sold it to the artist
Carlo Maratti; it also belonged briefly to
Napoleon's uncle, the noted collector,
Cardinal Fesch.*

Introduction

HOMAN POTTERTON

In the company of other European national galleries, the National Gallery of Ireland is really quite modern. It was established by Act of Parliament in 1854 and opened to the public ten years later in 1864, exactly forty years after the foundation of the National Gallery, London. In Britain, Sir George Beaumont's offer, in 1823, to give his collection to the Nation, and the opportunity to purchase the Angerstein Collection the following year, provided the impetus for the foundation of the National Gallery. In Ireland, thirty years later, there were no such concrete reasons for the establishment of a permanent public gallery of paintings; and the Dublin Gallery was conceived in a spirit, and founded on a basis, which consisted of little more than optimism and determination.

The Duke of Rutland when Viceroy in Ireland between 1784 and 1787 had in fact the notion of establishing a public gallery in Dublin and indeed he had gone so far as to appoint a Flemish painter working in Ireland, Peter de Gree, to be Keeper of the gallery. With the Duke's death in 1787, however, nothing more came of the project until about seventy years later. In 1853, two years after the Great Exhibition in London, a similar exhibition of arts and industries took place in Dublin. That Exhibition, which was housed in a temporary crystal palace on the site in Merrion Square now occupied by the National Gallery, included a loan exhibition of paintings from private collections in Ireland. Such was the public enthusiasm for this loan exhibition that at its close a group of interested people formed an association called The Irish Institution for the purpose of holding annual loan exhibitions of paintings and with the ultimate view of establishing a permanent public gallery in Dublin. The Committee of the Institution moved very quickly and within a year had an Act passed at Westminster which established the National Gallery of Ireland and incorporated a board of trustees to be known as Governors and Guardians. Although endowed with such a title, the Governors and Guardians when first convened had precisely nothing over which they could guard and even less that they could govern: there was no National Gallery building and no National Gallery collection.

That situation was, however, not to obtain for long. With unusual vigour the Board set about seeking donations of paintings for the new Gallery, and at the same time solicited subscriptions of money. Within a year, eleven paintings had been donated and sufficient funds had been raised to allow plans to be drawn up for the building of a Gallery.

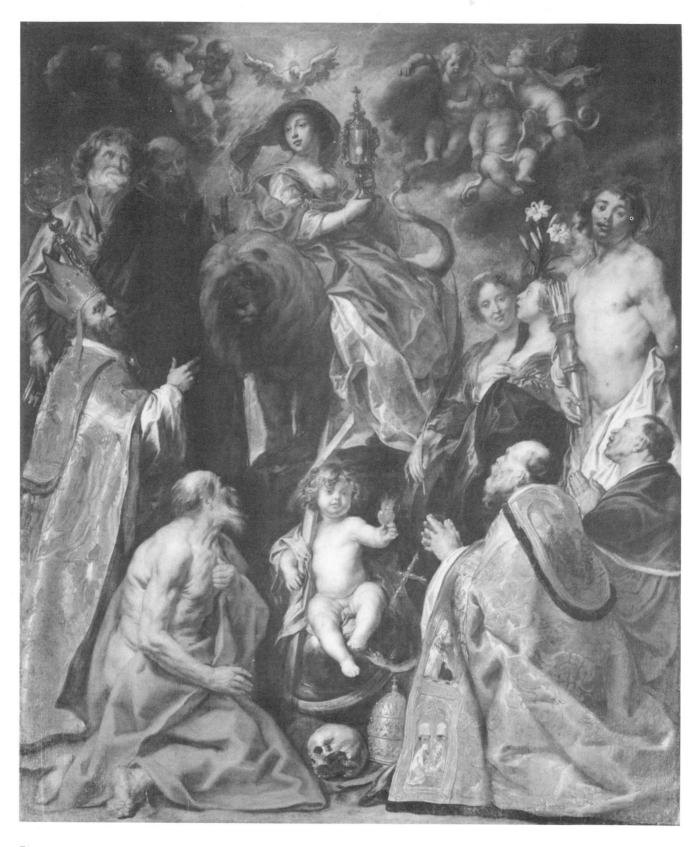

Fig. 2
THE CHURCH TRIUMPHANT by Jacob Jordaens (1593-1678). 280 × 231 cm. *A celebration of the majesty of the Roman church and tribute to its four Latin Fathers, this tour de force by Jordaens which dates from around 1630, was purchased in 1863, the year before the Gallery opened to the public.*

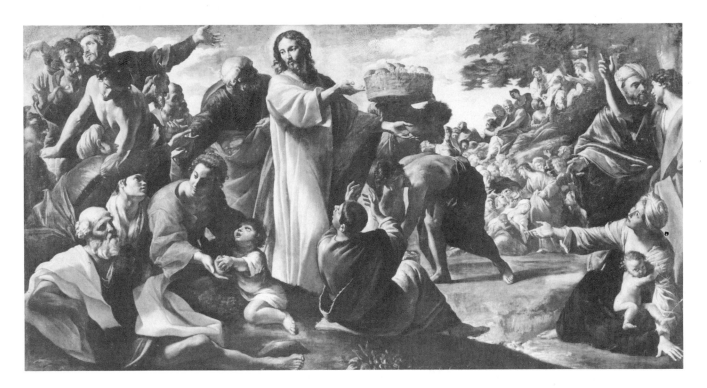

Fig. 3
THE MIRACLE OF THE LOAVES AND FISHES by Giovanni Lanfranco (1582-1647). 229 × 426 cm. *An overwhelming picture with life-size figures which dates from 1624-25 and with its companion,* THE LAST SUPPER, *was among the first purchases for the collection by the Board of Governors and Guardians.*

After the Dublin Exhibition of 1853 a Testimonial Fund was opened to commemorate the public services of the Irish railway magnate William Dargan, who had defrayed the expenses of that Exhibition, and in 1854 the Committee of the Fund gave £5,000 towards the building of a National Gallery. Together with public subscriptions and the help of Parliamentary Grants, the Gallery was built on Leinster Lawn and opened to the public in January 1864. The total cost of the building was about £30,000. The exterior design of the building was governed by the fact that it had to pair with the Natural History Museum on the other side of Leinster Lawn. The interior arrangements were by Francis Fowke an engineer in the Science and Art Department, London who was later to be Superintendant of the building of the South Kensington Museum (now the Victoria and Albert). The National Gallery of Ireland had the distinction of being the first public gallery to be illuminated by gas and had no fewer than 2,000 gas jets suspended from an oblong frame in the principal picture gallery, the walls of which, at the time of the opening, were painted maroon in imitation of the Grand Gallery in the Louvre. The building has since that time been extended on two occasions (in 1903 and 1968) so that it is now three times its original size.

At the same time as the building was being erected the Governors and Guardians also applied themselves to acquiring a collection. In 1855 they were approached by a

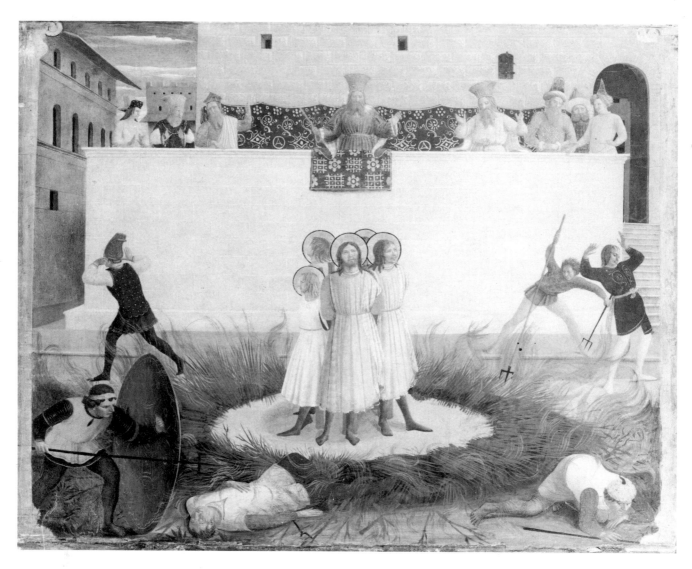

Fig. 4
THE ATTEMPTED MARTYRDOM OF SS. COSMAS AND DAMIAN WITH THEIR BROTHERS by Fra Angelico (1387-1455). 36 × 46 cm. *In 1438 Fra Angelico was commissioned by the Medici to paint an altarpiece for the convent of S. Marco in Florence, from which this lower* predella *panel comes. A masterpiece, complete in itself, it was purchased by Henry Doyle at the Graham sale in 1886.*

Roman dealer called Aducci who offered them a number of paintings, mostly seventeenth century Italian, and many of which had come from the celebrated collection of Cardinal Fesch. With the help of a loan from the Lord Chancellor, Sir Maziere Brady (who was a Governor and Guardian) a total of sixteen paintings were purchased from Aducci for the sum of £1,700 and these arrived in Dublin in 1857. Italian seicento paintings were not at a premium in the middle of the nineteenth century and it is not unlikely that the Governors and Guardians were influenced in their decision to buy these paintings by the fact that many of them were exceedingly large and would, therefore, fill the walls of the new Gallery. Whatever considerations were taken into account, the purchase was a notable one and included a masterpiece by the Milanese painter Giulio Cesare Procaccini, *The*

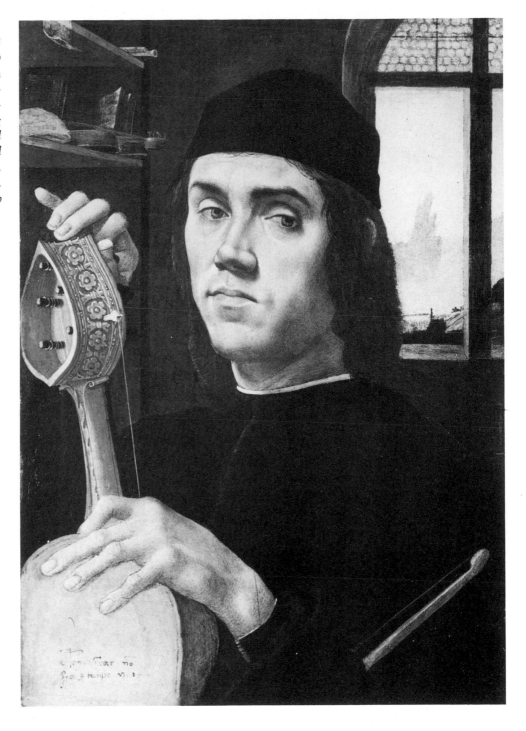

Fig. 5
PORTRAIT OF A MUSICIAN TUNING A LIRA DA BRACCIO by a Fifteenth century Italian artist. 51 × 36 cm. *An intriguing portrait which was purchased by Sir Walter Armstrong in 1897 as by Raffaellino del Garbo, but has also been attributed to Botticelli, Ercole de' Roberti, Cosima Tura, Lorenzo Costa, Francesco Francia and Filippino Lippi.*

Apotheosis of St. Charles Borommeo and two magnificent canvases by Giovanni Lanfranco which had been part of a series of paintings which the artist had painted for the Chapel of the Blessed Sacrament in the church of St. Paolo Fuori le Mura in Rome.

In 1862 two years before the opening of the Gallery, the Board appointed their first director, George Mulvany, who, like his contemporary at the National Gallery London, Charles Eastlake was a painter by profession. Mulvany immediately set

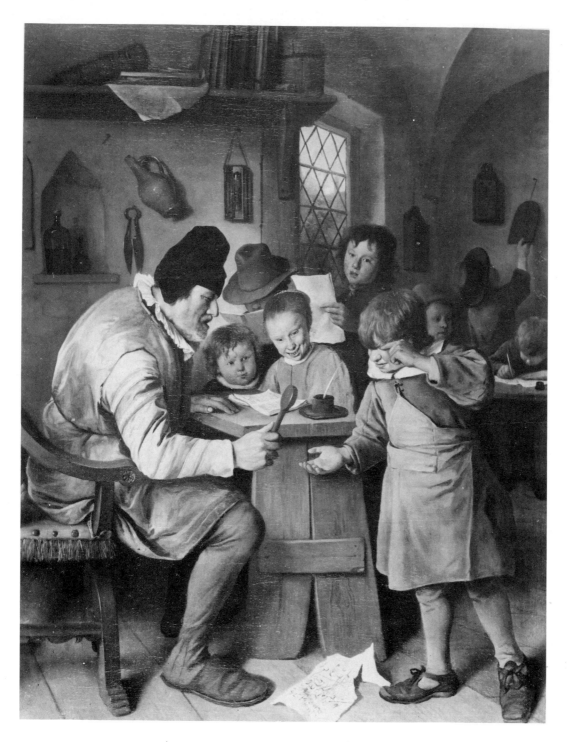

Fig. 6
THE VILLAGE SCHOOL by Jan Steen (1626-1679). 109 × 81 cm. *One of the large number of Dutch pictures added to the collection by Henry Doyle. It demonstrates Steen's ability to elevate genre to a major form of painting.*

about some further purchases and to this end travelled abroad annually. He bought a large altarpiece by Jacob Jordaens at the Allnutt sale in 1863 and the following year acquired the unusual *Portrait of a Man aged 28* by Georg Pencz which is included in this catalogue. (Cat. no. 21) Most of the money for these purchases was raised by public

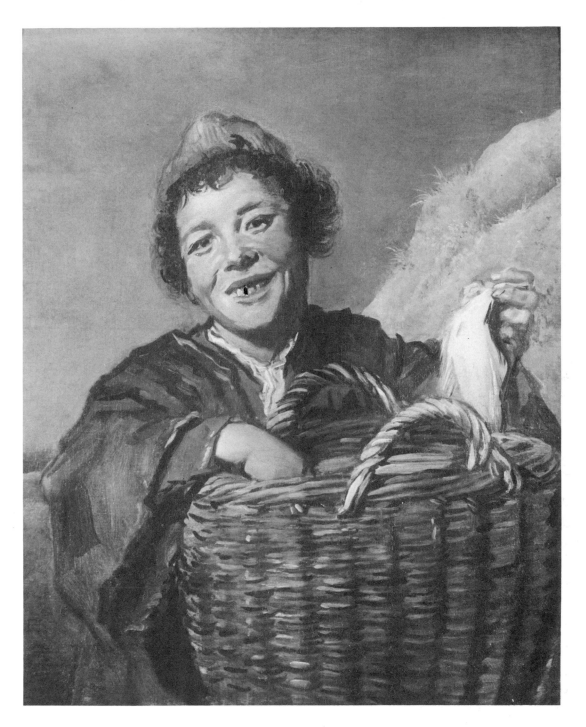

Fig. 7
A YOUNG FISHERBOY OF SCHEVENINGEN by Frans Hals (c.1580-1666) 72 × 58 cm. *An unusual subject by Hals painted following visits to the seashore near The Hague in the 1630s. It was purchased by Henry Doyle from a French collector in 1881.*

subscription although Parliament voted £2,500 for purchases in 1863-64 and a further £2,500 in 1865. In 1866 the Treasury agreed to an annual purchase grant of £1,000: a sum that was, amazingly, to remain fixed for the next seventy years until 1937!

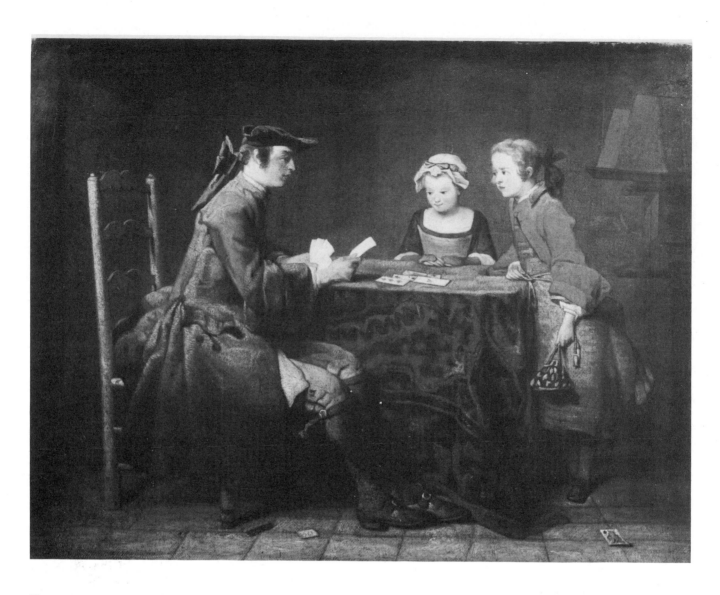

Fig. 8
LES TOURS DE CARTES by Jean-Baptiste Siméon Chardin (1699-1779). 31 × 39 cm. *Exhibited at the 1739 Salon with a pendant 'The Game of Goose' (now lost), this picture was engraved by J.-B. de Surugue in 1744. Sir Walter Armstrong purchased it in 1898.*

When the Gallery opened to the public in January 1864 there was a total of one hundred and thirty-eight oil paintings on show including a number which had been given on indefinite loan by the National Gallery London. Others had been presented to the Collection and the rest had been purchased. It was with the relatively small annual purchase grant of £1,000 that the greater part of the Dublin collection was purchased as it was not until the early years of the present century that the Gallery would be the recipient of any substantial donations of collections or trust funds. The credit for building the Collection, and what is more giving it its character, is due largely to two early directors, Henry Doyle and Walter Armstrong, both of whom carried out their responsibilities with great skill and connoisseurship. The purchases

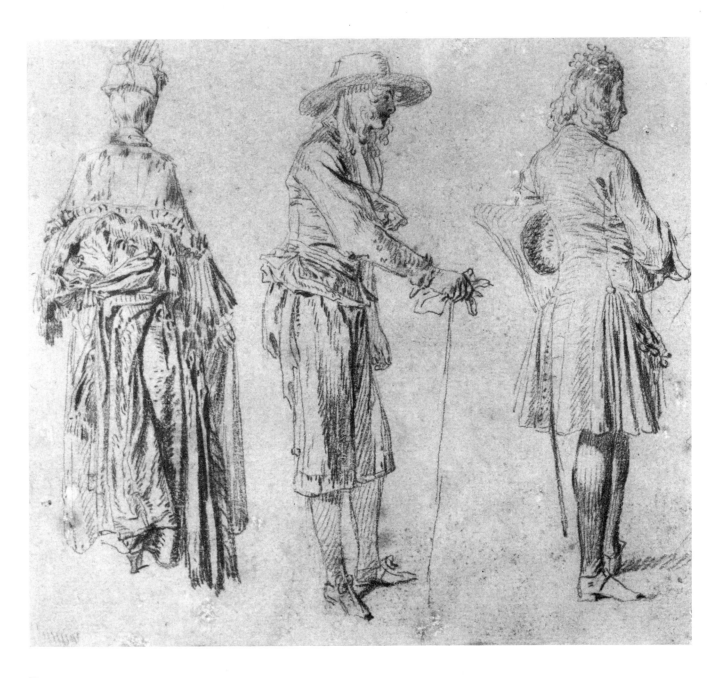

Fig. 9
A LADY AND TWO GENTLEMEN by Jean Antoine Watteau (1684-1721). 15 × 16.5 cm. *Dublin is fortunate to have four major drawings by Watteau, purchased by Henry Doyle in 1891 (also two landscapes once used in the drawing school of the Royal Dublin Society). These memorable figures in red chalk were included in compositions painted by Watteau about 1710.*

of Mulvany or indeed the part he played in the establishment of the Gallery, must not in any way be discredited, but the task of assembling from nothing, a collection of old masters worthy of a national gallery must have seemed quite daunting. In the early years, taking into account the fact that as 'it may be impossible to obtain an example of the greatest names in the history of art and that they may for years be only known to the Irish public through the imperfect means of copies', the Board's policy was to buy, on occasion, copies after the great masters such as Velázquez or

Fig. 10
FISHING BOATS ON FOLKESTONE BEACH, KENT by Joseph Mallord William Turner (1775-1851). **18 × 26 cm.** *The English collector Henry Vaughan bequeathed thirty-one watercolours by Turner to Dublin in 1900. They are exhibited in January with Turner's engraved* Liber Studiorum. *Vaughan bequeathed a similar group to the National Gallery of Scotland and presented Constable's* The Haywain *to the National Gallery, London.*

Titian. A copy of Titian's *St. John in Wilderness* which Mulvany purchased in 1863 is, however, now known to be a rare documented copy by Gian Antonio Guardi.

Neither Doyle nor Armstrong, however, were to be satisfied with copies. Both, although Doyle in particular, seem to have had a relatively free hand in making purchases and many of those purchases were made at Christie's. In the twenty-three years of his directorship, Doyle purchased many paintings which remain to-day among the finest in the Collection. Fra Angelico's *Attempted Martyrdom of SS. Cosmas and Damian,* was purchased in 1886 for £73.10s.; a large Jan Steen, *The Village School* bought in 1879 for £420; Reynolds's exotic portrait of the Irish *Earl of Bellamont* acquired in 1875 for £500; a Frans Hals *Fisherboy* purchased in Paris in 1881 for £400; and no fewer than four of the masterpieces in this catalogue were also acquired by Doyle: Poussin's *Lamentation* (Cat. no. 13), Titian's *Ecce Homo* (Cat. no. 2), Veronese's *SS. Phillip and James the Less* (Cat. no. 3), and Rembrandt's *Rest on the Flight into Egypt* (Cat.

Fig. 11
A PARODY ON RAPHAEL'S SCHOOL OF ATHENS by Joshua Reynolds (1723-1792). 97 × 135 cm. *A humorous depiction of Irish and British visitors to Rome in 1751, in the guise of the classical figures of Raphael's fresco in the Stanze. The central figure with an eye-glass later became the 1st Earl of Milltown and the picture formed part of the Milltown Gift in 1902.*

no. 24). Because of his method of purchase, Doyle was also instrumental in shaping the character of the Dublin collection. He personally attended auction sales and from a study of the catalogues of the sales which he attended, and the prices he paid for some pictures it is possible to deduce that on many occasions he made a spur of the moment decision and secured important pictures at a bargain price. In this way many unusual paintings by lesser-known artists were acquired. As later directors have built on this foundation it is very much a feature of the Dublin collection (well brought out by the selection of paintings in this catalogue) that masterpieces by well-known names are shown alongside paintings of great quality and beauty by artists whom even scholars may not know. Doyle's successor Walter Armstrong also added names to the collection: a charming small Chardin, a standing saint by Rubens and the paintings by Mantegna and Goya in this catalogue. (Cat. nos. 1 and 12) But Armstrong also favoured the unusual: Troost's *The Dilettante* (Cat. no. 34) and the highly enigmatic *Interior with Figures* by an artist of the Rembrandt School (Cat. no. 25).

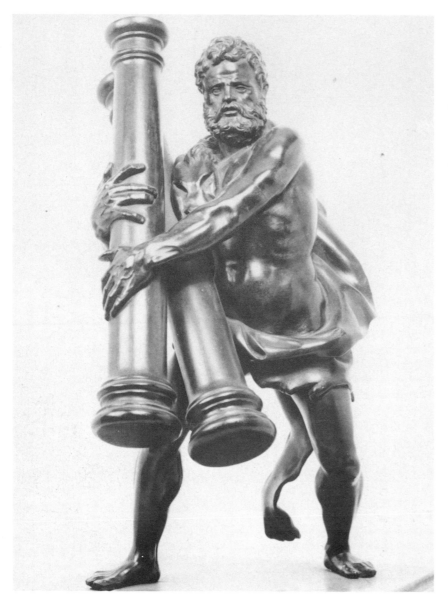

Drawings and watercolours were collected by the National Gallery of Ireland from its foundation, and indeed even before the Gallery was opened, a Dublin collector George Archibald Taylor, had bequeathed his collection of watercolours. Doyle built on this collection: he encouraged the important British collector William Smith to give the Gallery a very large collection of fine English watercolours and he bought an exceptional group of Watteau drawings at the James Sale in London in 1891. Armstrong, also, added a number of very fine old master drawings to the collection.

The twentieth century opened for the Gallery with three very important gifts: the Milltown Gift, the Sir Henry Page Turner Barron Bequest and the Vaughan Bequest of Turner watercolours. In 1902 the Countess of Milltown gave the entire contents of Russborough, county Wicklow to the Gallery in memory of her late husband the 6th and last Earl of Milltown. These pictures and sculptures had been

Fig. 13
A VIEW IN SUFFOLK by Thomas Gainsborough (1727-1788). 47 × 61 cm. *Of the nine Gainsboroughs in the collection, six were presented or bequeathed by Sir Hugh Lane. This view was painted by the young Gainsborough in the 1740s and is a precious record of his native Suffolk, inspired by the Dutch landscapes he had copied and restored.*

bought mainly in Italy during the middle of the eighteenth century by the 1st Earl of Milltown and had remained at Russborough until they came to the National Gallery. The collection was of a fairly typical country-house nature, the highlight of which was Poussin's beautiful *Holy Family*, but it also included the rare group of caricatures by Joshua Reynolds including his *Parody on the School of Athens*. A set of bronzes which were thought to be eighteenth century copies after *The Labours of Hercules* by Gianbologna, have subsequently been recognised as original. By the terms of the will of Sir Henry Page Turner Barron the Gallery was allowed to select a group of pictures from his collection. Barron, who had been a diplomat, had lived all his life on the Continent and had a very good small collection. From it Armstrong selected ten paintings including *Christ in the House of Martha and Mary* by Rubens (Cat. no. 22) and Salomon van Ruysdael's magnificent *The Halt* (Cat. no. 27).

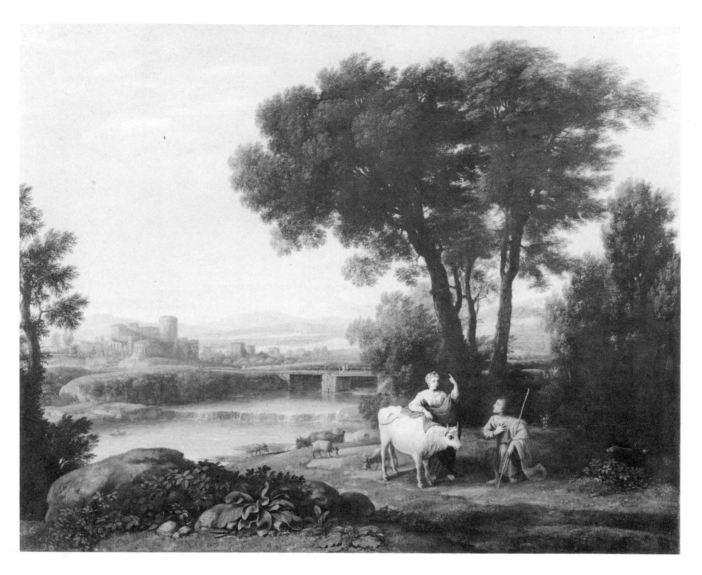

Fig. 14
JUNO CONFIDING IO TO THE CARE OF ARGUS by Claude Lorraine (1600-1682). 60 × 75 cm. *Claude recorded finishing this picture in his* Liber Veritatis *(British Museum) for a French patron, M. Basont in 1660. It was later in French and English collections before Sir Hugh Lane bequeathed it to Dublin in 1918.*

The name Hugh Lane is one that is familiar to many people, and linked by them to his collection of Impressionist paintings, including Renoir's famous *Les Parapluies.* Not everyone, however, will be familiar with the fact that Lane's collection of Old Masters far exceeded in quality his Impressionist collection, and that his Old Masters came to the National Gallery of Ireland. Lane was Irish by birth and became, at an early age, a very successful picture dealer in London. He was devoted to the cause of art in Ireland and indeed was knighted in 1909 in recognition of his services to that cause. From 1904 he was a Governor and Guardian of the National Gallery of Ireland and in April 1914 was appointed Director. Lane's directorship was short-lived for he was drowned in May 1915 when returning from America on the *Lusitania.* Lane's generosity to the National Gallery of Ireland was unique: at the ten

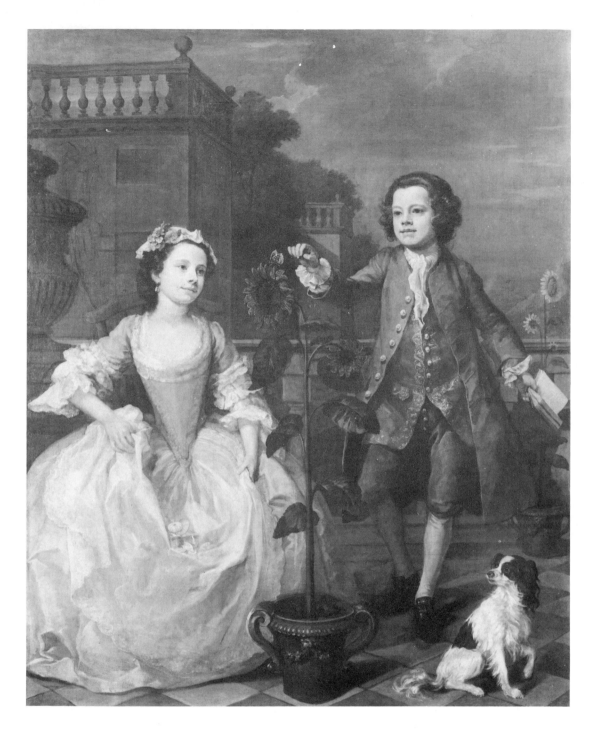

Fig. 15
THE MACKINNON CHILDREN by William Hogarth (1697-1764). 180 × 143 cm. *This engaging double portrait shows the influence of the Rococo on Hogarth during the 1740s, though he typically also makes it an allegory of the transitory nature of childhood. Sir Hugh Lane bequeathed it with forty-two other paintings in 1918.*

meetings at which he attended on the Board of Governors and Guardians he presented to the Gallery no fewer than fifteen pictures including a superb pair of gamepieces by the French eighteenth-century painter François Desportes, two paintings by Gainsborough, a Veronese and El Greco's *St. Francis* (Cat. no. 11). In his

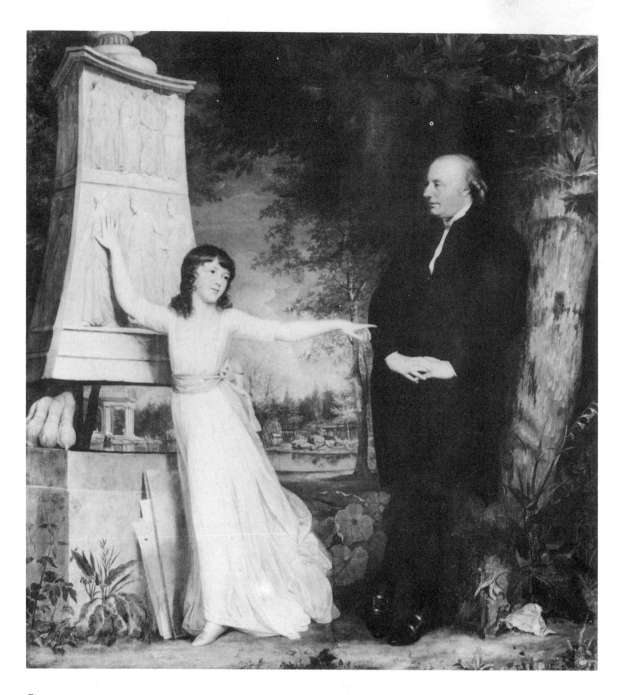

Fig. 16
THE EARL-BISHOP OF DERRY AND HIS GRAND-DAUGHTER LADY CAROLINE CRICHTON by Hugh Douglas
Hamilton (1739-1808). 230 × 139 cm. *Little known until its purchase with the Lane Fund in 1981, this is now
acknowledged as one of the finest 18th century Irish portraits. It shows a celebrated traveller, who built three country houses
for his collections, admiring an antique altar in the gardens of the Villa Borghese, Rome.*

will he bequeathed to the National Gallery of Ireland the residue of his property 'to
be invested and the income spent on buying pictures of deceased painters of
established merit'. As the residue of his estate included his collection, the Governors
and Guardians applied to the courts for permission to retain forty-three of his old
master paintings including a Titian, a Claude, a Goya, a Van Dyck, a Lawrence, two
paintings by Poussin, two by Hogarth and four by Gainsborough. From the trust

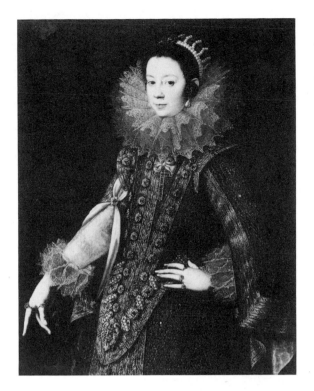

Fig. 17
JUANA DE SALINAS by Pantoja de la Cruz
(1551-1608). 105 × 82 cm. *A sumptuous
portrait which records for posterity this otherwise
unknown member of the Spanish court. Robert
Langton Douglas purchased it in 1920 with
monies bequeathed by Sir Hugh Lane.*

Fig. 18
TWO BALLET DANCERS
IN THE DRESSING
ROOM by Edgar
Degas (1834-1917).
48.5 × 64 cm. *A classic
pastel by Degas, probably
bought from the artist by
Edward Martyn in
1886. This musicologist,
who was one of the
founders of the Abbey
Theatre, bequeathed it to
the collection in 1924
together with oils by Corot
and Monet.*

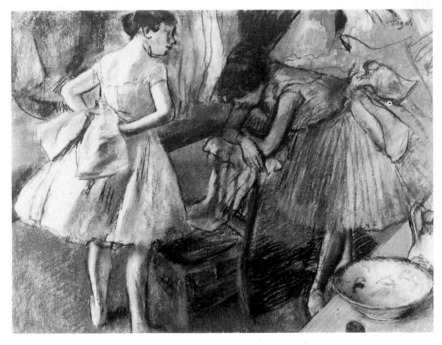

fund established by his bequest four of the paintings in this exhibition have subsequently been purchased: Gentileschi (Cat. no. 4), Castiglione (Cat. no. 6), Perronneau (Cat. no. 13) and Siberechts (Cat. no. 23).

Few public galleries could expect to be favoured so much by any single benefactor, and in such unusual circumstances as the National Gallery of Ireland was by Hugh Lane. Had he lived who knows what masterpieces might have come Dublin's way. With his death the Governors and Guardians cannot reasonably have expected that

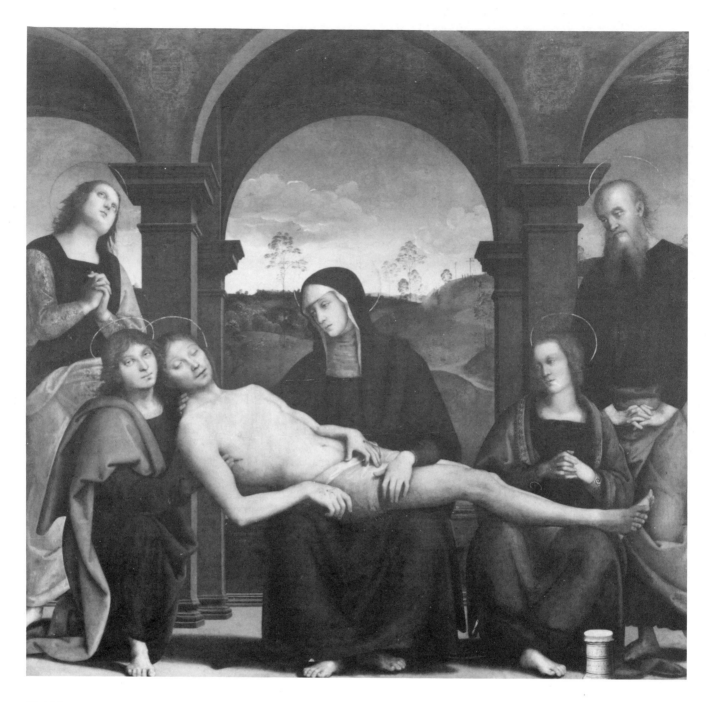

Fig. 19

THE PIETÀ by Perugino (1446-1523). 169.5 × 171.5 cm. *Thomas Bodkin purchased this moving depiction of the crucified Christ in 1931; the artist's signature in Latin was later discovered during cleaning. Another version in Florence is without the landscape which gives the Dublin picture its special quality.*

their Gallery would ever be as fortunate again. In having no such expectation, however, the Board were not to foresee that an Irishman, Edward Martyn would visit Paris in the 1880s and buy contemporary works by Degas and bequeath them to the Gallery; or that an American mining millionaire, Sir Alfred Chester Beatty, who had no Irish connections would settle in Dublin in his declining years and

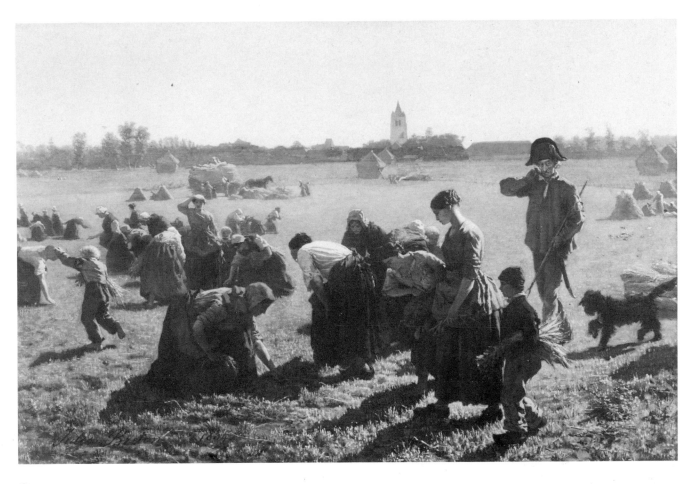

Fig. 20
THE GLEANERS by Jules Breton (1827-1906). 93 × 138 cm. *One of several masterpieces from the gift by Sir Alfred Chester Beatty of ninety French paintings in 1950. It was exhibited in 1855, two years before Jean François Millet's picture of the same subject now in the Louvre.*

present them with a comprehensive collection of Barbizon paintings, a large number of miniatures and an exquisite watercolour of *Monte Sainte Victoire* by Cézanne. But from its inception the National Gallery of Ireland has been subject to the unexpected and never more so than in 1950 when the acting director read a letter to the Board from George Bernard Shaw. Shaw proposed 'in his usual light-hearted manner' that a statue of him should be erected in front of the Gallery; and he paid tribute to the National Gallery of Ireland for the priceless part it played in his education when he was a boy in Dublin. In recognition of this he bequeathed to the Gallery one third part of his residual estate and this unusual bequest meant that for fifty years after his death the Gallery would receive one third of the royalties derived from his published works. The bequest has been used by the Gallery for the purchase of paintings and over the past twenty years works by Boucher, Fragonard, Nattier, Murillo, Goya and the pictures by Gérard (Cat. no. 17), Jacques-Louis David (Cat. no. 16) and Nolde (Cat. no. 35) in this catalogue have come to Dublin through Shaw's generosity.

From modest and inauspicious beginnings one hundred and thirty years ago the National Gallery of Ireland has grown and flourished more than its founders could

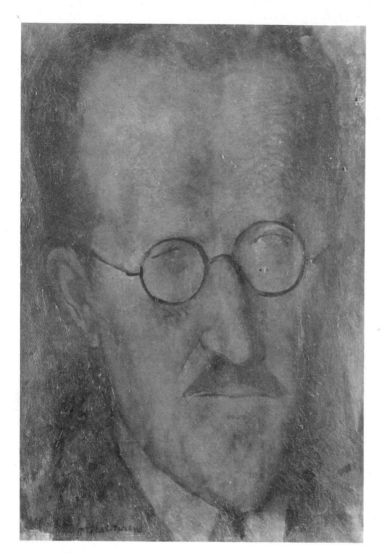

ever have imagined. The collection now includes about two and a half thousand oil paintings ranging over all schools and in date from the fifteenth to the twentieth centuries. Also included is the Irish national portrait collection and the national collection of Irish paintings. In addition the Gallery houses a collection of over five thousand drawings and watercolours and a collection of prints and sculpture.

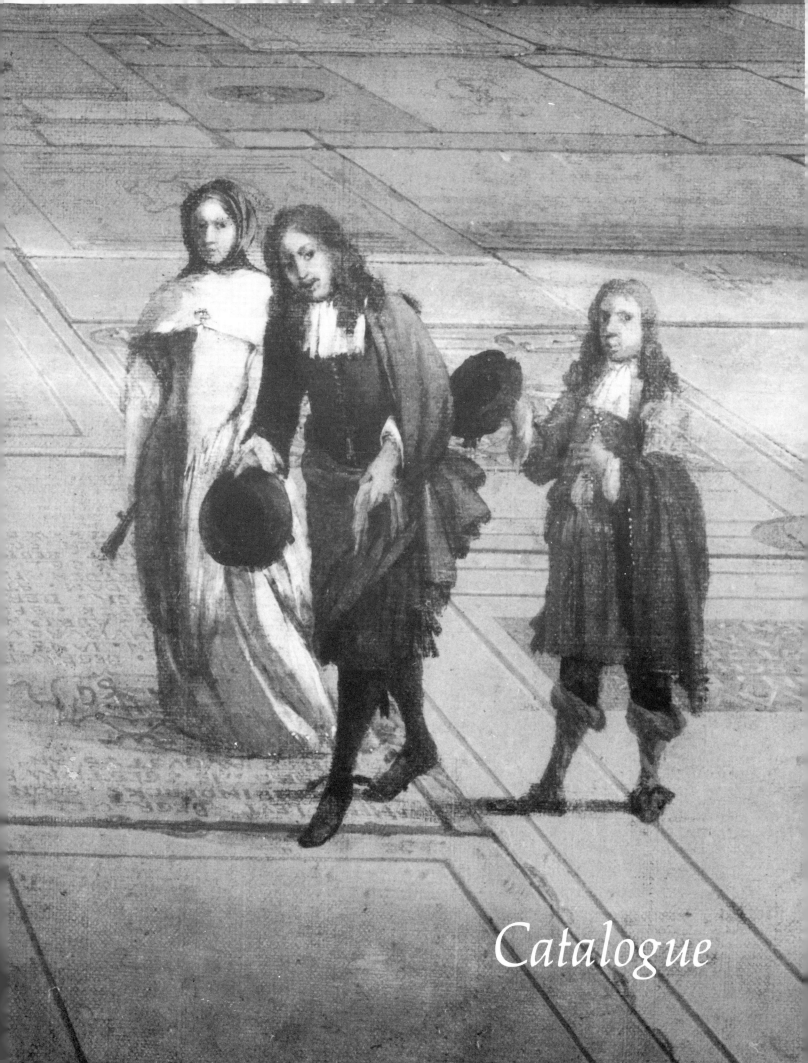

Catalogue

Catalogue entries, which are signed with initials, have been written by:

Raymond Keaveney (RK)
Adrian Le Harivel (ALH)
Homan Potterton (HP)
Michael Wynne (MW)

ACKNOWLEDGEMENTS

The authors of the catalogue acknowledge the assistance of the following: Dr David Oldfield, who is preparing a catalogue of the German paintings in the National Gallery of Ireland, for information on the German pictures; Christiaan Vogelaar, who is preparing a catalogue of the Early Netherlandish paintings in the National Gallery of Ireland, for checking last-minute information in Holland; Dr Martin Urban of the Nolde Stiftung, Seebüll for information on catalogue number 35; Sylvain Laveissière for information on Gérard (Cat. no. 17); Donal Begley for genealogical research in respect of catalogue number 12; Rupert Hodge of the Witt Library; Hugh Maguire in London; Elspeth Hector in the Library of the National Gallery London; and Janet Drew, Barbara Dawson and indeed all the staff of the National Gallery of Ireland.

Illustration on previous page: detail from Anthonie De Lorme *Interior of the St. Laurenskerk, Rotterdam* (Cat. no. 29).

Paintings in the Exhibition

			PAGE
1.	Andrea Mantegna	*Judith with the head of Holofernes*	4
2.	Titian ✓	*Ecce Homo*	7
3.	Veronese	*SS. Philip and James the Less*	10
4.	Orazio Gentileschi	*David and Goliath*	12
5.	Pensionante del Saraceni	*St. Peter denying Christ*	14
6.	Giovanni Benedetto Castiglione	*Shepherdess finding the infant Cyrus*	16
7.	Giovanni Battista Passeri	*Party feasting in a Garden*	20
8.	Bernardo Bellotto	*Dresden from the right bank of the Elbe above the Augustus Bridge*	22
9.	Bernardo Bellotto	*Dresden from the right bank of the Elbe below the Augustus Bridge*	24
10.	Giovanni Battista Tiepelo	*Allegory of the Immaculate Conception and of Redemption*	26
11.	El Greco	*St. Francis receiving the Stigmata*	28
12.	Francisco de Goya	*'El Conde del Tajo'*	30
13.	Nicolas Poussin	*The Lamentation over the Dead Christ*	32
14.	Nicolas Largillière	*Portrait of a Lady*	34
15.	Jean-Baptiste Perronneau	*Portrait of a Man*	36
16.	Jacques-Louis David	*The Funeral of Patroclus*	38
17.	François-Pascal-Simon Gérard	*Julie Bonaparte, Queen of Naples, with her daughters, Zénaïde and Charlotte*	42
18.	Eugène Delacroix	*Demosthenes on the Seashore*	44
19.	Conrad Faber	*Heinrich Knoblauch*	46
20.	Conrad Faber	*Katherina Knoblauch*	50
21.	Georg Pencz	*Portrait of a Man aged twenty-eight*	52
22.	Peter Paul Rubens with Jan Brueghel the Younger	*Christ in the House of Martha and Mary*	56
23.	Jan Siberechts	*The Farm Cart*	60
24.	Rembrandt van Rijn ✓	*Landscape with the Rest on the Flight into Egypt*	62
25.	School of Rembrandt c.1630	*Interior with figures*	66
26.	Gerbrandt van den Eeckhout	*Christ at the Synagogue in Nazareth*	68
27.	Salomon van Ruysdael	*The Halt*	70
28.	Frans Post	*A Brazilian Landscape*	72
29.	Anthonie De Lorme	*Interior of the St. Laurenskerk, Rotterdam*	74
30.	Nicolaes de Gyselaer	*Interior with figures*	76
31.	Jacob Duck	*Interior with a woman sleeping*	78
32.	Jacob Gerritsz. van Hasselt	*View from the Bishop's throne, west from the nave, towards the staircase tower in Utrecht Cathedral*	80
33.	Jan Mytens	*A Lady playing a Lute*	82
34.	Cornelis Troost	*Portrait of Jeronimus Tonneman and his son, Jeronimus: 'The Dilettanti'*	84
35.	Emil Nolde	*Women in the Garden*	86

3

Andrea Mantegna (Isola de Carturo c.1431–1506 Padua)

Born near Vicenza, Mantegna received his training from Francesco Squarcione at Padua, where his presence is first recorded in 1441. The most important influences on his development were the bronzes of Donatello and the paintings of the Bellini. In 1448 he was commissioned to decorate the Ovetari Chapel in the Church of the Eremitani in Padua. The quality and originality of these frescoes (now destroyed) must have been an important factor in prompting Ludovico Gonzaga to employ him as his court painter at Mantua. Mantegna worked for the Gonzaga from 1459 till his death, during which time he produced a series of brilliant works, notably his frescoes in the ducal palace, many of which include portraits of his patron's family, and his nine canvases showing the Triumph of Caesar in which he expertly displayed his knowledge of the classical world. Apart from his activity as a painter, Mantegna also produced a small number of engravings.

1 Judith with the head of Holofernes

Tempera on linen: 48.1 × 36.7 cm. (19 × 14½ ins.)
EXHIBITED: 1902, Royal Academy, London, *Winter Exhibition*, no. 46; 1930, Royal Academy, London, *Exhibition of Italian Art, 1200-1900*, no. 146; 1961, Palazzo Ducale, Mantua, *Andrea Mantegna*, no. 52; 1965, Israel Museum, Jerusalem, *Old Masters and the Bible*, no. 67.
PROVENANCE: Purchased in Italy by the Hon. Lewis Wingfield; John Malcolm of Poltalloch; Lord Malcolm of Poltalloch from whom purchased by the National Gallery of Ireland, per P.&D. Colnaghi, 1896. Cat. no. 442.
LITERATURE: Berenson 1901-16, vol. 1, p. 97; vol. 2, pp. 50, 55, 57ff; Kristeller 1901, p. 373, repr. p. 368, fig. 129; Yriarte 1901, p. 205; Duncan 1906, p. 7; Berenson 1910, pp. 48, 254; Crowe/Cavalcaselle 1912, vol. 2, p. 105, n. 3; Knapp 1910, p. 132; Venturi 1914, vol. 7, pt. 3, pp. 244, 247-248; Berenson 1931, p. 327; Fiocco 1937, p. 68; Tietze-Conrat 1955, pp. 181, 247, pl. 123; Bodkin 1956, p. 44; Cipriani 1956, (1962 ed.), p. 80, pl. 160; Davies 1961, p. 334; Paccagnini 1961, p. 71, no. 52, fig. 70; Gilbert 1962, p. 6; Vienna 1966, p. 48, no. 6; Bellonci/Garavaglia 1967, p. 114, no. 75; Berenson 1968, vol. 1, p. 239, pl. 334; Lady Gregory 1973, p. 148; Oberhuber 1973, p. 388, no. 4; Zeri 1974, p. 98; Shapley 1979, p. 296; Smith 1981, p. 10; Munich 1983, p. 308.

The subject of this picture, *Judith with the head of Holofernes*, must have held a particular fascination both for Mantegna and his patrons, as he treated the theme on numerous occasions and in various media. Undoubtedly, he executed versions for the Gonzaga at Mantua and we also know from a Medici inventory of 1492 of an example sent to Florence (possibly the picture in the National Gallery, Washington).

Judith, a figure from the Old Testament Apocrypha was the heroine of the Jewish people in their struggle against the Assyrians. When the city of Bethulia was besieged by enemy forces, (Judith, ch. 13, vs. 9-10), Judith, a rich and pious widow, feigned desertion to the Assyrian camp, where her great beauty quickly captivated the attention of their leader, Holofernes. Invited to his tent after a banquet she lulled the drunken general to sleep and then cut off his head with two swift blows of his sword and carried it away hidden in a sack. After the Assyrians discovered the dreadful deed they immediately lost heart, lifted the siege and fled in disarray.

Apart from describing an episode from biblical history, the scene of Judith with the head of Holofernes is most usually interpreted as symbolizing the victory of virtue over vice, in which respect Judith is also viewed as prefiguring the Virgin. On a secular level, the subject had a special significance for the small city states of Medieval and Renaissance Italy, which were under the constant threat of invasion and subjugation from their more powerful neighbours and other military powers further afield.

Some authorities have argued that the present finely wrought image, painted in grisaille on a fine linen support to imitate a carved relief or engraving in *pietra dura*, may have formed part of a series of similarly executed monochrome compositions which possibly had as its theme a sequence of biblical images depicting the misfortunes of men at the hands of scheming women. Two other grisailles of approximately the same dimensions (coincidentally displaying the same fold marks) and showing similar subject matter are in the National Gallery in London and in the Cabinet des Dessins in the Louvre.

The picture in London, the finest of the three, represents *Samson and Delilah*; the composition in the Louvre depicts the *Judgment of Solomon*. Two further grisailles of similar dimensions are in the Kunsthistorisches Museum in Vienna, one illustrating the *Sacrifice of Abraham*, the other showing *David and Goliath*.

Critics are fairly evenly divided on the question of Mantegna's authorship of the present composition. Though, compared to the London painting, the Dublin grisaille does not exhibit the same uniform high quality, most writers are convinced that the invention of the design is due to Mantegna, many of them

Continued overleaf

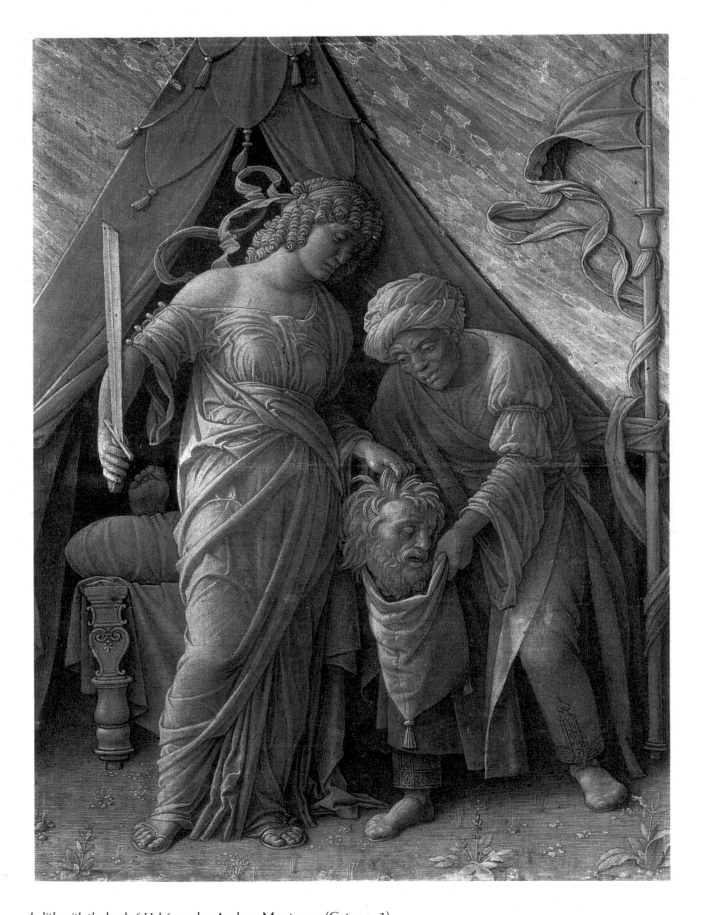

Judith with the head of Holofernes by Andrea Mantegna (Cat. no. 1)

believing that the execution is also by the hand of the master, though some believe it to be a studio product.

In Crowe and Cavalcaselle's *History of Painting in North Italy* (1912 ed., p. 105, no. 3), the picture is referred to as 'perhaps an original by Mantegna'. Kristeller (1901, p. 373) considering the quality of the work to be superior to that of the *Judith* in Montreal, remarked '... rather better, but still only a school work ...'. Ellen Duncan (1906, p. 7) accepted the composition as the work of Mantegna and speculated on its thematic relationship to the grisailles in London and Paris. Fritz Knapp (1910, p. 132), however, included it among the studio works only. Bernard Berenson, (1901-16, vol. 1, p. 97) viewed it as a mediocre painting by the great artist, but still authentic and retained it among the master's *oeuvre* in his list compiled some fifty years later (1968, I, p. 239, 'late work'). Venturi, (1914, vol. 7, p. 244) was less inclined to accept Mantegna's authorship of the piece and considered it instead a version after the richly coloured image now in Washington (National Gallery). E. Tietze-Conrat (1955, p. 198) accepted the composition as the invention of Mantegna but was more undecided as to whether or not the execution was his. Fiocco (1937, p. 68), gave the work to the master with reservations. In the catalogue to the Mantegna Exhibition, (Mantua 1961, no. 52). Paccagnini observed that the composition must be considered as the creation of Mantegna who should also be acknowledged as having had a major part in its execution, a view more or less

shared by Creighton Gilbert in his review of the exhibition (1962, p. 6). Davies, (1961, p. 334), writing on the London *Samson and Delilah* repeated Ellen Duncan's suggestion that the Dublin picture may have belonged to a series of uneven quality which might also have included the Paris *Judgment of Solomon*, a theory also discussed by Alistair Smith (1981, p. 10). Davies, in addition, made reference to a *Judith*, in grisaille, which was listed in an inventory of Gonzaga possessions dated 1709 and which might conceivably refer to the present version. Cipriani (1962, p. 80), not impressed by the quality of the present picture, included it among the attributed works only. Konrad Oberhuber, (1966, no. 6, see also 1973, no. 148), commenting on an engraving of the subject referred to the Dublin grisaille as the master's finest painting of the Judith theme. Garavaglia, (1967, no. 75), included the picture among the master's works but was not altogether convinced of the attribution. Zeri, (1974, p. 98), was impressed by the quality of the work and remarked on the technique employed which reflected Mantegna's interest in the Antique and evidenced the classical and archaeological revival which influenced his work to such a notable degree.

There are drawings of the subject, attributed to Mantegna, in Florence (Uffizi), Washington (National Gallery), and Chatsworth (collection of the Duke of Devonshire). Engravings of the subject, based on designs by Mantegna, were executed by Zoan Andrea and Girolamo Mocetto.

RK

Tiziano Vecellio, called Titian (Pieve di Cadore c.1480/85–1576 Venice)

Titian was born the second of five children of Gregorio Vecellio. At an early age he travelled to Venice where he first became apprenticed to the minor artist Sebastiano Zuccatti before moving to the Studio of Gentile Bellini and thence to Giovanni Bellini, who was his real master. In 1508 he was employed along with Giorgione to decorate the facade of the Fondaco dei Tedeschi in Venice, and the influence of his brilliant young colleague permeated his own work for many years afterwards, infusing it with a delicate sense of poetry. In 1515 he was employed to paint an altarpiece depicting the Assumption of the Virgin for the Church of the Frari, which, when completed in 1518, marked the achievement of the first monumental High Renaissance creation in Venice. This was quickly followed by commissions for a number of mythological compositions for Alfonso d'Este at Ferrara, in which the artist showed himself a master in the evocation of the classical world. His reputation established, Titian now received requests for work from all over Italy and Europe, enjoying the patronage of the Venetian government, the Papacy and the Emperor, together with commissions from the most illustrious families of Italy, including the Gonzaga, Este, della Rovere, and Farnese. The beautifully balanced, harmonious and richly coloured creations of his early maturity were followed, intermittently at first, by a sequence of canvases which display inventiveness and an exciting dynamic verve, reflecting the Mannerist trend popular during the middle years of the century. His late, mature works, manufactured in an increasingly personal manner, present magnificent, frequently profound images which conjur up, in their chromatic intensity and richly textured paint, sometimes applied and managed directly with the fingers, images of powerful poetic intensity.

2 Ecce Homo

Oil on canvas: 73.4 × 56 cm. (28⅞ × 22 ins.)
EXHIBITED: 1883, Royal Academy, London, no. 182; 1955, City of Birmingham Museum and Art Gallery, Birmingham, *Italian Art from the Thirteenth to the Seventeenth Century*, no. 107.
PROVENANCE: Van Dyck (?); Sir William Knighton sale, Christie's, London, 21 May and ff., 1885, lot 520, where purchased by the National Gallery of Ireland. Cat. no. 75.
LITERATURE: Duncan 1906-07, p. 7; Müller-Rostock 1922, pp. 22, 24; Gore 1955, p. 218; McGreevy 1956, p. 70; Berenson 1957, p. 185; Haskell 1958, p. 140; Suida 1959-60, p. 67; Jonescu 1960, p. 41; Richter/Morelli 1960, p. 409; Cagli/Valcanover 1969, p. 128, no. 413; Pallucchini 1969, pp. 158, 305, no. 422; Wethey 1969, pp. 87-88, no. 34, pl. 100; Zeri 1974, p. 100, fig. 24; Fisher 1977, p. 88, n. 85, fig. 77; Heinemann 1980, p. 440; Pérez Sánchez 1980, p. 354; Rearick 1980, p. 373, fig. 239; Mason Rinaldi 1984, p. 145, no. 560.
ENGRAVED: by Lucas Vorsterman.
COPIES: 1. Formerly in the Lucien Bonaparte collection. 2. Ringling Museum, Sarasota, weak but exact copy, according to Wethey, (1969, p. 88). Suida, (*Catalogue* 1949, p. 61; 1959-60, p. 67, fig. 82) ascribes the copy to Peterzano.

The title of the present painting derives from the Vulgate version of the Bible (John, ch. 19, vs. 4-6) where, during the Passion, Pontius Pilate, the Roman Governor of Judea, presented the tortured figure of Christ to the crowds gathered outside the Judgment Hall with the words 'Ecce Home' — 'Behold the Man!', thus hoping that the pitiful image of the Saviour, scourged and crowned with thorns, would evoke sympathy and compassion in the hearts of the mob vociferously demanding his death.

This shocking vision of the suffering Christ is a development, not of medieval religious fanaticism, though some designs, mostly in manuscripts, did depict the motif before the fifteenth century, but of the early Renaissance. In the sixteenth century the subject quickly gained in popularity, its special appeal heightened by the growth of Counter-Reformation religious fervour. In his review of Federico Zeri's book, *Pittura e Controriforma*, a publication which discusses the increasing devotional character of sixteenth century art, Francis Haskell commented 'He (Zeri) shows most interestingly that classical humanist "Renaissance" art, ever since the earliest years of the sixteenth century, had been making way for a more devotional, pietistic sort of painting'. The representation of Christ, as presented in 'Ecce Homo' compositions belongs to this 'devotional, pietistic' tendency, furnishing an image devoid of distracting narrative detail, intended to arouse in the beholder a fervent, emotive and spiritual response.

Titian treated this subject on many occasions, the first extant version being the somewhat atypical, crowded, narrative essay, dated 1543, which is now in Vienna. The later, 'devotional', renditions of the theme, showing Christ alone or accompanied by just one or two of his tormentors, were among the most requested and frequently repeated images to issue from his studio during his later years.

Continued overleaf

Though the present picture bears a traditional attribution to Titian, its authorship has been questioned by some writers. Exhibited at Burlington House in 1883 as by Titian, the painting was published by Richter two years later (1885, p. 409) as the work of the great Venetian master. In the same year it entered the collection where it retained its status in all the published catalogues (1890, 1898, 1904) up to 1914. In the edition published that year, Walter Armstrong, the Director, changed the attribution to Matteo Cerezo, a seventeenth century Spanish artist and cited an iconographic source in Andrea Solario's painting of the same subject in the Poldi Pezzoli Museum. The Cerezo label was retained till 1955, when the then Director, Thomas McGreevy, on the suggestion of Bernard Berenson, sent the picture to be examined and cleaned in London. St John Gore, (1955, p. 218), having viewed the restored canvas, (which brought to light the *pentimento* of the reed's original position), and after consulting with Professor Wilde and others, reattributed the picture to Titian and proposed a dating of c.1560, just prior to the commissioning of the Ancona altarpiece, a composition with which it shares evident stylistic traits. In August of the same year it was exhibited as the work of Titian at the City Art Gallery, Birmingham. In 1956 McGreevy (p. 70), corrected the error of his illustrious predecessor and reaffirmed the traditional attribution to Titian, citing Berenson, Wilde and Lionello Venturi as his authorities. Berenson, (1957, p. 185), included the composition as a late work in his list of the artist's works. Teodoro Jonescu, (1960, p. 41), remarked on the stylistic similarities between the Dublin *Ecce Homo* and the version by Titian in the Brukenthal Museum at Sibiu. In their catalogues of Titian's *oeuvre*, Pallucchini (1969, no. 422), Valcanover (1969, no. 413) and Wethey (1969, no. 34) all maintained Titian's authorship of the painting and agreed with Gore's dating of c.1558-60. Federico Zeri (1974, p. 100) in his survey of Italian pictures in the collection referred to this image as the master's finest rendition of this pathetic subject.

A number of authors, Rearick (1977, p. 373), Heinemann (1977, p. 440, and Rinaldi (1984, p. 145, no. 560) have noted the influence of this design on the work of the young Palma Giovane, M. R. Fisher (1977, p. 88) going so far as to suggest that the canvas could be the work of Titian's former student.

The composition was engraved by Lucas Vorsterman and this has led to the theory that the present picture may be that listed among Van Dyck's possessions in an inventory of his effects drawn up in 1644, (J. Müller-Rostock 1922, p. 22, no. 17). It is known that Van Dyck made numerous drawings of the *Ecce Homo* motif, many of them certainly based on compositions by Titian, (Martin/Feigenbaum 1979, no. 33).

Most probably the present picture was originally accompanied by a pendant representing the *Mater Dolorosa*.

RK

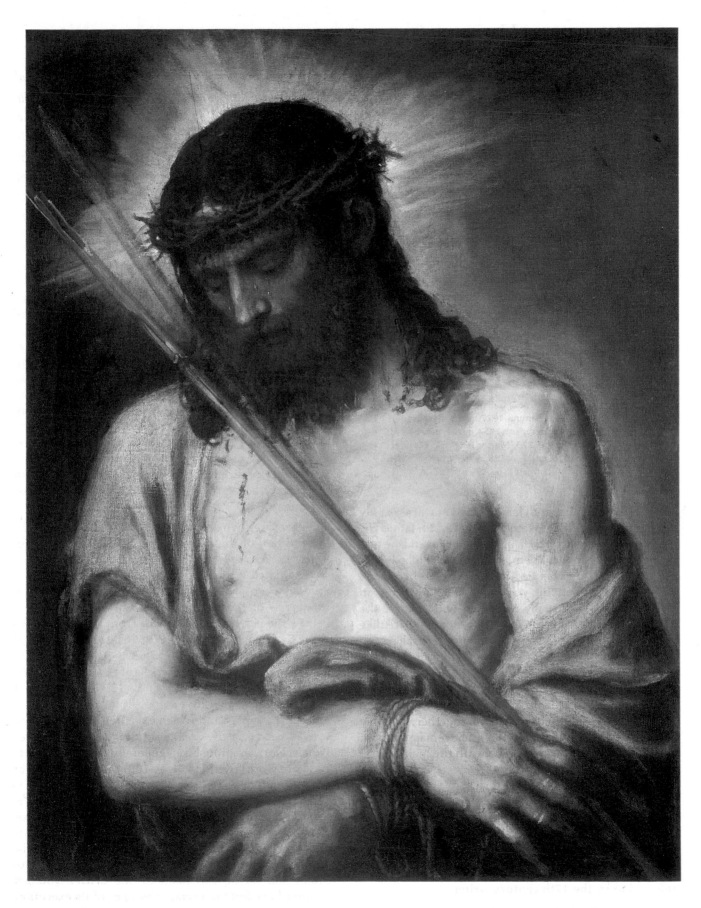

Ecce Homo by Titian (Cat. no. 2)

Paolo Caliari, called Veronese (Verona 1528–1588 Venice)

In many ways the most attractive of the great Venetian painters of the sixteenth century, Veronese received his initial training in his native Verona in the studio of Antonio Badile. His subsequent development shows that he also studied the works of Titian, Giulio Romano and Parmigianino. Veronese settled in Venice in 1555 where his burgeoning talents as a dazzling colourist and capable and inventive decorator won him a steady flow of contracts for official, religious and private commissions. He is best known for his magnificent Feast *or* Supper *compositions, the most notable of which is the spectacular* Wedding Feast at Cana *ordered in 1562 for San Giorgio Maggiore. The irreverent aspect of the* Feast *painted for SS. Giovanni e Paolo caused him to be called before the Inquisition in 1573. This inconvenient incident had no serious effect on his subsequent career and indeed the last decade of his life was probably the busiest for his well staffed studio.*

3 SS. Philip and James the Less

Oil on canvas: 208.8 × 159 cm. (82 × 63 ins.). (This canvas was cut down on three sides at some date in its history, possibly to accommodate placing it in a smaller frame. It has since been extended again to something approaching what must have been its original dimension, to fit its present frame).

PROVENANCE: Duke of Buckingham, 1653 (?), (Davies 1906-07, p. 380); Thomas Kibble sale, Christie's, London, 5 June 1886, lot 120; sale, Christie's, London, 29 June, 1889, lot 108, listed as 'Property of a Gentleman', where purchased by the National Gallery of Ireland. Cat. no. 115.

LITERATURE: Davies 1906-07, p. 380; Caliari 1909, pp. 162-63, 359, n. 4; Ridolfi 1914/24, p. 331; Osmond 1927, p. 83; Berenson 1932, p. 421; McGreevy 1956, p. 76; Berenson 1957, p. 131; Berenson 1958, p. 135; Crosato Larcher 1968, p. 223; Marini 1968, no. 126; Zeri 1974, pp. 100-101; Pignatti 1976, vol. 1, p. 180, no. A76; von Hadeln 1978, p. 130, no. 80; Piovene/Marini 1981, p. 109, no. 126.

The apostles Philip and James the Less are readily identifiable by their respective attributes, St. James the Less by the club with which, according to legend, he was beaten to death in Jerusalem in 62 A.D.; St. Philip by the cross to which he was tied with a rope and crucified upside down when he was martyred, reputedly in Phrygia. James is usually identified with 'James, the Lord's brother' (Gal., ch. 1, vs.19), hence his Christlike appearance. He was the first bishop of Jerusalem and accepted by most authorities as the author of the *Epistle of St. James,* which explains why he holds a book. The book placed at the feet of St. Philip most probably refers to that apostle's zeal in preaching the gospels. The two saints are frequently represented together, as they share the same feast day (1st May). The remains of both apostles are presumed to rest beneath the high altar of Santi Apostoli in Rome.

Ridolfi (1648, p. 331) recorded that the town of Lecce in Apulia, which had a small Venetian colony, preserved a painting of the Apostles SS. Philip and James the Less by Veronese. No other known picture by the great Venetian master depicts these two saints and it is reasonable to assume that the present picture is the one referred to by the 17th century writer.

According to Paolo Caliari (1909, p. 359) the painting was in the church of San Pasquale. Von Hadeln, (1914-24, I, p. 331), in his annotated edition of Ridolfi's survey, remarked that he could find no trace of any work by Veronese either in San Pasquale or in any other church in Lecce. This is not surprising, as the picture is recorded on the English market in 1886, (Kibble sale, Christie's, 5 June). Indeed, the canvas may have been in England as early as 1635, when a picture of 'two other evangelists' by Veronese was recorded in the collection of the Duke of Buckingham (Davies 1906-07, p. 380), though Ridolfi's remarks of 1648 would seem to preclude this. Caliari (1909, p. 359), when referring to the painting's location in S. Pasquale, quoted a Professor Antonio Fiorentino as his source. We do not know whether Professor Fiorentino actually saw the picture there, or perhaps had access to an old guidebook or some archival document.

This picture, which in some respects echoes the composition of the artist's *Apparition of the Virgin to SS. Anthony, Abbot and Paul* (Norfolk, Virginia; Pignatti 1976, no. 124, dated. c.1561/62), entered the collection in 1889 and has been given to Veronese in all the published catalogues of the collection. Not all critics, however, believe the picture to be entirely from the artist's own hand. Berenson (1932, p. 421; 1957, p. 135) accepted it as autograph. Crosato Larcher (1968, p. 223) referred to it as among the most spiritual works of the master. Marini (1968, no. 126 and 1981, no. 126) saw it as a substantially collaborative composition, with the assistance of the same hand which executed portions of the canvas depicting *SS. James and Augustine* at Burghley House, Northamptonshire, (generally acknowledged to be a late work). Zeri (1974, p. 100) considered it to be from the master's finest period and dated the work to the 1560's. Fritz Heinemann, in a letter (August, 1975) referred to the canvas as a late work by Veronese. Pignatti, (1976, no. A76) in his monograph on the life and work of Paolo, listed the picture among the attributed works, acknowledging the design as autograph and seeing the hand of the artist's younger brother Benedetto in certain passages of its execution.

RK

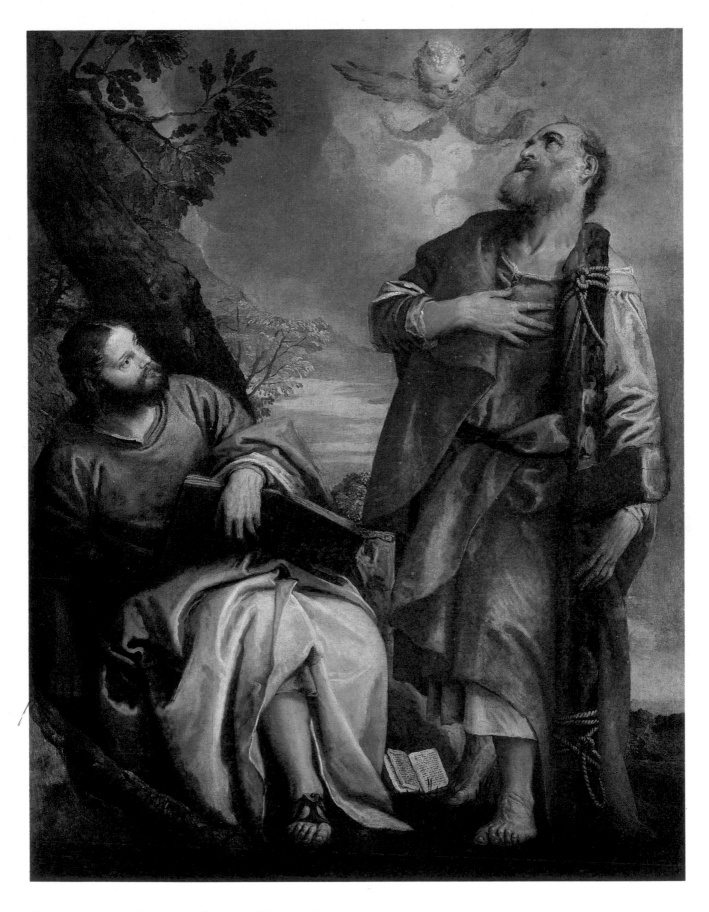

SS. Philip and James the Less by Veronese (Cat. no. 3)

Orazio Gentileschi (Pisa 1562–1647 London)

Having studied in Pisa with his half-brother Aurelio Lomi and his uncle Bacci Lomi, Gentileschi went down to Rome. There he studied further under Agostino Tassi, with whom he began to collaborate a little later. Gentileschi's role was to put the figures into Tassi's landscapes, sometimes in major commissions such as those for the papal Quirinal Palace and the Palazzo Rospigliosi. Gentileschi also did many altarpieces for Roman churches. He went to France for a short while, and then to England on foot of an introduction to King Charles I made by Van Dyck. Several of his works are in the Royal Collections still. Gentileschi died in London.

4 David and Goliath

Oil on canvas, 186 × 136 cm. (73¼ × 53½ ins.)
EXHIBITED: 1951 Palazzo Reale, Milan, *Mostra del Caravaggio e dei Caravaggeschi*, no. 108.
PROVENANCE: A small sweet shop in Limehouse, London, whence acquired by Tomás Harris, London, from whom purchased by the National Gallery of Ireland, 1936. Cat. no. 980.
LITERATURE: Longhi 1943, p. 22; Emiliani 1958, p. 43; Wittkower 1973, p. 43; Marini 1974, pp. 232, 282; Moir 1976, nos. 47, 47a, 47b, 47c, 54a, 54b, 54c, p. 134, n. 225, p. 138, n. 235.

The story of David and Goliath is told in Chapter 17 of the *First Book of Samuel*. Goliath was one of the great warriors of the Philistines. He challenged to fight any man from the troops of the Israelites. King Saul and his senior advisers were terrified. David came forward, and went out to meet Goliath, armed with his sling and five stones. With the first stone he knocked Goliath to the ground, having hit him in the middle of the forehead. David ran forward, took Goliath's sword, and then cut off Goliath's head. The Philistines, dismayed, fled.

The attribution to Gentileschi is unequivocal. Longhi suggests a date at the beginning of the second decade of the 17th century, (Longhi 1943, p. 22), which seems eminently reasonable given the striking Caravaggesque qualities of the painting. Could one even suggest a slightly earlier date, as Wittkower writes that it 'must have been created in Rome at an early period of his career' (Wittkower 1973, p. 43). Both of these would agree with Emiliani's date of c.1610 (Emiliani 1958, p. 43).

No. 4 has no direct prototype in the known works of Caravaggio. In the Prado there is a painting of David and Goliath at a point in the story where Goliath's head has been quite definitely severed. Moir convincingly argues that the latter is an early copy of a missing Caravaggio (Moir 1976, p. 107, no. 54a; p. 138, n. 235; ill. no. 37). No. 4 is quite in sympathy with the Caravaggesque spirit. The story of David and Goliath was one which was used frequently by the Caravaggesque painters (Moir 1976, p. 107, nos. 54b and 54c; p. 103, nos. 47, 47a, 47b, 47c; p. 134, n. 225). Compositionally, the Caravaggio composition referred to above is that which is closest to the structure of no. 4. Caravaggio treated the theme of David and Goliath in at least two other compositions, namely that in Galleria Borghese, Rome (Marini 1974, p. 282), and that in the Kunsthistorishes Museum, Vienna (Marini 1974, p. 232).

MW

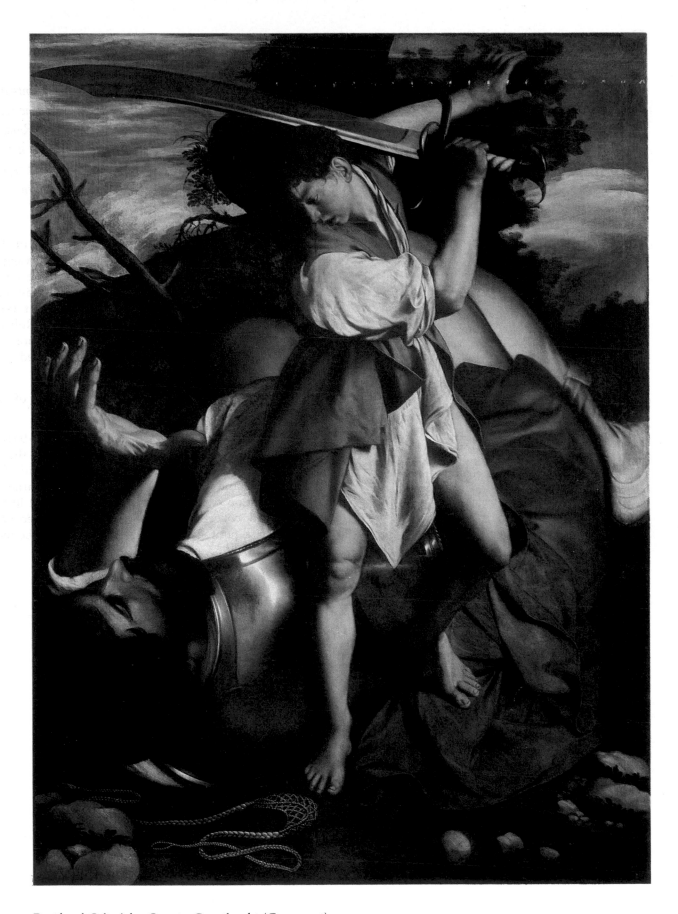

David and Goliath by Orazio Gentileschi (Cat. no. 4)

Pensionante del Saraceni (active in Rome 1610–1620)

'The designation invented for this unknown painter, whose oeuvre is reasonably consistent, has misled students into searching among Saraceni's followers for his name, and even LeClerc, with whom he has nothing specific in common. . . . In fact there is hardly a suggestion of Saraceni in his style. He is a close follower of Caravaggio, probably active in Rome in the second and third decades [of the seventeenth century], and possibly French since his artistic personality is not far removed from La Tour's. . . .' (Nicolson/Wright, 1974, p. 33). There are many variations of emphasis on different aspects of this artist's style and origin, but the quotation given above places him in context as far as is possible at present.

5 St. Peter denying Christ

Oil on canvas, 104.4 × 133 cm. (41 × 52¼ ins.)
PROVENANCE: The Marquess of Sligo, Westport House, County Mayo; Lord Terence Morris Browne, Westport House, County Mayo; Lady Isabel Mary Peyronnet Browne, Mount Browne, Guildford, Surrey; F. A. Drey, London, from whom purchased by the National Gallery of Ireland, 1948. Cat. no. 1178.
LITERATURE: Nicolson/Wright 1974, p. 33; Rosenberg 1983, p. 355.
VERSIONS: Pinacoteca Vaticana, Vatican City; Musée de la Chartreuse, Douai; unlocated collection of Rivera Schreiber (photograph in the Witt Library, Courtauld Institute of Art, London).

After the arrest of Christ, while he was being questioned in the guardroom, St. Peter and some of the apostles stood outside. A maid recognised St. Peter and went over to him. She challenged him as being one of Christ's followers. St. Peter denied this. (Luke, ch. 22, vs. 54 ff.).

There are some people (in the minority) who see in this picture, and in the other versions, the subject 'Job mocked by his wife' (Nicolson/Wright 1974, p. 33).

First entered in the manuscript catalogue of the National Gallery of Ireland as 'attributed to Caravaggio', it remained so described until the 1971 catalogue. It was Benedict Nicolson who first suggested 'Pensionante del Saraceni' during a visit to Dublin in September 1968. 'Pensionante del Saraceni' is the creation of Roberto Longhi, a name to indicate the unknown author of a number of works stylistically very closely related.

For this work a date in the second decade of the seventeenth century is proposed.

The prime version of this picture is considered to be that in the Pinacoteca Vaticana. Other versions are that in the Musée de la Chartreuse, Douai (formerly with Paul Rosenberg and Co., New York, in 1981, and earlier in the collection of Count Terzi, Rome) and that in the unlocated collection of Rivera Schreiber, recorded through a photograph in the Witt Library, London (Rosenberg 1983, p. 355).

MW

St. Peter denying Christ by Pensionante del Saraceni (Cat. no. 5)

Giovanni Benedetto Castiglione (Genoa 1616–1670 Mantua)

A native of Genoa, Castiglione studied there under Giovanni Battista Poggi and Giovanni Andrea de' Ferrari. Not being satisfied with his success in his native city, Castiglione went to Rome where he worked for a picture dealer called Pellegrino Peri. Following an introduction to the Duke of Mantua, he was appointed a court painter and moved to Mantua in 1651 where he lived until his death. Apart from working for the Duke, he undertook commissions for other members of the Gonzaga family, and other patrons.

6 Shepherdess finding the infant Cyrus

Oil on canvas, 234 × 226.5 cm. (92 × 89¼ ins.)
EXHIBITED: 1857 Manchester, *Art Treasures Exhibition*, no. 834.
PROVENANCE: Dukes of Mantua (*Fonti* 1971, p. 108, no. 1); the 9th Earl of Lincoln (subsequently the 2nd Duke of Newcastle), by 1765; thence by family descent to the Earl of Lincoln (heir to the 8th Duke of Newcastle) at whose sale Christie's, London, 4 June, 1937, lot 19 purchased by the National Gallery of Ireland. Cat. no. 994.
LITERATURE: Delogu 1928, pl. 35; Blunt 1954, p. 33, fig. 15, p. 40, no. 183; Jullian 1956, pp. 25-38; Torriti 1967, p. 28, fig. 20, p. 30, fig. 21, p. 300, n. 12; *Fonti* 1971, p. 108, no. 1; Percy 1971, p. 43, fig. 36, p. 126, p. 129, no. 118; Meroni 1978, p. 34.
ENGRAVED: by John Boydell on the basis of a drawing by Richard Earlom. Published by Boydell, 1 May 1765. The National Gallery of Ireland has an impression of this print (Dublin 1985, cat. no. 11,943).

DRAWINGS: Royal Library, Windsor Castle (Blunt 1954, p. 40, no. 183); Accademia, Venice (Delogu 1928, pl. 35); Musée de Dijon, Dijon (Inv. T. 120A).

Cyrus was the grandson of Astyages, King of Media, who, having dreamt that Cyrus would grow up to overthrow him, had the child given to a shepherd to be abandoned on a mountainside. The shepherd and his wife, whose own son had just died, reared Cyrus, leaving their own dead son in his place. In Median the wife's name meant 'bitch', which gave rise to the

Continued overleaf

Fig. A *Shepherdess finding the infant Cyrus* by G. B. Castiglione. Drawing in brown ink, 19.3 × 26.9 cm. Musée de Dijon.

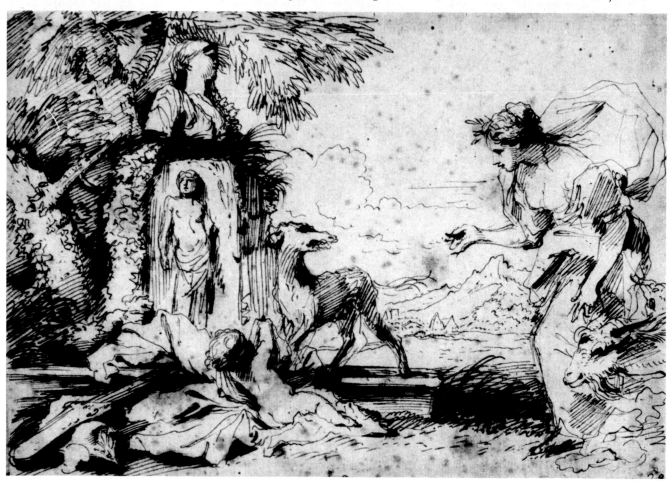

16

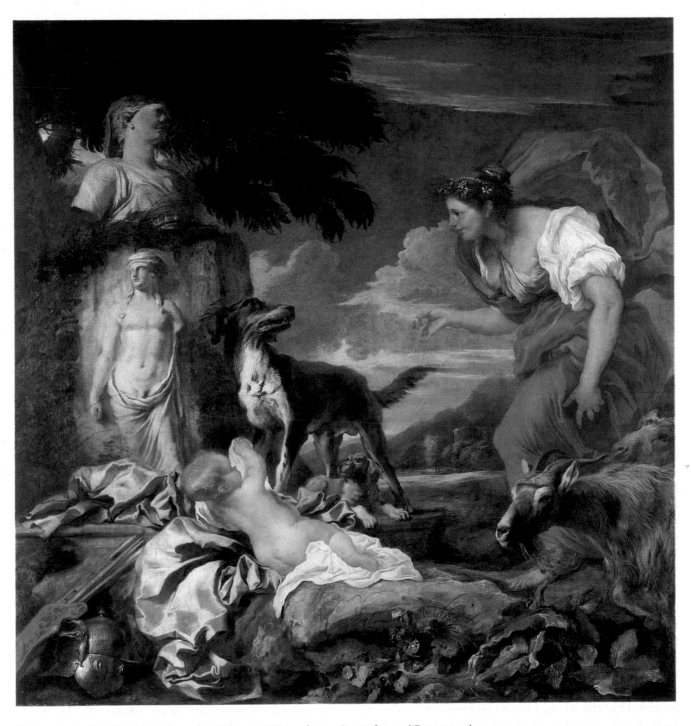

Shepherdess finding the infant Cyrus by Giovanni Benedetto Castiglione (Cat. no. 6)

tradition that Cyrus was abandoned, suckled by a bitch and there discovered by the shepherd's wife (Herodotus I: 101-129). The crown beside the bust, the quiver of arrows and helmet (bottom left) are possibly intended as symbols appropriate to Cyrus who was to become a great warrior and founder of the Persian Empire.

The theme, like *The Finding of Romulus and Remus*, has a biblical parallel in *The Finding of Moses;* in all three great future leaders have been cast out and abandoned as infants and subsequently recovered. Castiglione's literary contemporaries certainly sought out such parallels between pagan and biblical literature, and Ann Percy has pointed out in the case of another subject that Castiglione may well have 'consciously pursued this type of intellectualising syncretism' (Percy 1971, p. 126).

The Dublin painting is regarded as one of the finest and most beautiful works by Castiglione. As it was in Mantua by 1705 and relates to the *Deucalion and Pyrrha,* dated 1655, now in Berlin, it seems very likely that it was painted during Castiglione's Mantua years, 1651-59. The statue of a man in relief is almost identical to that in the *Deucalion and Pyrrha* at the Bodemuseum, Berlin.

G. B. Castiglione painted the subject on at least one other occasion, the canvas now in the vestibule of the Palazzo Durazzo-Pallavacini, Genoa (Torriti 1967, p. 28, fig. 20, p. 30, fig. 21, p. 300, n. 12). A copy of this painting was at Christie's sale on 27 June 1969, lot 38 (97 × 132 cm.). Giovanni Benedetto's son, Francesco also executed the same theme (Percy 1971, p. 43, fig. 36), in a painting whose present whereabouts are unknown, and two drawings for it (Percy 1971, p. 129, no. 118).

Another Cyrus painting is that which was at Houghton Hall, Norfolk, in the eighteenth century and given to G. B. Castiglione. U. Meroni suggested that this painting might now be Dublin's. Clearly that is not possible because the measurements given in his source as '2 feet 4 inches ½ high, by 3 feet 6 inches ¼ wide' are not only incorrect but the wrong proportion for no. 994 (Meroni 1978, p. 54). The ex-Houghton Hall painting is now supposed to be the one in the Hermitage and attributed to Vasallo. A painting in the Musée des Beaux-Arts at Lyons is a more expansive composition though smaller

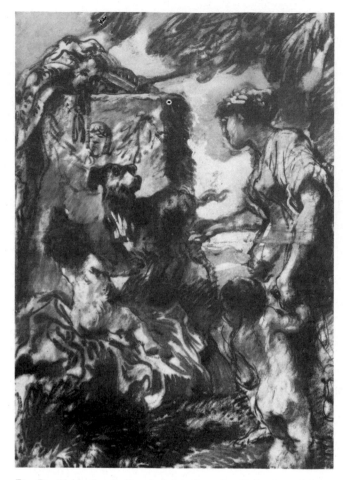

Fig. B *Shepherdess finding the infant Cyrus* by G. B. Castiglione. Drawing in brown and red oil paint, 34.5 × 24 cm.
(By gracious permission of Her Majesty Queen Elizabeth II)

than the Dublin canvas (Jullian 1956, pp. 25-38); and most historians regard it as having been painted after Castiglione's death.

A drawing in the Royal Library at Windsor (Fig. B) is probably a first idea for part of the Dublin painting (Blunt 1954, p. 40, no. 183). A drawing of a bust in the Accademia, Venice (Delogu 1928, pl. 35), is preparatory to Castiglione's etching of 1648 *The Genius of Castiglione* (Fig. C). This is similar to the bust on top of a grass-topped pedestal seen here (Blunt 1954, p. 33, fig. 15). A very important drawing including the complete composition (as a horizontal rather than a square format) is Inv. T.120A (19.3 × 26.9 cm.) in brown ink, belonging to the Musée de Dijon (Fig. A).

MW

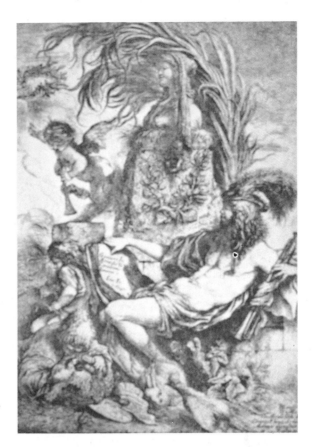

Fig. C *The Genius of Castiglione.*
Etching by G. B. Castiglione.
Dated 1648.

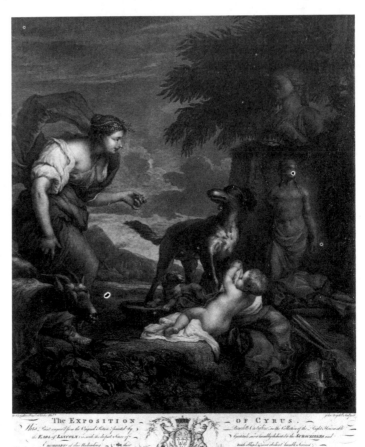

Fig. D *The Exposition of Cyrus.*
Engraving by John Boydell
after a drawing by Richard
Earlom from Castiglione's
original painting then in the
collection of the Earl of
Lincoln. Dated 1 May 1765.

Giovanni Battista Passeri (Rome c.1610–1679 Rome)

This artist is known to more people as the author of a work on the lives of seventeenth century artists in Rome than as a painter. A follower of Domenichino, and indeed his successor as President of the Academy of St. Luke, Passeri painted portraits, still-life and religious paintings, as well as historical ones. Late in life he took holy orders, and was attached to the church of S. Maria in Via Lata (at the top of the Via del Corso), Rome.

7 Party feasting in a Garden

Oil on canvas, 76 × 61.5 cm. (30 × 24¼ ins.)
Signed, on left hand side, almost centrally, on sarcophagus: *Io: Baptista Passarus Rom Facie.a.*
Inscribed, on same sarcophagus, before the signature: *DMS*
Inscribed, on shield, on carved support of table facing the viewer: *cadun./etremanent.*
EXHIBITED: 1958 Belfast Museum and Art Gallery, Belfast, *Loan Collection from the National Gallery of Ireland.*
PROVENANCE: Messrs Sabin, London; Messrs P. & D. Colnaghi, London, from whom purchased by the National Gallery of Ireland, 1937. Cat. no. 993.
LITERATURE: Crookshank 1964, pp. 179-180; Spike 1980, no. 31.

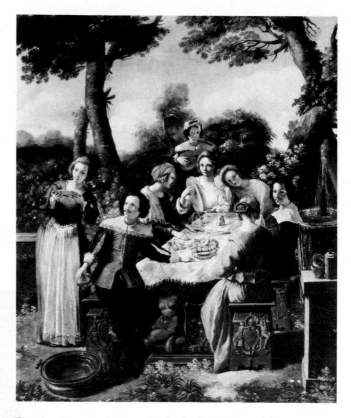

Fig. A *Party feasting in a Garden* by G. B. Passeri (Cat. no. 7) photographed before cleaning, 1984. The statues on the extreme right and left of the painting, and the urn in the centre had been overpainted.

Inscribed on the sarcophagus: *DMS* which stand for *Dis Manibus Sacrum* (sacred to the gods of the underworld). The end of the table faces the viewer and on its carved support is a shield decorated with flowers and bearing the motto *cadun./etremanent* (they fall and yet remain). When writing about the painting Anne Crookshank suggested that this inscription might refer to the flowers, but on balance felt that, despite its rather insigificant position, it should be related to the *DMS* before Passeri's signature (Crookshank 1964, pp. 179-180). The serious expression of those feasting has been noted by Crookshank, which would seem to be at odds with the concept of a meal out of doors, and the use of musical instruments. The full meaning of the subject remains elusive. It may lie somewhere along the lines of a family ceremonial banquet in memory of a deceased relative. Sergio Benedetti has made an interesting suggestion that some of the words which Passeri used in his life of Pietro Testa might well be applicable to the Dublin painting: 'My opinion would be that in the depiction of stories or narratives, either religious or non-religious, one should never introduce personal poetical concepts, in order to avoid confusing the general public; such additions might be permitted, however, in the treatment of fables or idealizations.' (a free translation from Passeri 1772, p. 184). The picture exhibited here may fall into the latter category.

Purchased as an Italian seventeenth century painting, no firm attribution was proposed until Anne Crookshank read the inscription style signature correctly when the picture was on loan to the Belfast Museum and Art Gallery (now the Ulster Museum) in 1958. Her reading was confirmed by infra-red photography. During the cleaning and restoration of the painting, in 1983, the bacchic fountain figure on the right hand side, the urn looming up in the background, to the right of centre, and the statue of a man at the left hand side were all revealed; they had been covered by overpainting.

The Dublin Passeri remains at present his only known signed work in oils. It served as the basis for the firm attribution to him of a somewhat larger painting, *Musical Party in a Garden* (oil on canvas, 0.736 × 0.990), in the Robert and Bertina Suida Manning Collection, New York (Spike 1980, no. 31).

MW

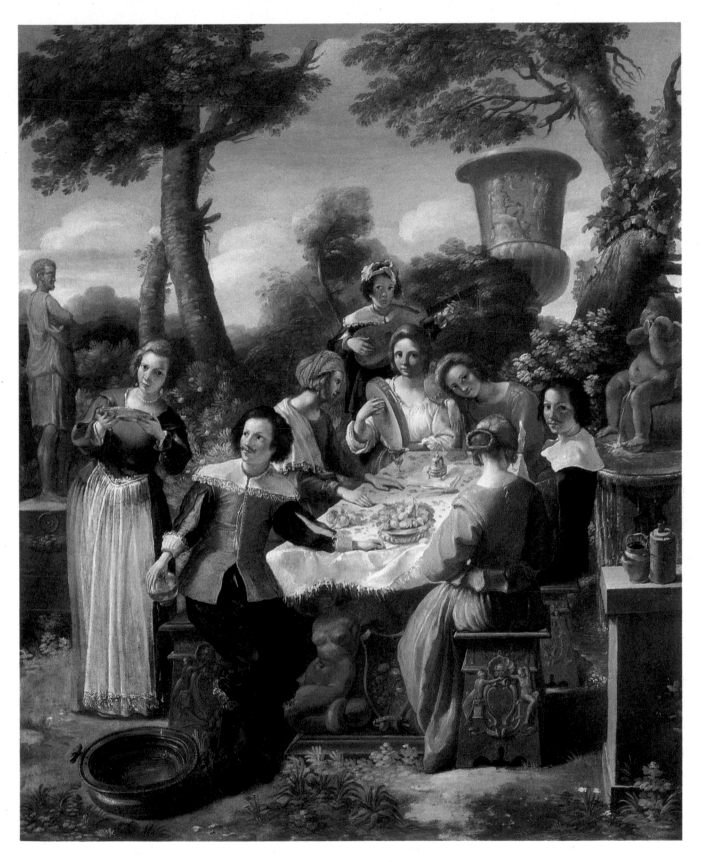

Party feasting in a Garden by Giovanni Battista Passeri (Cat. no. 7)

Bernardo Bellotto (Venice 1720–1780 Warsaw)

Bellotto trained under his uncle, Canaletto. Like his uncle he became known as a view painter. Having visited and painted in several Italian cities, he emigrated, and is definitely recorded as being in Dresden in 1748, where he became a court painter to the Elector of Saxony. He made short visits to Vienna and Munich, and finally left Dresden for Warsaw in 1767. The King of Poland, Stanislaus Poniatowski, gave him many commissions. Outside of Italy, but particularly in Poland, Bellotto was also known as Canaletto, which has frequently given rise to confusion between the work of uncle and nephew, although their styles are quite distinctive.

8 Dresden from the right bank of the Elbe above the Augustus bridge

Oil on canvas, 51.5 × 84 cm. (20¼ × 33 ins.)
EXHIBITED: 1911 Burlington Fine Arts Club, London, *Venetian Painting of the Eighteenth Century*, no. 21; 1954-55 Royal Academy, London, *European Masters of the Eighteenth Century*, no. 302.
PROVENANCE: M. B. Naryschkin sale, Paris 5 April 1883 lot 2 where purchased by the National Gallery of Ireland. Cat. no. 181.
LITERATURE: Hempel 1965, pp. 196-199; Kozakiewicz 1972, nos. 142, 144; Dresden 1979, no. 606.
VERSIONS: State Art Collections, Gallery of Old Master Paintings, Dresden (Kozakiewicz 1972, p. 107, no. 140); North Carolina Museum of Art, Raleigh, North Carolina (Kozakiewicz 1972, p. 107, no. 141); Private collection, Atherton, California (Kozakiewicz 1972, pp. 108 and 115, no. 143).

The differences between the various versions of this view are very slight. The artist engraved the view and the Dublin version shows more of the view than the others; it is therefore closer to the engraving, which is Bellotto's own work (Kozakiewicz 1972, p. 115, no. 144). The principal buildings are that of the Protestant church of the Virgin, with its dome completed to the designs of George Bähr (1726-43) (Hempel 1965, pp. 196-198). In front of it are the gallery and terrace of the most influential Count Brühl. The Augustus bridge was constructed to the designs of Daniel Pöppelmann (1727-1731) (Dresden 1979, p. 103, no. 606). The church with the tower and spire is the Catholic Court Church, designed by the Roman architect, Gaetano Chiaveri (1689-1770), who had already worked at St. Petersbourg and Warsaw. The building of the church commenced in 1738 and was completed just before this painting was executed (Hempel 1965, pp. 198-199). Earlier versions show scaffolding on the tower, for example that in Dresden dated 1748 (Dresden 1979, p. 103, no. 606).

Kozakiewicz dates this painting to about 1750 (Kozakiewicz 1972, p. 108, no. 142). Bellotto had arrived in Dresden in 1747.

MW

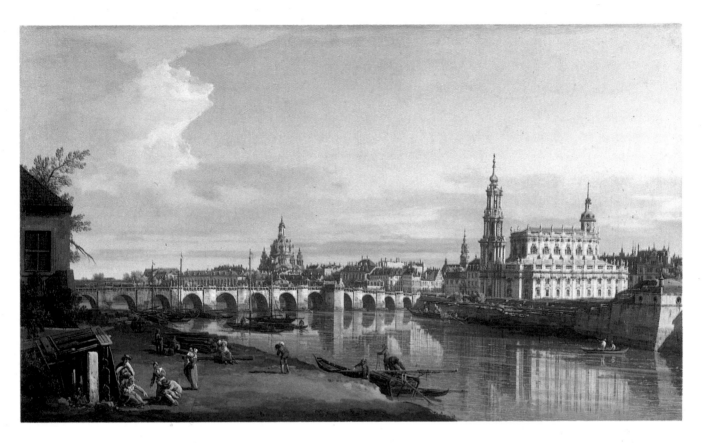

Dresden from the right bank of the Elbe above the Augustus bridge by Bernardo Bellotto (Cat. no. 8)

Bernardo Bellotto (Venice 1720–1780 Warsaw)

(For biography see preceeding catalogue entry).

9 Dresden from the right bank of the Elbe below the Augustus bridge

Oil on canvas, 51.5 × 84 cm. (20¼ × 33 ins.)
Signed, bottom edge, centrally: *Bernard Bellotto dit Canaletto Peintre du Roi*
EXHIBITED: 1911 Burlington Fine Arts Club, London, *Venetian Painting of the Eighteenth Century,* no. 17.
PROVENANCE: M. B. Naryschkin sale, Paris 5 April 1883, lot 3 where purchased by the National Gallery of Ireland. Cat. no. 182.
LITERATURE: Hempel 1965, pp. 196-199; Kozakiewicz 1972, nos. 148, 150; Dresden 1979, no. 606.
VERSIONS: State Art Collections, Gallery of Old Master Paintings, Dresden (Kozakiewicz 1972, pp. 115-116, no. 146); Collection Marques de Deleitosa, Madrid (Kozakiewicz 1972, p. 116, no. 147); State Art Collections, Gallery of Old Master Paintings, Dresden (Kozakiewicz 1972, pp. 116-121, no. 149).

The differences between the versions of this view as listed are very slight. The artist engraved the view, and no. 182 shows more of the view than the others; it is therefore closer to the engraving, which is Bellotto's own work (Kozakiewicz 1972, p. 121, no. 150). The tower of the Catholic Court Church, on the right in this view, was just completed before this painting was executed. The architect of the church was the Italian, Gaetano Chiaveri, (1689-1770). Construction commenced in 1738 (Hempel 1965, pp. 198-199). The impressive bridge, the Augustus Bridge, was designed by Daniel Pöppelmann and built 1727-1731 (Dresden 1979, p. 103, no. 606). Beyond the bridge, one can clearly see the Protestant Church of the Virgin, whose dome was constructed 1726-43 to the designs of George Bähr (Hempel 1965, pp. 196-198). Kozakiewicz dates this painting to about 1750 (Kozakiewicz 1972, p. 116, no. 148).

MW

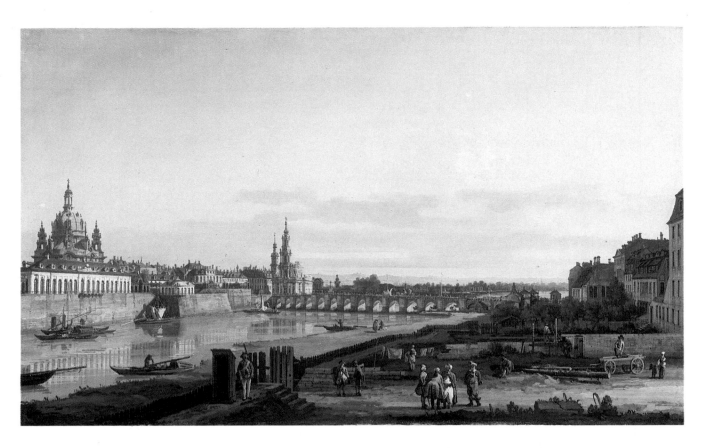

Dresden from the right bank of the Elbe below the Augustus bridge by Bernardo Bellotto (Cat. no. 9)

Giovanni Battista Tiepolo (Venice 1696–1770 Madrid)

Tiepolo's early life as a painter in Venice was greatly influenced by the work of both Sebastiano Ricci and Giovanni Battista Piazzetta. He became arguably the greatest exponent of the Rococo style in Italy, particularly in fresco. His work is to be found throughout the Veneto. Called abroad, some of his finest achievements are in the Residenz at Würzburg; in 1762 he went to Spain to work for the court, endowing it with an impressive heritage before his death in Madrid.

10 Allegory of the Immaculate Conception and of Redemption

Oil on paper, laid on canvas, 58.7 × 45 cm. (23 × 17¾ ins.)
EXHIBITED: 1960 Herbert Art Gallery and Museum, Coventry, *Loan Exhibition*, no. 43.
PROVENANCE: Collection G.A. F. Cavendish Bentick, at whose sale Christie's, London, 13 July 1891 and following days lot 771 purchased by the National Gallery of Ireland. Cat. no. 353.
LITERATURE: *Litaniae* 1576, p. 103, *ad versum*; Ripa 1611, p. 204; *Missale* 1951, p. 510; Morassi 1962, p. 11; Prado 1963, p. 675; Pallucchini 1968, no. 287; Rizzi 1971, no. 98; Wynne 1980, pp. 382-384; Jones 1981, p. 223, p. 224, fig. 6, p. 225, fig. 10; Whistler 1985, pp. 172-173.

God the Father appears amid the clouds, surrounded by angels. To the top left is the dove representing the Holy Spirit. Almost centrally is the Virgin, kneeling, with stars forming a halo and the moon below her feet (*The Apocalypse*, 12, 1). Also below her is a terrestrial globe on which crawls a serpent with an apple in its mouth. Iconographically this may be considered an Allegory of the Immaculate Conception and an Allegory of Redemption.

Iconographically the woman of the Apocalypse has a long tradition as the image of the Virgin signifying the Immaculate Conception.

The allegory of Redemption is quite clear. Following the sin of Adam, the Lord said to the serpent: 'I will put emnity between you and the woman, and between your seed and her seed; ...' (Genesis, ch. 3, v. 15). The serpent holds in his mouth an apple, the traditional image of the fruit of the tree which Adam had been forbidden to touch or eat (Genesis, ch. 2, vs. 15-17). The mirror held by a cherub just above the serpent's head, may well be a reference to one of the medieval descriptions of the Virgin: *Speculum sine macula* (the mirror without blemish). The palm stricken down is a symbol of fallen mankind. A palm tree is used in such imagery because 'The righteous flourish like the palm tree, ...' Psalm 92, vs. 12-15). The pillar on the left hand side is most probably a reference to another title for the Virgin found in medieval hymnology: *turris Davidica* (the tower of David) (*Litaniae* 1576, p. 103, *ad versum*). Normally the tower is like the tower of an ancient castle, with windows looking out on all sides, and less like the obelisk shape which it has in this painting. One cannot rule out the possibility of the structure being meant to depict the tower of Baris, mentioned in the sixth chapter of

Speculum Humanae Salvationis, where it symbolizes the unassailable purity of the Virgin.

Obelisks are found in many of Tiepolo's compositions, but it is useful to note two very prominent ones in late works. One is to be found in his fresco of 1762-64 for the Throne Room of the Royal Palace, Madrid, *Glory of the Spanish monarchy*. In this the obelisk stands for princely glory (Jones 1981, p. 223; p. 224, fig. 6; p. 225, fig. 10). Another important work, a painting executed between 1762 and 1770, for the imperial court at St. Petersbourg, *Monument to the glory of heroes* is composed around an obelisk. The painting is missing but its composition is known through Lorenzo Tiepolo's engraving (Rizzi 1971, no. 98). The concept of glory or honour represented by an obelisk is found in Ripa's *Iconologia* ... (Ripa 1611, p. 204). In no. 353 the expression of honour or glory applied to the Virgin is very appropriate: *Tu gloria Hierusalem* (You are the glory of Jerusalem) (*Missale* 1951, p. 510). Consequently, one must allow for the possibility of this attribute in this painting, which, after all, is not far from the concept of 'The tower of David'.

The powerful dual allegory of the Immaculate Conception fused with that of Redemption is not unique in the work of Tiepolo. For example, it occurs with some minor changes in the altarpiece which Tiepolo painted for the church of the Franciscan Friary of St. Paschal Babylon at Aranjuez, a favourite summer retreat of the Spanish Royal Family in the eighteenth century (Wynne 1980, pp. 382-384). The altarpiece is now in the Prado (Prado 1963, p. 675).

There is no record known, at present, of a larger canvas, for which the Dublin painting might have been a preliminary sketch. Recently Catherine Whistler made an interesting hypothesis (Whistler 1985, pp. 172-3). Tiepolo was commissioned on 2 September 1769, to execute the frescos of the dome of the collegiate chapel of St. Ildefonso, at La Granja. By the time of Tiepolo's death the building was not ready for his frescos. Whistler's suggestion is that no. 10 might have been a sketch for one part of the frescos.

Morassi dates the painting *circa* 1760-70 (Morassi 1962, p. 11). Pallucchini proposes a date of 1766-70 (Pallucchini 1968, no. 287).

MW

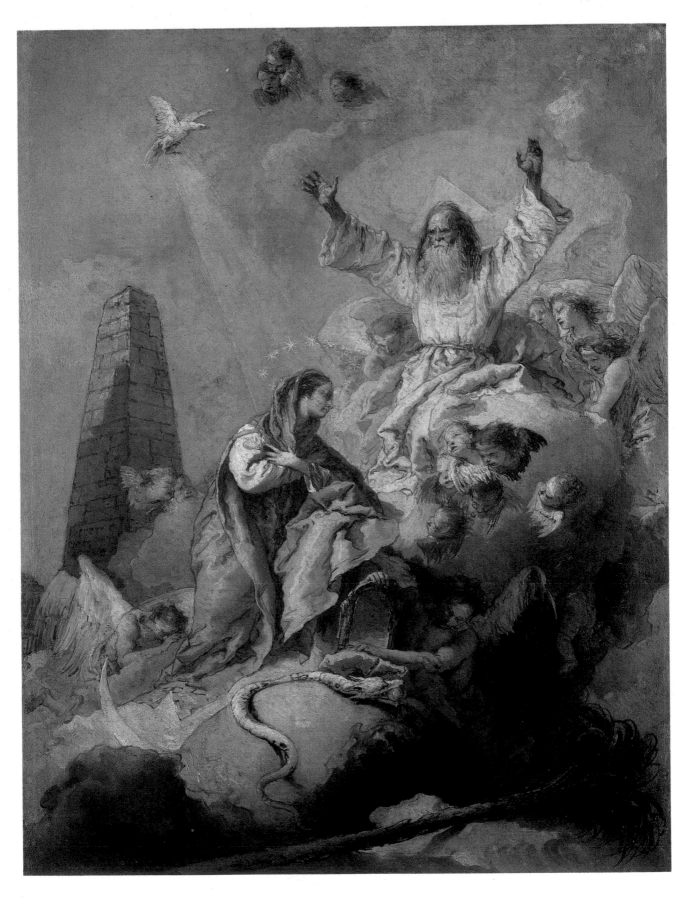

Allegory of the Immaculate Conception and of Redemption by Giovanni Battista Tiepolo (Cat. no. 10)

Domenikos Theotokopoulos, called El Greco (Crete 1541–1614 Toledo)

Born in Crete in 1541, El Greco practised art in the native Cretan post-Byzantine style until 1568 when he moved to Venice. There he eschewed the company of the Madonneri to learn the contemporary Italian idiom, possibly studying for a while in Titian's studio. Late in 1570 he moved to Rome where he was introduced to society by the celebrated miniature painter Giulio Clovio. His Christ Healing the Blind (N.Y. Metropolitan) demonstrates his accomplished though somewhat eclectic handling of the Roman maniera. In 1577 El Greco moved again, this time to Spain. A disagreement with the Canons of the Cathedral of Toledo concerning The Disrobing of Christ, delivered in 1579 and the refusal of the king, Philip II, to accept his Martyrdom of St. Maurice in 1584 ended his dreams of official patronage. Other sectors of Spanish society, however, approved of his highly individual and spiritually intense style of painting and were willing to offer him support and patronage.

11 St. Francis receiving the Stigmata

Oil on canvas: 114.8 × 106.3 cm. (45 × 41 ins.)

EXHIBITED: 1902, Museo Nacional de Pintura, Madrid, *Exposición de las obras del Greco*, no. 30; 1911, Galerie Heinemann, Munich, no. 29; 1913/4, Grafton Galleries, London, *Exhibition of Spanish Old Masters*, no. 130.

PROVENANCE: Ricardo Pascual de Quinto (1902); Durand-Ruel, Paris (?); Sir Hugh Lane, by whom presented to the National Gallery of Ireland, 1914. Cat. no. 658.

LITERATURE: Viniegra 1902, p. 25, no. 30, ills.; Cossío 1908, pp. 97, 376, no. 119, (no. 212, 1972 ed.); Lafond 1913, pp. 70, vii; Witt 1915, pp. 56, 57; Mayer 1916, p. 25, ills. p. 27; Mayer 1926, pp. 39-40; Rutter 1930, p. 103, no. 112; Legendre/Hartmann 1937, p. 420; Thieme-Becker, vol. 33; Camón Aznar 1950, vol. 1, p. 342, vol. 2, no. 552; Bodkin 1956, pp. 39-40, pl. ix; Gaya Nuño 1958, p. 194, no. 1280; Gudiol 1962, p. 197; Wethey 1962, vol. 2, pp. 219-220, no. X261; Manzini/Frati 1969, p. 101, no. 59E; Lady Gregory 1973, pp. 130, 149, 167, 193, 204, 260; White 1974, pp. 114-115, fig. 5; Mulcahy 1984, p. 31.

In 1224, on the feast of the Exaltation of the Cross (14th September), while on retreat on Mount Alverna, St. Francis (1181/2-1226) experienced a mystical vision. During the course of this supernatural apparition, witnessed by his disciple, Brother Leo, and recounted by his biographer Tommaso da Celano, Francis received the wounds of the crucified Christ on his body from a seraphic figure with six wings, its arms outstretched and feet together as on a cross. The open wounds remained on the body of the saint until his death two years later. According to commentators, most notably St. Bonaventure, who identified the seraphic vision as Christ Himself, this miraculous event was to be interpreted as a sign of divine recognition on the saintly life of the *Poverello*, who was canonized by Pope Gregory IX in 1228, just two years after his death.

According to Wethey (1962, II, p. 114) El Greco painted at least ten different versions of the Franciscan legend though Gudiol (1962, p. 196) put the number of versions at thirteen. Depending on how one interprets the various images, the master invented three to four basic models for representing the stigmatization of the saint, the Dublin picture being based on a prototype devised for a composition in the collection of the Marqués de Pidal in Madrid (Wethey 1962, fig. 253), though Gudiol (1962, p. 196) believes the version in the museum at Bilbao to be earlier. In replicas produced from this model (Wethey 1962, nos. X258-X279) the saint is shown alone, before an intense blue sky torn with clouds against which the seraphic vision is seen. A strong, formal discipline dominates the scene and the structures are geometrized, as the whole scene wavers between naturalism and abstraction.

Nothing is known of the history of the present painting till it appeared in the exhibition of the master's works in Madrid in 1902 (no. 30). Cossío, writing in 1908, (no. 119) dated the work to 1584-1594. R.C. Witt (1915, pp. 56-57) admired the composition and considered it the noblest and most spiritual of the artist's many representations of the saint, dating it to c.1590. Mayer (1926, no. 236, pp. 39-40) included it among the artist's *oeuvre* and dated it 1582-86. Camón Aznar (1950, no. 552, p. 342) dated it to 1590. Gaya Nuño (1958, p. 194, no. 1280) listed it as one of the master's works to be found in collections outside of Spain and dated it to 1590. Gudiol (1962, p. 197) considered it an excellent replica of the prototype in the Museum at Bilbao, in which the expressionism is accentuated by gesture and mental concentration. Wethey (1962 no. X261) saw the canvas as a much restored work and did not accept it as autograph, a judgement apparently accepted by Waterhouse (1964, p. 238). Frati, (Manzini/Frati 1969, no. 59E) included the composition in her survey of the artist's output and dated it to the period 1580-90. Rosemarie Mulcahy (1984, p. 31), having had the opportunity to examine the composition after its recent restoration, was enthusiastic about its newly revealed qualities which had for so long hidden beneath a coating of varnish and grime. This cleaning has established that damage to the canvas was not nearly as extensive as estimated by Wethey.

RK

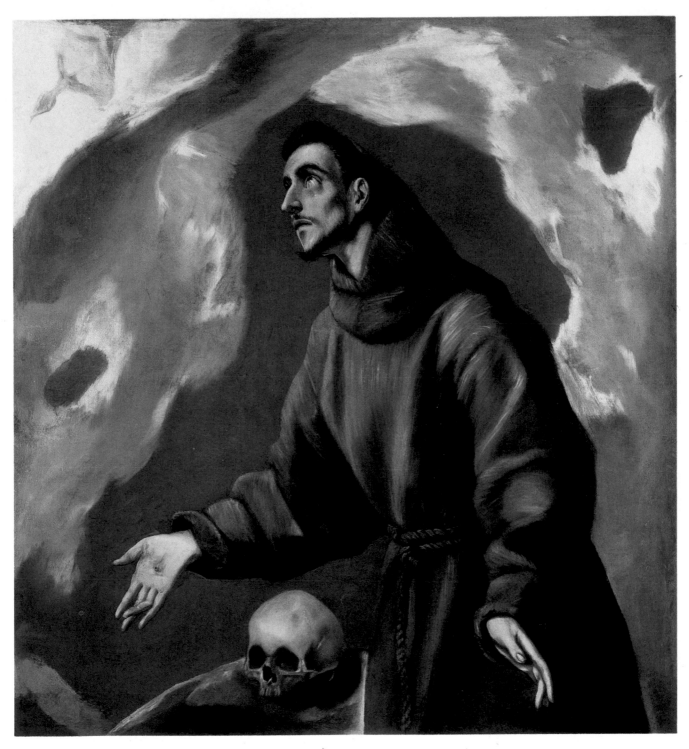

St. Francis receiving the Stigmata by El Greco (Cat. no. 11)

Yorick

Francisco de Goya (Fuendetodos 1746-1828 Bordeaux)

Brought up in Saragossa, Goya moved to Madrid in 1763. Failing to gain access to the Academy, he pursued his studies with Francesco Bayeau, whose daughter, Josefa, he later married. On Bayeau's advice he travelled to Rome and Parma in 1770-71. Late in 1774 he was called to court in Madrid to assist with the preparation of cartoons for the Royal Tapestry Factory. Establishing a reputation as a talented decorator and portraitist he was made a member of the Academy in 1780, appointed a Painter to the King in 1786 and was made a Court Painter in 1789. In 1792 Goya suffered a near fatal illness, the effects of which, coupled with his experiences during the traumatic reign of Charles IV, effected a profound change on his personality and art. Continuing to work as the most accomplished portraitist at court and among the nobility and bourgeoisie, Goya now began to produce, in his darker moments, Caprichos, *compositions which gave flesh to his private fears, fantasies and thoughts. His first set of 80 satirical prints based on such subject matter were published in 1799 (*Los Caprichos*). These were later followed by the* Disasters of War *(1808),* La Tauromaquia *(1816),* Los Disparates *(1824). The major decorative undertakings of the latter part of his career were the frescoes for San Antonio de la Florida (1798) and the bewildering and haunting* Black Paintings *for his own residence at Quinto del Sordo (1819). Goya remained in Spain during the period of French occupation (1808-1813). After the restoration of the Spanish monarchy, however, he felt his life was increasingly under threat and in 1824 he moved to France, to Bordeaux, where he died in 1828.*

12 'El Conde del Tajo'

Oil on canvas: 62.5 × 52.5 cm. (24½ × 20 ins.)

EXHIBITED: 1911, Grafton Galleries, London, *Exhibition of Old Masters*, no. 53; 1954-5, Royal Academy, London, *European Masters of the Eighteenth Century*, no. 359; 1963-4, Royal Academy, London, *Goya and his Times*, no. 75.

PROVENANCE: Marqués de la Vega Inclán, Madrid; Messrs Sulley and Co., London, from whom purchased by the National Gallery of Ireland, 1908. Cat. no. 600.

LITERATURE: Mayer 1925, p. 204, no. 429, fig. 176; Gaya Nuño 1958, p. 163, no. 935; Gudiol 1970, vol. 1, p. 119; p. 296, no. 454; vol. 3, fig. 727, p. 604; Gassier/Wilson 1971; De Angelis 1974, p. 139, no. 756; Aznar 1980, vol. 3, p. 31; Glendinning 1980, p. 357.

The identity of the sitter in the present portrait has not yet been satisfactorily determined. When purchased for the collection in 1908 it carried a label which referred to the subject as 'El Conde del Tajo'. We have no knowledge of what this man looked like and indeed we cannot be sure that he ever existed. A national census compiled in 1787 recorded that out of a total population of ten million or so inhabitants, about 500,000 were listed as members of the nobility, ranging in status from lowly *hidalgos*, who frequently owned little more than their title, to the great land rich grandees. There is no listing for the title *Conde del Tajo* in any of the standard directories of Spanish nobility and it is conceivable that the traditional identity tag is spurious. Nigel Glendinning (1980, p. 357) has suggested that the portrait may represent Antonio Raimundo Ibáñez (1747-1809), assassinated in 1809 on account of his friendship with Manuel de Godoy, who established the Royal Foundry and China Factory of Sargadelos in Galicia. There is a portrait of Ibáñez, (Gassier/Wilson 1971, no. 862), in the Baltimore

Museum of Art which dates to c.1805-08 in which the subject is shown half-length, turned to the right. The resemblance between the sitters in both pictures is not altogether convincing, though obviously the discrepancies could no doubt be influenced by the time lapse between the execution of the two canvases (as much as ten years) and the much restored condition of the Baltimore painting.

Critics are divided regarding the attribution of the present picture to Goya, some have accepted it as autograph, others have rejected it, while some have ignored it altogether. Mayer (1925, no. 429) included it among the master's works. Gaya Nuño (1958, no. 935), who tentatively dated the portrait to 1795, listed it among Goya's paintings to be found in collections outside Spain. Gudiol (1970, no. 454, p. 296), who dated it to c.1800, considered it a minor yet authentic portrait. Camón Aznar (1980, III, p. 31) saw it as a painting which conveyed the open, impulsive and sympathetic nature of the sitter and suggested a date of 1797-98 for its execution. De Angelis (1974, no. 756), who dated the canvas to 1800, was sceptical as to the picture's authenticity and listed it among the attributed works. Of the many critics who have written on Goya's art Gassier and Wilson (1971) are among the most notable authorities to have neglected referring to the portrait. Nigel Glendinning (1980, p. 357), reviewing the monograph on the artist by Xavier de Salas (1979) disagreed with that writer's reluctance to include the present painting among the master's *oeuvre* remarking, 'but I confess I still like the so-called *Conde del Tajo* in the National Gallery Dublin, although I believe it is more likely that the sitter is Raimundo Ibáñez . . .'.

RK

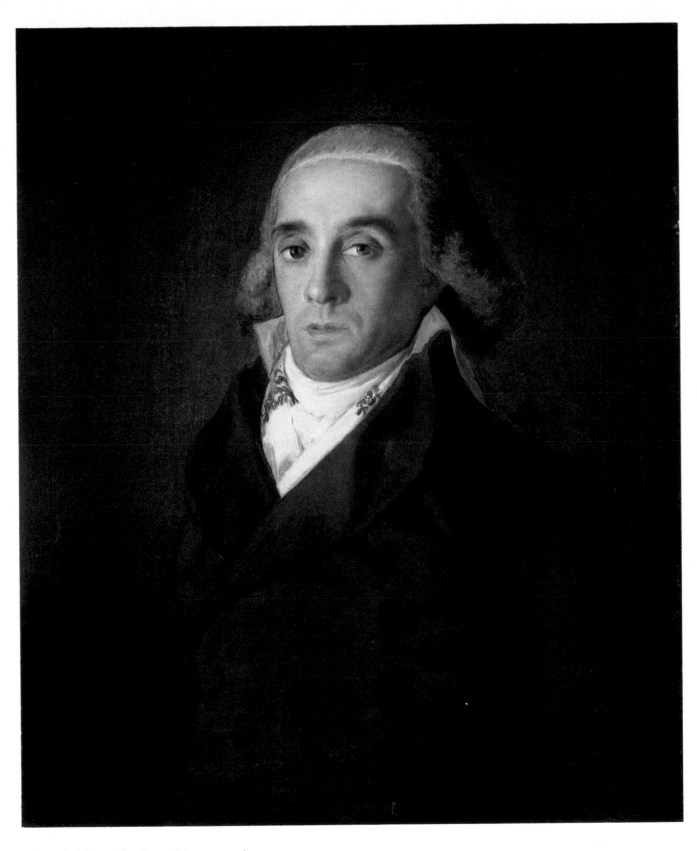

'El Conde del Tajo' by Goya (Cat. no. 12)

Nicolas Poussin (Les Andelys 1594–1665 Rome)

The outstanding genius of seventeenth-century French art, Poussin received his earliest training at Rouen and Paris before moving to Rome in 1624. There, after an initial and unfruitful attempt to win public commissions, he passed his career painting classically conceived compositions, of modest dimensions, for a select circle of educated and highly cultured patrons.

13 The Lamentation over the Dead Christ

Oil on canvas: 94 × 130 cm. (38 × 52 ins.)

EXHIBITED: 1932, Royal Academy, London, *Exhibition of French Art 1200-1900*, no. 120; 1937, Palais National des Arts, Paris, *Chefs d'oeuvre de l'art français*, no. 115; 1960, Musée du Louvre, Paris, *Exposition Nicolas Poussin*, no. 96; 1962, Palazzo dell'Archiginnasio, Bologna, *L'Ideale Classico del Seicento in Italia e la Pittura di Paesaggio*, no. 84; 1977-8, Villa Medici, Rome and Stadtische Kunsthalle, Düsseldorf, *Nicolas Poussin (1594-1665)*, no. 42.

PROVENANCE: Pointel (?); listed in the Inventory of the painter Samuel Bossière (1620-1703), drawn up by the artist (De Laroque 1872, p. 28) as *Christ que l'on va mettre au sépulcre*, though this could also refer to the painting in Munich; The Adriaan Bout sale, The Hague, 11 August, 1733, lot 6, though again this could be a reference to the Munich picture, however, the dimensions given, 38 × 54 inches, correspond more closely to the Dublin picture; acquired by Sir William Hamilton in Rome c.1780 (?) (Grautoff 1914, vol. 2, no. 113); Hamilton Palace sale, Christie's, London, 17 July and ff., 1882, lot 1120, where purchased by the National Gallery of Ireland. Cat. no. 214.

LITERATURE: Smith 1837, vol. 8, p. 60, no. 121; Waagen 1854-57, vol. 3, p. 300; Andresen 1863, no. A205; De Laroque 1872, p. 28; Friedlaender 1914, pp. 98, 256; Grautoff 1914, vol. 1, p. 228, vol. 2, no. 113; Magne 1914, p. 209, no. 195; Bodkin 1932, p. 180; Blunt 1950, p. 40; Licht 1954, p. 91; Wildenstein 1955, no. 69; Mahon 1960, p. 304, n. 107; Mahon 1962, pp. 118-119; Wild 1962, pp. 232, 237-242; Wildenstein 1962, p. 170; Bean 1964, no. 54; Blunt 1966, vol. I, pp. 227, 301, 304, 306, 309, vol. 2, p. 57, no. 83; Badt 1969, pp. 32, 370ff, 460, 607ff, pl. 174; Thullier 1974, p. 110, no. 206; Rittinger 1979, p. 192; Hirst 1981, p. 48, fig. 36; Rosenberg 1977/78, no. 42; Wild 1980, pp. 160, 178, no. 190.

ENGRAVED: by Jean Pesne, (1623-1700).

COPIES: 1. In the Skä Kyrka, Färentuna Härad, Sweden. 2. Abbé Dussel, St. Saturnin, Lozère. 3. Formerly in the collection of Count Stroganoff, St. Petersburg. (Grautoff 1914, vol. 2, p. 279) in grisaille.

This intense, solemn rendering of the *Lamentation* is among the most moving of all Poussin's creations. The desolate scene, with landscape and architecture reduced to elemental shapes, has Mary and the mourning disciples grouped protectively round the dead Christ as they prepare his body for the tomb.

The motif of Christ's dead body is inspired by Sebastiano del Piombo's *Pietà* painted for the church of San Francesco in Viterbo (now in the Museo Civico) which in turn was based on a drawing supplied by Michelangelo. The poetic, crepuscular lighting may also derive from the same source. The tragic figure of the Virgin is based upon an engraving of the *Lamentation*

by Marcantonio Raimondi (Bartsch no. 34), executed after a design by Raphael.

The overall rational and lucid disposition of the scene, coupled with the carefully controlled, articulate gestures of the figures, and the use of colour, indicate that this picture is a product of the artist's maturity. Grautoff, (1914, no. 113), dated the composition 1643-38. Friedlaender, (1914, p. 98), saw it as a late work. Mahon, (1960, p. 304, N.107), first proposed 1655 as the most likely date for the creation of the piece, but later (1962, pp. 118-119) modified his assessment to 1654-56, observing that it must have been executed before the National Gallery *Annunciation* which is documented as 1657. Blunt (1962, no. 96), who in the first edition of the Paris Exhibition catalogue placed it *vers 1650*, quickly reconsidered his remarks and in the second edition suggested a dating of 1655-57, an opinion he retained in his *Catalogue raisonné* (1966, no. 83), of the artist's *oeuvre*. Thullier, (1974, no. 206) observed that it could perhaps have been painted even later than 1657. Wild, (1962, pp. 237-242 and 1980, no. 190), commented that the composition may once have belonged to a series of pictures painted in the 1650's, possibly for the Parisian banker Pointel who had been in Rome during the period 1654-57. Pointel had on an earlier trip acquired *The Holy Family with Ten Figures* (N.G.I. 925) along with other works by the master.

Poussin's first extant rendering of the *Lamentation* theme, painted c.1629, is in the Alte Pinakothek, Munich (Blunt 1966, no. 82). Two drawings of the subject are at Windsor and the Metropolitan Museum, (Friedlaender/Blunt 1939-74, nos 400 and 401), both generally regarded as dating to the late 1630's. Of the two, the Windsor sheet relates more closely to the present painting showing the body of Christ laid almost flat across the composition, which also includes a tomb of stark architectural outline. A late painting of the *Lamentation* (exhibited, London, 1979, Anthony Dallas & Sons, p. 8 of catalogue) is closely related to the present composition, the figure of the Virgin being repeated in exactly the same pose. This picture, like the Dublin canvas, formed part of a series of four compositions (see Wild 1962, pp. 238 ff., and Rosenberg 1977, no. 43) and may date to c.1660.

RK

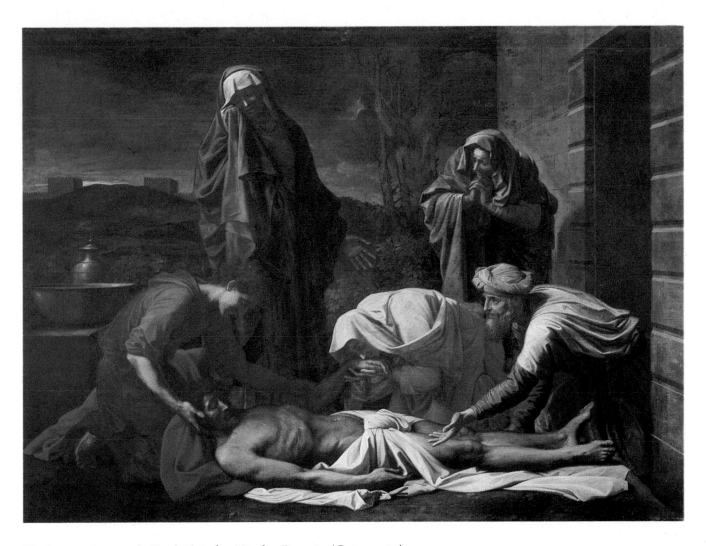

The Lamentation over the Dead Christ by Nicolas Poussin (Cat. no. 13)

Nicolas Largillière (Paris 1656–1746 Paris)

Born in Paris, Largillière received his training in Antwerp with the still-life and genre artist Antoine Goubaud. While in Antwerp, where he was accepted as a Master Painter in 1672, he may also have spent some time working with the artist Jan Davidsz de Heem. By 1670 Largillière had moved to London where he made the acquaintance of Sir Peter Lely, one of the foremost portraitists of the age. He also knew and worked alongside the Italian, Antonio Verrio, on the decorations at Windsor Castle. In 1679 he arrived in Paris, possibly moving there to escape the anti-catholic sentiments which were prevalent in England at this time. In Paris he was befriended by the Flemish artist, Adam Frans van der Meulen, who introduced him to Le Brun, thus opening to him access to Royal patronage. In 1683 Largillière was made an agréé of the Académie and in 1686 he was accepted as a full member, presenting his magnificient portrait of Le Brun (Louvre) as his reception piece. Although he also painted history pieces and still-lifes, Largillière made his reputation as a portraitist working for the aristocracy and the bourgeoisie. *He was also the official painter to the Corps de Ville of Paris. For this body he executed five of his most important commissions, drawing on the tradition of the Dutch municipal and society group portraits. His spectacular* Ex voto *canvas depicting the Échevins of the City of Paris before Ste. Geneviève (1696, Paris, Church of Saint Etienne-du-Mont) is the only example to survive. About 1685 he made a short return visit to London where he painted portraits of King James and his Queen, Mary of Modena. In 1724 he was appointed Director of the Académie Royale, a post he held till 1742. Largillière produced a prolific number of pictures over the course of his career, only slowing down over the last three years of his long life. P. J. Mariette listed over fifteen hundred works by him in and around Paris alone.*

14 Portrait of a Lady

Oil on canvas: 75 × 63 cm. (28¾ × 24¼ ins.)
EXHIBITED: 1902-3 Royal Hibernian Academy, Dublin. *Winter Exhibition of Old Masters of the early English and French Schools,* no. 54, (where incorrectly identified as *'Portrait of Lady Marshall').*
PROVENANCE: The Misses Dunne (1902); A. D. A. Cottingham Esq., from whom purchased by the National Gallery of Ireland, 1963. Cat. no. 1753.

In the lucrative realm of portraiture in eighteenth century Paris, Largillière and his great rival, Hyacinthe Rigaud (1659-1743), both drew their clientele from the circles of the aristocracy and the wealthy merchant and banking classes, Rigaud being generally favoured for male portraits, Largillière for the female. Largillière's abilities as a portrayer of feminine charms and beauty and the riches he obtained in the execution of these skills were commented upon by Dézallier d'Argenville. Writing in 1752 he remarked:

"Son habilité pour peindre les Dames, dont les grâces, loin de diminuer, gagnaient beaucoup entre ses mains"

In 1699, at around the time this picture was painted, he was charging one hundred and forty *livres* for bust length portraits.

This delightful image of an unknown lady (once incorrectly identified as Lady Marshall) displays Largillière's considerable talents to great advantage. The magnificent colouring in the costume, the healthy, rosy complexion of the subject's attractive features, the beautifully naturalistic and finely rendered details of the flowers and pearls which decorate her hair, together with the vibrant handling of the brushwork, all reflect his Flemish heritage and training and bear testimony to his debt to Rubens and Van Dyck.

It is difficult to determine an exact chronology for Largillière's vast *oeuvre,* (almost 2,000 portraits), which spanned over sixty very productive years, however, it is generally acknowledged that as his career progressed, his approach to portraiture did evolve, with the pomposity of the *Grand Siècle* effigies gradually giving way and surrendering to the more intimate and charming presentation of his subjects, developing an approach which pointed the way forward to the more ephemeral, exotic creations of the Rococo and the pastoral images of Boucher and the mythological portraits of Nattier. The present engaging depiction of feminine beauty, most probably dates, therefore, to sometime around about 1710, or perhaps a short time later.

RK

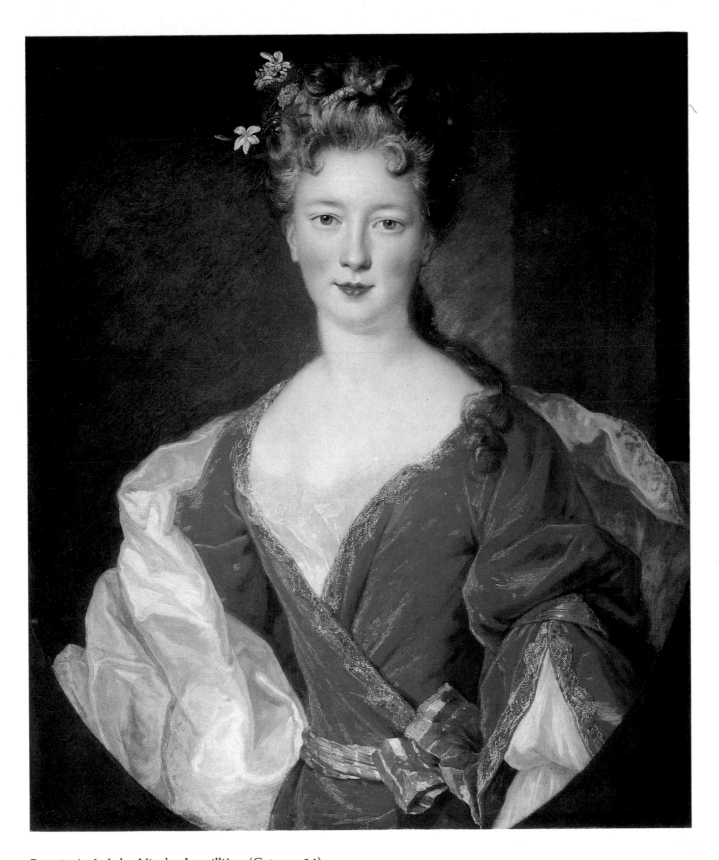

Portrait of a Lady by Nicolas Largillière (Cat. no. 14)

Jean-Baptiste Perronneau (Paris 1715–1783 Amsterdam)

Born in Paris, Perronneau obtained his initial training from Charles Natoire before attaching himself to the engraver Laurent Cars. After working for a brief spell as an engraver he pursued a career as a portraitist working in oils and in pastels, a medium which enjoyed considerable popularity at this time following Rosalba Carriera's triumphant reception in Paris in 1720. Perronneau achieved his first notable successes in Orléans where he was befriended by the amateur Desfriches, patron of Pigalle and Cochin. His early works reflect the influence of Nattier. Made an agréé of the Académie in 1746 and a full member in 1753 with his portraits Adam l'Aîné and J.-B. Oudry as his reception pieces, Perronneau exhibited at the Salon from 1746 to 1779. A more honest and more psychologically revealing portraitist than his illustrious contemporary Maurice-Quentin de la Tour (1704-88), he never achieved the same popularity and acceptance as the latter, and the greater part of his career, from 1755 onwards, was passed in frequent peregrinations seeking out commissions in the provinces and all across Europe, visiting Holland in 1754, 1755, 1761, 1772, 1780, 1783; Italy in 1759; England in 1761; Russia in 1781 and Poland in 1782. It was while on one of these frequent trips that he died in Amsterdam in 1783.

15 Portrait of a Man

Oil on canvas: 72.5 × 58.5 cm. (28⅝ × 23 ins.)
Signed and dated top right: *Perronneau 1766*
EXHIBITED: 1932, Royal Academy, London, *Exhibition of French Art, 1200-1900*, no. 236; 1932, City of Manchester Art Gallery, Manchester, *French Art Exhibition*; 1968, Royal Academy, London, *France in the Eighteenth Century*, no. 552.
PROVENANCE: Thos. Agnew & Sons, London, from whom purchased by the National Gallery of Ireland, 1929. Cat. no. 920.
LITERATURE: Kalnein/Levey 1972, p. 131.

Though he lived out his career in the shadow of his more fashionable and successful contemporary, La Tour, Perronneau's art is today highly regarded and his portraits are not infrequently more greatly esteemed than those of his generally better known rival. Unlike La Tour, who worked almost exclusively in pastels, Perronneau was an accomplished oil painter and many of his finest achievements are in this medium. In his pictures he generally portrayed his subjects in bust or three quarter length format, placing them against a finely modelled, neutral background, accompanied by a minimum of accessories, as in the present picture. The intimate, uncluttered settings, together with the sensitive use of light and colour and the honest portrayal of character reflect a sensibility akin to that of Chardin.

This portrait, painted in 1766, displays all the finest qualities of Perronneau's art. Michael Levey (1972, p. 131) referred to it in a perceptive and appreciative comment, stating it was 'as pungent and penetrating as a Goya'. The identity of the sitter, who holds in his left hand a piece of paper inscribed with the words *'Agriculture, arts et commerce'* has not yet been satisfactorily determined. It has been suggested that the subject is Pierre Fulcrand de Rosset (1708?-1788), a native of Montpellier, the author of a poem with the somewhat unlikely title *L'Agriculture,* (Paris, 1774-82), who also wrote an essay entitled *Traité sur la commerce.* His features, which were recorded in an engraving, are said to resemble those of the present sitter. The canvas has never been lined.

RK

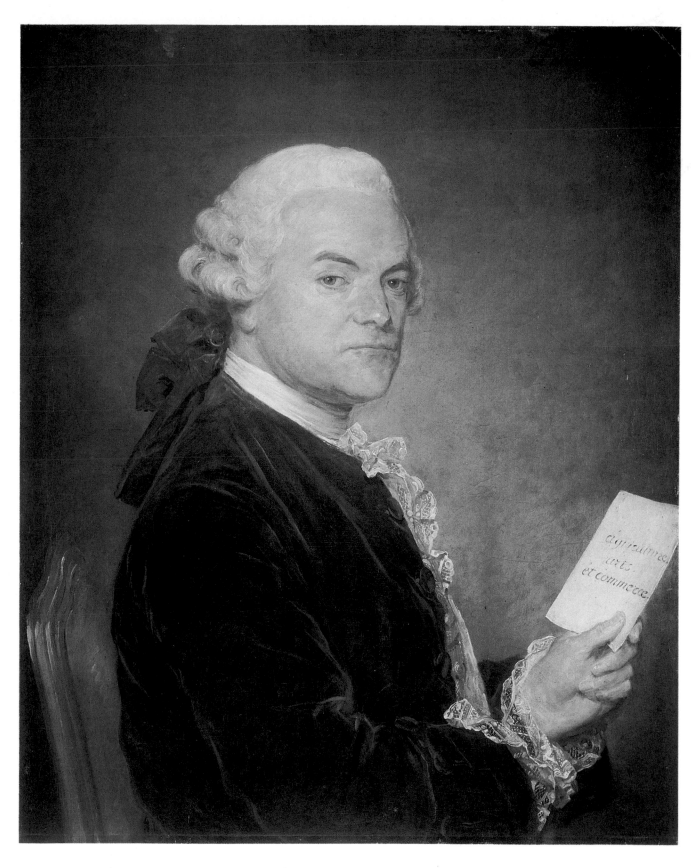

Portrait of a Man by Jean-Baptiste Perronneau (Cat. no. 15)

Jacques-Louis David (Paris 1748–1825 Brussels)

Born in Paris in 1748, David lost his father in 1757 and was taken into the care of his mother's family. At the suggestion of Boucher, to whom he was related, he initiated his study of painting with Vien. He studied regularly at the Académie which he entered in 1766 without showing any exceptional talent, painting in a style which reflected the art of Boucher more than his master Vien, and it was not until 1774 that he succeeded in winning, at his fourth attempt, the Prix de Rome. In Rome his studies were supervised by his old master Vien. There, with his indefatigable study and sketching after the Antique and the Great Masters, he quickly divested himself of an inherited, retardataire style and by the date of his return to Paris (1780) he had already conceived an articulate, neo-classical idiom. At his first Salon of 1781 he exhibited three works which manifested a mature reformed vision and caused a sensation. The following year he was received into the Académie with Andromache. Already popular as a portraitist he accepted a royal commission to paint the Oath of Horatii (painted in Rome 1784/5) and shortly afterwards painted the Death of Socrates and Brutus. Sympathetic to the Revolution he supported the reforms and was rewarded with important offices both in the administration of the arts and public affairs. Inspired by revolutionary fervour he painted the Death of Marat (1793). Imprisoned twice on suspicion of treason after the death of Robespierre, he recommenced his artistic activities on his release, completing his great canvas The Sabines in 1799. Following the rising star of Napoleon, he allied himself to the young general and expressed his admiration in Napoleon Crossing the Saint-Bernard, (1801). Napoleon rewarded him with commissions, many of which were never executed, the most notable achievements being the Coronation (1806-07) and The Distribution of the Eagles. His last great work of this period was Leonidas at Thermopylae which had been in gestation for almost 15 years. With the fall of the Empire, and the Restoration of the Monarchy David sought exile in Brussels where he proved popular as a portraitist and where he painted a number of mythological compositions which were conceived in a different key to his earlier masterpieces.

16 The Funeral of Patroclus

Oil on canvas, 93.5 × 217.5 cm. (36¾ × 85½ ins.)
Signed and dated, bottom left: *J.L. David f. Roma 1779*
EXHIBITED: 1778, Palazzo Mancini, Rome; 1781, Paris, Salon, no. 314; 1974/5, Grand Palais, Paris and Detroit Institute of Arts, Detroit, *De David a Delacroix, la peinture française de 1774 a 1830*, no. 27; 1981/2, Villa Medici, Rome, *David e Roma*, no. 22.
PROVENANCE: sold by the artist to M. Fontanel, Paris, 12 March, 1782 (del Caso 1972, p. 686); Acton family, Naples; Serra, Duca del Cardinale, Naples (prior to 1840); Heim Gallery, London, where purchased by the National Gallery of Ireland, 1973. Cat. no. 4060.
LITERATURE: Anon 1781, p. 436; de Bachaumont 1777-1789, vol. 19, pp. 341-342; Sue 1793, pp. 275-280; Anon 1824, p. 26; Gamond 1826, pp. 14, 161; Coupin 1827, p. 52; de Villars 1850, p. 69; David 1867, pp. 32-40; de Montaiglon 1875-92, vol. 8, p. 376; David 1880, pp. 12, 22-23, 632; de Montaiglon 1887-1912, (1904), p. 421; *L'Exposition Centennale* 1912, p. 187; Thieme-Becker vol. 8, p. 459; Lapauze 1924, p. 367; Cantinelli 1930, p. 13; Holma 1940, pp. 33-34, 125; *David 1948*, 88; Hautecoeur 1954, pp. 41-42; Seznec/Adhémar 1967, pp. 299, 332, 350, 351, 378; Rosenberg 1970, pp. 31-39; Sérullaz 1972, p. 18, no. 31; del Caso 1972, p. 686, n. 10, 11; Sérullaz 1972, p. 327, no. 550; Rosenberg 1972-73, no. 39; Rosenberg 1973, pp. 78-79; Wildenstein 1973, nos. 43, 45, 88, 98, 1368, 1810, 1938; Verbraeken 1973, p. 49, nos. 5 and 6; Rosenblum 1973, pp. 567-576; Lacambre 1973, pp. 302-303; Dessins 1974-75, no. 13, p. 32; Schnapper 1974, p. 383, no. 6; Howard 1975, pp. 59-61; Brookner 1980, p. 56; Rome 1981, p. 100, no. 22, p. 240.
DRAWINGS: Cabinet des Dessins, Musée du Louvre, Paris, inv. no. RF4004; Musée Eugène Boudin, Honfleur, inv. no. 37-1-62; Musée de Narbonne, copy drawing by Jacques Gamelin (1738-1803).

This spectacular composition represents the climactic moment from Homer's epic account of the funeral of Patroclus, an episode in the Trojan war (Iliad, Bk. XXIII, V. 110 ss). The impressive *mise-en-scène* has an air of operatic pomp as its hero, Achilles, surrounded by a tumultuous cast of mourners and victims, bids a last farewell to his colleague in arms. Centre stage, atop a short sequence of steps, which lead to the base of the enormous funeral pyre, Achilles mourns over the lifeless body of his slain companion. To his right the Greeks add the bodies of some of the twelve noble Trojan captives, including several of the sons of Priam, to the pyre, the last of whom are shown being ritually killed in the secondary scene depicted to the left. In the right foreground, the body of Hector, who had earlier despatched Patroclus with a single blow, after Apollo had previously identified and wounded him, is depicted secured by his heels to the chariot of his victim. In the extreme right foreground, a pair of goats and other sacrificial animals are drawn up and the urn which is to receive the hero's ashes is carried forward. The Greek ships are visible near to the shore. The whole magnificent scene is richly orchestrated through the careful disposition of main and ancillary activities and

Continued overleaf

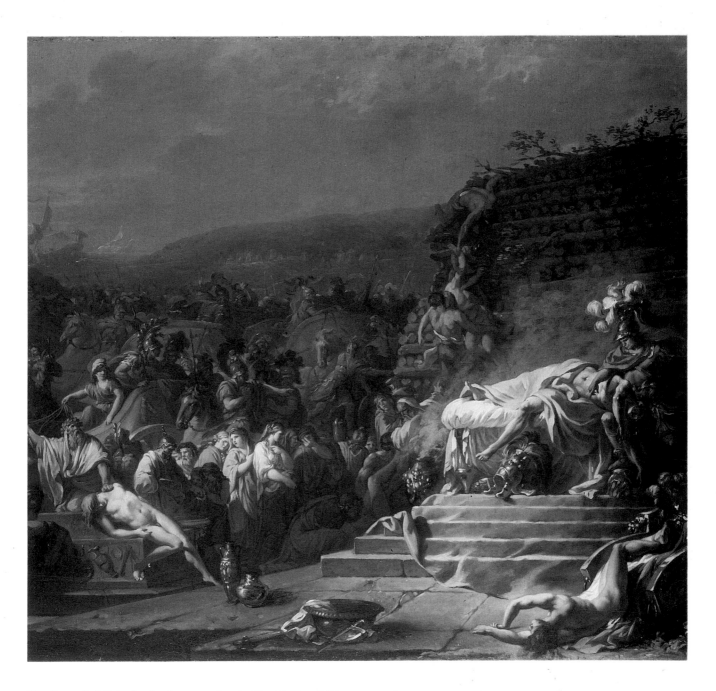

The Funeral of Patroclus by Jacques-Louis David *(detail)* (Cat. no. 16)

animated through the skillful application of brilliant flashes of light and colour.

This sketch, painted during the artist's stay at the French Academy in Rome, (1775-1780), is considered a pivotal work in his development. The exuberant, almost baroque style of his earlier works is here, for the first time, subjected to a discipline which will lead, within a few years, to the distillation of a mature, confident, neo-classical style. David's dissatisfaction with the florid approach of his earlier work is documented through the evolution of his designs for the present composition. This can be assessed in drawings at Paris and Honfleur. The earlier drawing (Fig. C), in the Louvre is a fanciful visualisation of the scene, with gods and other mythological figures present in attendance, the scene itself fragmented in a sequence of episodes which jostle for attention. The Honfleur sheet (Fig. A) shows a more realistic, ordered and disciplined arrangement of the scene, which is only slightly more elaborate in its detail than the painted version. By the time he had executed this sketch, however, David's ambitions to achieve a new, more rational and classically inspired style had advanced to such an extent that he abandoned the intention to work the present design up into a fully finished picture. His ambitions for this painting and his disappointment with the result are recorded in his uncompleted draft autobiography:

Fig. A *The Funeral of Patroclus* by J.-L. David. Drawing in pen, ink and wash, 33 cm. high. (Musée Eugène Boudin, Honfleur).

'Je continuai donc a mé conduire à Rome dans ces principes quand, voulant essayer mes forces dans la composition, j'entrepris de faire sur la toile une grande esquisse assez terminée représentant la mort de Patrocle sur le bûcher dans les bras d'Achille, Hector au bas du bûcher attaché par les pieds au char de son vainqueur. Calchas immolant douze princes troyens et tous les Grecs réunis montés sur leurs chars. Cette composition fit quelque plaisir à Rome, on voyait des intentions au goût antique, mais hélas! on y voyait encore certaines traces françaises. Je les apercus moi-même, me proposant bien de m'en corriger aussitôt que l'occasion s'en présenterait.' (Wildenstein 1973, p. 157, no. 1368).

Almost contemporaneously with the conception of the present piece David drew a frieze-like composition (E. B. Crocker Museum, Sacramento, no. 408, see Howard, 1975), also illustrating the funeral of Patroclus' in an antique style which reflects his search for a more authentic classical approach to art, devoid of French influences.

Generally acknowledged to have been painted in 1778, despite the dated signature *J.L. David f. Roma 1779*, this canvas was first exhibited at the Palazzo Mancini, in 1778, along with other works by students of the Académie Française in Rome. The following year it was sent to Paris to be submitted for judgement at the *Académie de la Peinture* where it is mentioned in the proceedings for April of that year (De Montaiglon, Vol. VIII, p. 377). In 1781, one year after his return to Paris, David submitted the sketch to be exhibited at the Salon (1781, no. 314), where it hung alongside his more recent creations *Belisarius, St. Roch*, and his *Portrait of Count Potocki*. Though the painting was poorly hung and already appeared dated compared to its three companions, Diderot (Seznec/Adhémar 1967, vol. 4, p. 378) was impressed by it, commenting '*Les Funerailles de Patrocle du même* (David) *superbe esquisse, belle d'effet, plein de sentiment'*. In the winter of 1781-82 David reputedly used it as a support for a table top. Shortly afterwards, he disposed of the picture to a M. Fontanel of the Montpellier *Académie des Beaux-Arts* for 2,400 *livres*. While at Montpellier Jacques Gamelin drew a copy of the composition (Lacambre 1973, p. 303). In 1840 it was recorded in the Serra collection in Naples, after which date there is no record of the painting till 1972.

RK

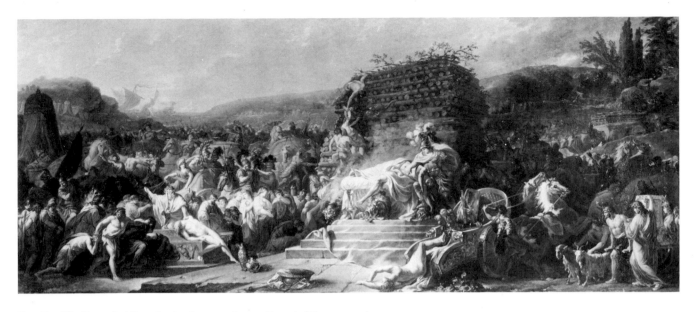

Fig. B *The Funeral of Patroclus* by Jacques-Louis David. (Cat. no. 16)

Fig. C *The Funeral of Patroclus* by Jacques-Louis David. Drawing in pen, ink and grey wash, 33.1 × 75.7 cm. (Musée du Louvre).

François-Pascal-Simon Gérard (Rome 1770–1837 Paris)

Born in Rome, Gérard moved to Paris with his parents in 1780. After studying with the sculptor Pajou and with the painter Brenet, he entered the studio of David in 1786 where he completed his training. Relatively unsuccessful early in his career, Gérard initially derived much of his income by working for publishers, most notably Didot, supplying illustrations for editions of Racine and Virgil. His portraits of the artist Isabey and Countess Regnault (exhibited 1796, 1799) confirmed his abilities as a superb portraitist and won him a constant flood of commissions from the Emperor and his family. In 1798 he achieved his most outstanding success as a history painter with his composition Cupid and Psyche. After the fall of the Empire, with the support of Tallyrand, Gérard attained favour at the court of Louis XVIII becoming premier peintre in 1817. His popularity was such that he was called 'Le peintre des Rois et le Roi des peintres'. He was created a Baron in 1819.

17 Julie Bonaparte, Queen of Naples, with her daughters, Zénaïde and Charlotte

Oil on canvas: 200 × 143.5 cm. (79½ × 56½ ins.)
Signed, lower right: *F. Gerard*
EXHIBITED: 1808, Paris, Salon, no. 243 (?); 1972, Heim Gallery, London, *Paintings and Sculptures 1770-1830*, no. 20.
PROVENANCE: Joseph Bonaparte, King of Naples and Spain; Zénaïde, Princess of Canino; Cardinal Lucien Bonaparte; Marchese Julie di Roccagiovine and her descendants; Heim Gallery, London, where purchased by the National Gallery of Ireland, 1972. Cat. no. 4055.
LITERATURE: Gérard 1852-57, vol. 1, pl. 22; Lenormant 1847; Gérard 1886, vol. 2, p. 404; Bertin 1893, pp. 24, 91, 418; Pérat 1909-10, p. 7; Valynseele 1954, pp. 41-43; Ansaldi 1955, p. 38; de l'Ain 1970, p. 351, n. 1; Constans 1980, p. 59.
ENGRAVED: Pierre Adam (Gérard 1852-7, vol. 1, pl. 22).
COPIES: 1. Musée national du château de Versailles, MV 4874, Inv. 4784, LP 2069, (Cf. Constans 1980, p. 59); 2. Formerly Musée national de Malmaison, (Dépôt collection Prince Napoléon).

This attractive full length group portrait depicts Marie-Julie Clary (1771-1845), the wife of Joseph Bonaparte, with her two daughters Zénaïde (1801-1854) and Charlotte (1802-1839). We have little or no knowledge of Julie, the daughter of a well-to-do Marseilles merchant, prior to her meeting with Joseph Bonaparte, who was initially attracted to her more celebrated younger sister. He turned his attentions to Julie only after his younger brother, Napoleon, became enamoured of the more spirited Desirée. Julie married Joseph in August 1794 and as his wife became Queen, first of Naples (1806-08) and then of Spain (1808-13). After the fall of the Empire she was sought out by the authorities who wanted her to leave with her husband for the United States or else be exiled to Russia. With the intervention of Desirée's husband, Bernadotte, King of Sweden, however, she was allowed to retire, first to Frankfurt and later to Brussels, where J-L. David frequented her salon, and where the two daughters had their portrait painted by the artist, (1821, Rome, Museo Napoleonico). Both girls married cousins, Zénaïde espousing Charles-Lucien Bonaparte, Prince of Canino; Charlotte taking Napoleon Louis, brother of Napoleon III, as her partner.

The present portrait was painted in 1807 for Joseph Bonaparte (Gérard 1886, vol. 2, p. 404) and not 1810 as had been proposed by Charles Lenormant (1847, p. 182). It was traditionally believed to represent the Queen and her children at Malmaison, though it had also been suggested, (Malmaison 1968, no. 92) that the setting is the old château of Mortefontaine, a property once owned by Julie and her husband. The picture was back in the artist's studio in 1818 where it was seen by the writer François Andrieux. He wrote to Joseph Bonaparte on 13th March, (de L'Ain 1970, p. 351, n. 1), explaining that while it was there, serving as the prototype for the copy to be sent to Julie at Frankfurt, it had been vandalised by Prussian troops who slashed the canvas with their sabres (hence the two tears down the face of the Queen and the diagonal cut across her knees, visible in ultraviolet light). Later the picture travelled to America to join its owner at his residence at Point-Breeze, near Philadelphia (de L'Ain 1970, p. 351) where it hung in the main room along with other portraits by Gérard. According to family papers (Ansaldi 1955, p. 38), the portrait was inherited by Zénaïde, Princess of Canino, after whose death it passed to her son, Cardinal Lucien Bonaparte (1828-1900) who had married Alessandro del Gallo, Marchese di Rocca-Giovine, with whose family it remained for many years.

A copy of this composition (possibly by Eléonore Godefroid ?) from the collection of Prince Louis Napoleon, was until recently at Malmaison (Malmaison 1968, no. 92). It was allegedly ordered by Joseph Bonaparte for his younger daughter, (Ansaldi 1955, p. 38). Jean Baptiste Wicar (1762-1834) painted a slightly larger group portrait of the Queen and her two children in 1809 (Naples, Museo di Capodimonte) in which Julie is shown standing wearing very similar robes with her daughter Zénaïde in almost the identical pose to that which she assumes in the present picture. In light of the many similarities, particularly the children's portraits, it seems probable that Wicar used Gérard's canvas as the model for his own painting.

RK

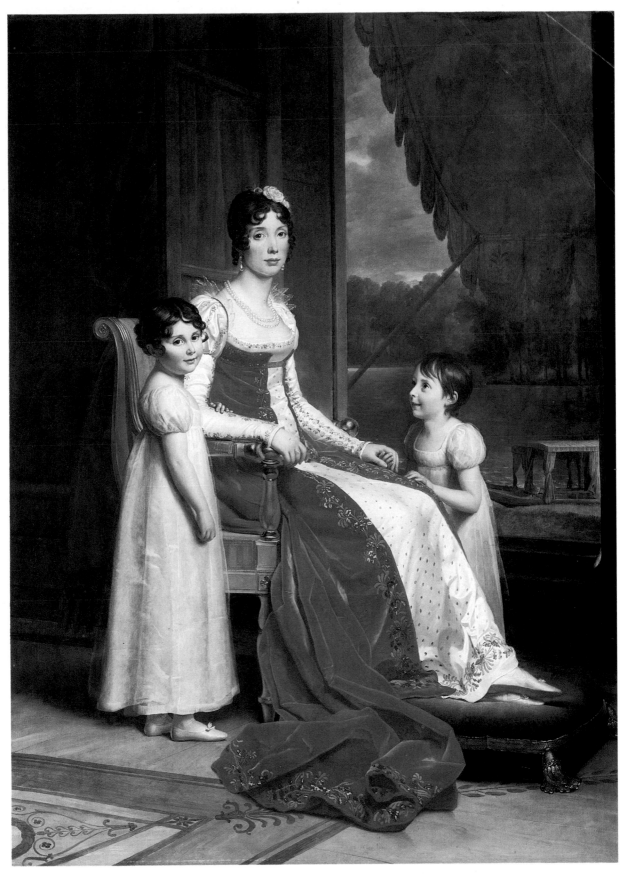

Julie Bonaparte, Queen of Naples, with her daughters, Zénaïde and Charlotte by François-Pascal-Simon Gérard
(Cat. no. 17)

Eugène Delacroix (Charenton-St. Maurice 1798-1863 Paris)

Delacroix was the leading painter of the Romantic movement in France. He was a pupil of Baron Guerin, but formed his personal style from a constant study of past Masters, particularly the great colourists Veronese and Rubens. He admired the work of Bonington and Constable and was of the first artists to use photography as an artistic aid. In the 1820s the vivid colours and controversial subject matter of The Massacre at Chios *and* Sardanapalus *(Louvre, Paris) made him the leading opponent of the classical tradition upheld by Ingres. Official favour from the 1830s brought him important public commissions in Paris and Rouen and the State bought at least one picture from each annual Salon. Delacroix's output was enormous including religious, mythological, literary and historical subjects, also portraits, still-life and animal pictures. His* Journal, *a private diary kept before 1824 and after 1847, reveals him as a lucid critic and an artist receptive to both contemporary and Old Master pictures.*

18 Demosthenes on the Seashore

Oil on paper, laid on panel, 47.5 × 58 cm. (18^{11}/$_{16}$ × 22^7/$_8$ ins.)
Signed below foreground rock: *Eug. Delacroix 1859.*
EXHIBITED: 1860, Galerie Francis Petit, 26 Boulevard des Italiens, Paris, no. 167; 1885, Ecole des Beaux-Arts, Paris, *Monument Delacroix* no. 170 (to raise funds for the monument to Delacroix in the gardens of the Luxembourg Palace).
PROVENANCE: Francis Petit by 1860; M. le Chevalier de Knieff; Carlin Sale, Hôtel Drouot, Paris, 29 April 1872, lot 7; M.P. Sale, Hôtel Drouot, Paris, 16 March 1877, lot 13; Henri Rigaud in 1885; Anon Sale Hôtel Drouot, Paris, 3 April 1933, lot 4 (ill.), bt. Georges Bernheim et Cie., Paris from whom purchased by the National Gallery of Ireland 1934. Cat. no. 964.
LITERATURE: Moreau 1873, p.259; Robaut 1885, no. 1373; Moreau-Nelaton 1916, vol. 2, pp. 187, 194; Escholier 1929, vol. 3, p. 254; Huyghe 1963, p. 418; Serullaz 1973, p. 362; Bortolatto 1975, no. 765.
VERSION: Private Collection, France. Oil on canvas, 49 × 59 cm.

Demosthenes was one of the greatest Athenian orators of the fourth century BC. Demosthenes was born in 383 BC and made his first public speeches about 355 BC. He was mocked for a slight speech impediment, but was said to have corrected this by running uphill while reciting verse and declaiming on the seashore against the noise of the sea with a mouthful of pebbles, as in Delacroix's picture. Demosthenes' political career was more tragic than this colourful but probably apochryphal story. He opposed the designs of both Philip of Macedon and Alexander the Great against Athens, but could not forstall the city's subjugation. Only his renowned honesty and powerful oratory prevented imprisonment or exile. He died at Athens in 322 BC.

Demosthenes on the Seashore was for sale at Francis Petit's gallery the year after it was painted. Petit was a dealer and close friend of Delacroix's and later one of his executors. In 1853 Delacroix painted a *Christe dans la Barque* for him (possibly the one in the Bürhle Collection, Zurich) and Demosthenes may have been a similar commission. It is one of a number of instances in the 1850s where Delacroix returns to an earlier picture for his theme. He first painted a *Demosthenes on the Seashore* about 1844 to exemplify classical oratory. It was part of a major State commission to decorate the library ceiling of the Chambre des Deputés (now Assemblée Nationale) at the Palais Bourbon in Paris. Working on a long narrow space divided into five domed units, he gave each section a different theme (natural sciences, philosophy, legislation, theology and poetry). Demosthenes was one of four pendentives illustrating legislation. One of Delacroix's three assistants was a pupil from Toulouse, Louis de Planet, who recorded in his *Souvenirs* (Trapp 1971, p. 312) that Delacroix painted six of the pendentives himself, including *Demosthenes,* providing detailed sketches for the others. The pendentives were painted at his studio in oil on canvas and then attached to the ceiling. Delacroix described the overall scheme to his friend Theophile Thoré who published an account in *Le Constitutionel* (31 January, 1848). Of the preliminary designs that Delacroix probably consulted in 1859 for the Dublin picture there is a drawing for the figure (Private Collection, France; listed by Serullaz), and two sketches that were in Delacroix's posthumous sale (Robaut no. 871, at Christie's 2 December 1966 and Robaut no. 872 in a private collection, Switzerland).

The architectural framework of the Palais Bourbon ceiling necessitated a centrally placed figure whose gestures and sandaled feet do not immediately identify him at Demosthenes. Here the outstretched arm is more emphatic and the billowing drapery reinforces the suggestion of movement. Demosthenes' bearded face with open mouth corresponds to surviving Antique busts of him, for instance that from the Payne Knight collection in the British Museum. Delacroix has not however copied the only surviving full-length statue of Demosthenes, a copy of a lost one by Polykleitos. This rather sombre figure at repose is known both with a scroll (Vatican Museums, Rome) and without (Carlsberg Glyptotek, Copenhagen). Delacroix no doubt knew of the figure from his large collection of engravings (it was also drawn by Rubens), but he has found his own pose, illustrative through the brushwork and colour of the orator's inner passion.

ALH

44

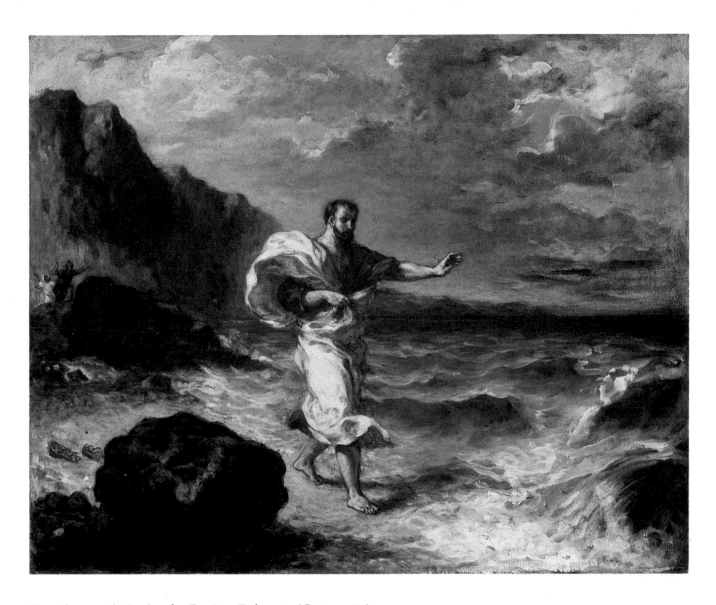

Demosthenes on the Seashore by Eugène Delacroix (Cat. no. 18)

Conrad Faber (Creuznach c.1500–1552/3 Frankfurt)

Faber came from Creuznach (today Bad Kreuznach), a small village to the west of Frankfurt-am-Main. He was working in Frankfurt by 1525 and no doubt found the atmosphere of this free Imperial city more congenial than the nearer Bishop Elector's court at Mainz, which Grünewald for instance was to leave in 1526, coming also to Frankfurt. In this same year Faber was apprenticed to Hans Fyoll. None of this minor artist's work has been identified with certainty but Faber was already working in his own distinct manner, an amalgam of current German and Flemish portrait styles. Approximately forty portraits by him survive and rather unusually he does not appear to have tried religious or mythological painting. Many of his sitters belong to the important patrician family of Limpburg in Frankfurt. Changes in the landscape backgrounds to his portraits around 1530 suggest that he had travelled to Passau and the Danube region. In the early 1540s he was working to the north at Lich for the Counts Solms, but he retained his links with Frankfurt, having become a citizen in 1538 and gaining a sinecure as city iron-weigher from 1547. One of his last known works as an impressive woodcut of the July-August 1552 siege of Frankfurt (Historisches Museum, Frankfurt), his only known print. It combines an aerial view with a plan of the city and was pubished in 1553. Fourteen of Faber's portraits are signed with the distinctive monogram (standing for Conrad von Creuznach) seen on the reverse of the Dublin portraits. It is only in the present century that Faber's oeuvre has been rediscovered and he was at first known as the Master of the Holzhausen portraits from the portraits of that family now in the Städelsches Kunstinstitut, Frankfurt.

19 Heinrich Knoblauch

Oil on panel, 50 × 35 cm. (19⅝ × 12½ ins.)
Inscribed, dated and signed on reverse: *HEINRICH KNOBELAVCH SEINES ALTERS XXV FELICITAS VESTENNERIN. SEIN GEMAHEL. YRES ALTERS XXII/MCCCCCXXIX/ ƆvC* (in monogram) (Heinrich Knoblauch his age twenty-five, Felicitas Ufstenner his wife, her age twenty-two, 1529.)
EXHIBITED: 1906, Burlington Fine Arts Club, London, *Early German Art,* no. 20.
PROVENANCE:Hamilton Palace collection no. 54; Hamilton Palace Sale, Christie's, London, 17 June 1882, lot 88, bt. Christopher Beckett-Denison; his Sale, Christie's, London, 13 June 1885, lot 916, where purchased by the National Gallery of Ireland. Cat. no. 243.
LITERATURE:Von Lersner 1706, vol. 1, pp. 103, 120; Friedlander 1913, p. 147; Collins Baker 1920, p. 194; Auerbach 1937, pp. 22, 23; Hugelsdorfer 1939, pp. 22-24; Brücker 1965, p. 161.

Heinrich Knoblauch was born in 1503/04, son of Johann Knoblauch and Katherina Gelthaus, members of the ruling house of Limpburg in Frankfurt. Knoblauch means garlic and this is the emblem on his coat of arms and also his signet ring. Nothing is known of Heinrich's life: the partly seen sword in his hand is a fasionable accessory rather than an indication of military prowess. He died young in 1536. There may have originally been a pendant portrait of his wife Felicitas Uffstenner, also of the House of Limpburg, whom he married in 1527 and who is mentioned on the reverse of this portrait. Eight pairs of portraits by Faber survive all of which show the lady on the right facing her husband. In Dublin this role is taken by Heinrich's younger sister Katherina (Cat. no. 20). Faber also painted his elder sister Anna (1510-67) and her husband Johann von Glauburg in 1545 (Gemäldegalerie, Berlin-Dahlem).

The picture's history is not known before it belonged to the 12th Duke of Hamilton, when the sitter's name was unnoticed and the artist thought to be Hans Holbein the Younger. It belonged briefly to the avid collector Christopher Beckett-Denison, who according to a posthumous *Times* leading article (5 June 1885) had purchased about a quarter of the Duke's collection, but did not live to enjoy them having fallen fatally ill during a visit to Ireland. At his sale the picture was described as by Hans Asper and so catalogued when first acquired by Dublin.

In the 1908 catalogue it was correctly given to the Master of the Holzhausen portraits on the basis of information from Alban Head. He had seen the four portraits of members of the Holzhausen family (Städelsches Kunstinstitut, Frankfurt) and noted the identical monogram on the reverse. At this date it was believed to be that of Melchior Feselen, but by 1928 was correctly identified with Conrad Faber.

Faber's sitters are invariably painted to the same formula with a half or three-quarter length figure faced away from the viewer and silhouetted against a distant open landscape, with a river or lake. Hans Memling popularised the open landscape in late 15th century Flemish portraits, while similar effects are seen on altarpieces where donor portraits kneel against a landscape. Faber's presentation recalls the early Viennese work of Lucas Cranach, for instance the so-called *Dr Johann Reuss and his Wife*, pendant portraits of

Continued overleaf

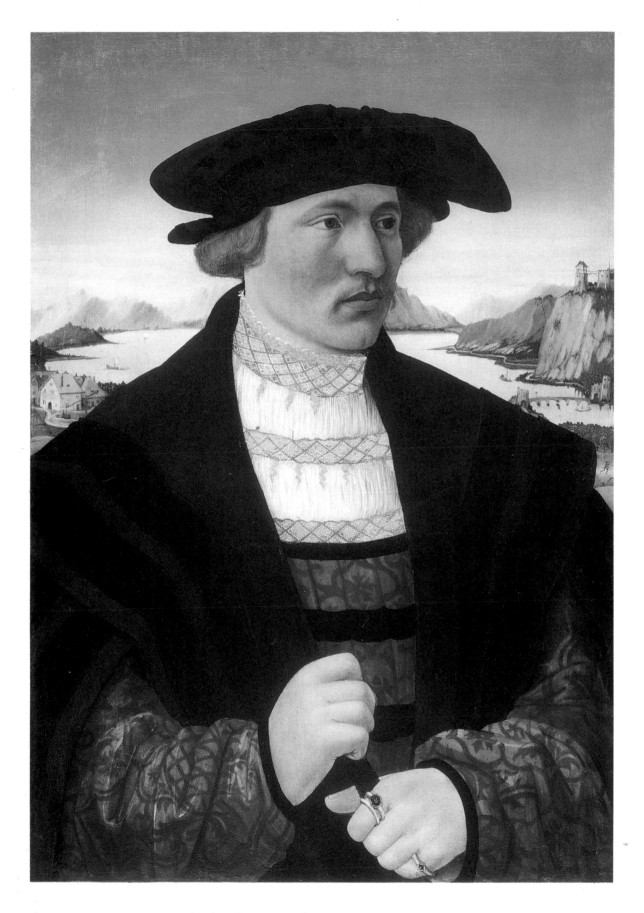

Heinrich Knoblauch by Conrad Faber (Cat. no. 19)

1503 (Germanisches National-museum, Nuremberg) or the more florid style of Munich artist Manuel Wertinger (*Wilhelm IV and his Wife Maria Jacobaer*, Alte Pinakothek, Munich, 1526). Pendant portraits of *Ulrich and Elizabeth Hynsberg* (Private Collection, Switzerland, 1525) attributed to a middle Rhenish Master probably also influenced his development. Of similar size to Heinrich Knoblauch (45.7 × 33 cm., 18 × 13 ins.) they are less sensitively painted with the landscape separated from the figures by a wall.

Heinrich Knoblauch is close in style to the first dated Faber of 1526 (*Johann von Stralenberg*, Städelsches Kunstinstitut, Frankfurt), similarly formed within a strong triangular pattern. The paint on the folds of the coat and the embroidered pattern of Heinrich's sleeves is modelled for enhanced realism. Gold leaf is applied to indicate his gold rings and the gold thread woven into his shirt. Inner tension is implied by the tensely poised and well rounded hands, which are a recurrent feature in Faber's male portraits. Faber has moved away from the majestic strongly Flemish *Claus Stralburg* (Van Heek Collection, S'Heerenberg) of about 1525 where the face is more deeply modelled and the gloved hands hold symbolic flowers and a pomander. Heinrich Knoblauch seems less realistic due to his flatter facial modelling and the abrupt shifts of recession in the landscape. Minute details of a woman drawing water at a well, ships on the lake and a lively hunt in progress beyond Heinrich's shoulder demand equal attention. Similar village houses are a running feature of Dürer's prints, while the bridge guarded by a tower can be traced back to Jan Van Eyck's townscapes. The rock with vertical face is another Flemish motif often used by Faber (*Haman von Holzhausen*, Städelisches Kunstinstitut, Frankfurt and *Portrait of a White Bearded Man*, Duke of Northumberland, Syon House).

ALH

Fig. A The reverse of the portrait of *Heinrich Knoblauch* by Conrad Faber (Cat. no. 19) showing his coat-of-arms combined with those of his wife Felicitas Uffstenner. The Knoblauch coat-of-arms consist of three cloves of garlic on a black ground, those of Uffstenner, a gold cock's leg grasping a red stone in its claw on a blue ground. The seal in the top right-hand corner is that of Christopher Beckett-Denison at whose sale in 1885 the picture was purchased by the National Gallery of Ireland.

Fig. B The reverse of the portrait of *Katherina Knoblauch* by Conrad Faber (Cat. no. 20) showing her coat-of-arms. In the centre is the Knoblauch coat-of-arms, three cloves of garlic on a black ground; and this is also shown top-left and bottom right. The other shields are of the Völcker family (a harp on a red ground) in the upper right corner and the Gelthaus family (three silver hunting horns with gold bands on a red ground) in the lower left. There is an illegible wax seal in the lower left corner.

Conrad Faber (Creuznach c.1500–1552/3 Frankfurt)

(For biography see preceeding catalogue entry).

20 Katherina Knoblauch

Oil on panel, 51 × 36 cm. (19⅞ × 14⅛ ins.)
Inscribed, dated and signed on reverse: *KATHERINA KNOB-LAVCHIN/YRES ALTERS ·XIX·/ ·M·D·XXXII·/ ꙂvC* (in monogram)
(Katherina Knoblauch her age 19. 1532)
EXHIBITED:1885, Royal Academy, London, *Old Masters* no. 174; 1906, Burlington Fine Arts Club, London, *Early German Art* no. 26.
PROVENANCE: Henry Farrer; his sale, Christie's, London, 15-16 June 1866, lot 289, where purchased by the National Gallery of Ireland. Cat. no. 21.
LITERATURE:Von Lersner 1706, Vol. 1, pp. 103, 115, 120; Friedlander 1913, p. 147; Collins Baker 1920, p. 194; Hugelsdorfer 1939, p. 194; Brücker 1965, pp. 171-72; Laver 1969, p. 80, plate 78.

Faber painted pendant portraits of Katherina Knoblauch (1512/13-42) and her husband Friedrich Rohrbach in 1532. His portrait is now in the Art Institute of Chicago (fig. A) and its dimensions are almost identical (50.7 × 35.7 cm., 19⅞ × 14 ins.). Both portraits were in the Farrer Sale when Katherina alone was purchased by

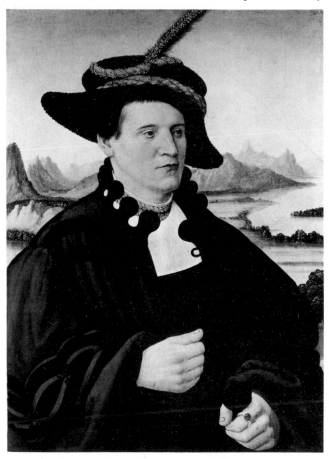

Fig. A *Friedrich Rohrback*, aged 25, by Conrad Faber. Dated 1532 on reverse. He was the husband of Katherina Knoblauch. (Courtesy of the Art Institute of Chicago, Charles H. and Mary Worcester Collection).

Dublin. Although sold at Christie's as by George Pencz, Katherina Knoblauch was entered in the National Gallery of Ireland register as *Portrait of a Lady* by Hans Asper, the Swiss artist. In the 1867 catalogue she was called Margaret Knoblauchin of Zurich (sic.), amended to Katherina in 1890. As with her elder brother Heinrich (cat. no. 19) Faber was only properly identified as the artist in 1928.

The landscape in Katherina's portrait is continued in that of her husband to give a vast panorama of distant mountains below which nestles a substantial town. Faber has made the landscape more convincing by omitting human activities from the middle distance as in Heinrich's portrait and merging the outlines of a far off cathedral and churches into the distant blue. His aerial perspective is a link to the Danube School. In the same year he included the city of Passau at the confluence of the rivers Danube and Inn in his portrait of *Hans Schönitz* (Uffizi, Florence) and it strongly suggests a visit to the area between painting the two Dublin portraits.

Faber shares the contemporary Northern fascination with mountains seen a generation earlier in the lake and mountains precisely observed by Albrecht Dürer (*Self-Portrait*, Prado, Madrid, 1498) or in the fantastic scenery of Joachim Patinir. In the 1530s Albrecht Altdorfer, the leading artist of the Ratisbon School was still active and Wolf Huber, resident in Passau, also delineated such scenery with great exactitude. Faber's portraits in this decade are more assured and even attain a certain grandeur on occasion. The illusion of Katherina's painted dress is enhanced by the extensive use of tooled gold leaf from her elegantly decolleté chemise to the elaborate gilt belt and surfeit of rings on her clasped hands, a typical feature of Faber women. The transition to the landscape works less well with a ledge masquerading as a hedge behind her.

Faber did not maintain this equilibrium in his female portraits. A year later in the comparable pendant portraits of *Johann Reys and Anna Uffstenderin* (New York, Sotheby Park Burnet, 7 June 1978, lot 20) the woman is similarly dressed but is reduced to half-length and posed against a flatter landscape with an oversize repoussoir tree to balance the figure. Both women have large areas left above the head as if for an inscription. Faber's late style is appropriately seen in the 1545 portrait of Katherina's sister Anna (Gemäldegalerie, Berlin-Dahlem). She is similar in composition and wardrobe but her ungainly massiveness reflects German mannerism.

ALH

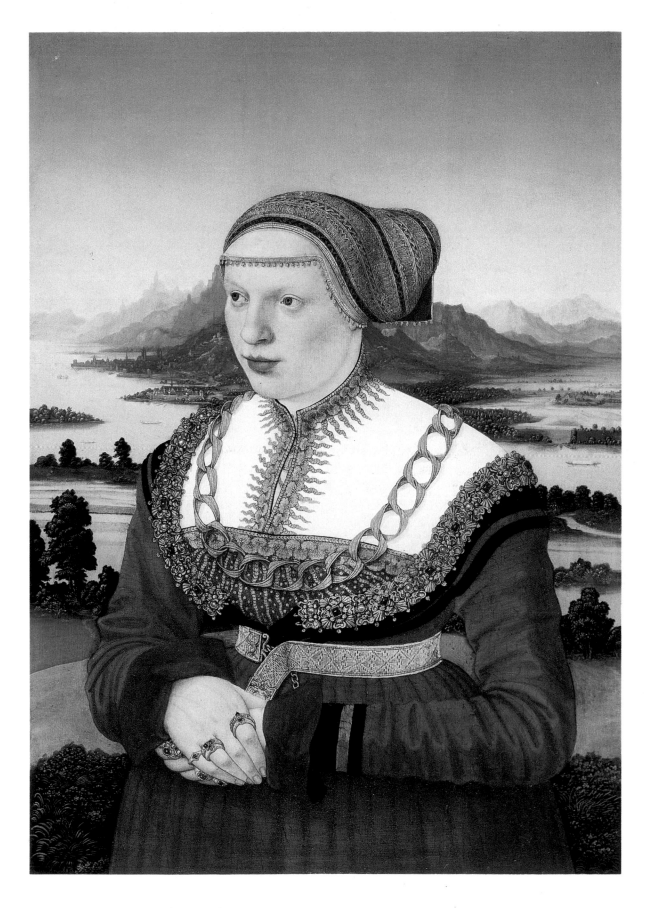

Katherina Knoblauch by Conrad Faber (Cat. no. 20)

Georg Pencz (c. 1500–Leipzig 1550)

Pencz's origins are unknown but he was already a practising artist in 1523 when he registered as a citizen in Nuremberg, where Albrecht Dürer was the leading painter. Pencz may not have been an actual pupil of Dürer's but his influence can be seen in an altarpiece for Cracow Cathedral and as late as 1544 he made a copy of a Dürer St. Jerome (Germanisches Nationalmuseum, Nuremberg). He was also said to have carried out Dürer's designs for the decoration of the Nuremberg Council Chamber (destroyed) in 1521. The impact of the Reformation with its questioning of the established order was generally dampened in Nuremberg and used to engender a sense of civic pride and independence. Unfortunately Pencz with the artist brothers Barthel and Hans Sebald Beham were outspoken critics of the authorities, being followers of the peasant leader Thomas Müntzer. They were summoned before a court on 6 February 1525 and expelled from the city. The Behams settled in Munich and Frankfurt, but Pencz was able to return after ten months. In 1532 he was named the city's Official Painter. He had travelled to Italy by this date, adapting the mythological subject matter of Venetian art for a Germanic audience with a porcelain surface to his nudes and often explanatory tablets (Venus and Amor, Gemäldegalerie, Berlin-Dahlem c.1528). This new subject matter (tried only once by Dürer) was for private erudite patrons and outnumbers Pencz's few religious commissions, such as the surviving Adoration of the Magi *panels (Gemäldegalerie, Dresden, c. 1530) painted with brighter colours in a mannerist style influenced by Albrecht Altdorfer. The Fall of Phaeton ceiling of 1534 (Gartensaal, Hirschvogelhaus, Nuremberg) shows a rare Northern interest in illusionistic painting, inspired by Giulio Romano's work at Mantua. A shared taste for erotic subject matter is seen in Pencz's large output of prints. Pencz almost certainly revisited Italy after 1541 as a Last Judgement drawing (Hermitage, Leningrad) contains figures from Michelangelo's Sistine chapel fresco which had just been completed. In 1550 he was appointed Court Painter to Duke Albrecht I of Königsberg but died en route at Leipzig.*

21 Portrait of a Man aged twenty-eight

Oil on panel, 86.2 × 66.3 cm. (33⅞ × 26 ins.)
Inscribed, signed and dated in the upper right corner: *AETATIS S XXVIII 15 GP (in monogram) 49.*
PROVENANCE: Purchased in Paris by the National Gallery of Ireland, 1864. Cat. no. 1373.
LITERATURE: Gmelin 1966, no. 37, pp. 92-93; Radcliffe 1974, pp. 46-51.

The sitter in this impressive portrait has not been identified. The inscription follows Pencz's usual practice of giving the year (1549) and the man's age (twenty-eight, misread as twenty-seven until recent cleaning). Gmelin (1966) suggested that he is Albrecht Jamnitzer (d. 1555) and Radcliffe (1974) that he is Georg Vischer (born c.1520), both of whom were Nuremberg sculptors, specialising in small bronzes of the type seen here. No portrait of either exists and David Oldfield is probably correct in doubting that this is a sculptor at all as the format of a man holding sculpture or with it in the same room is the preserve of collectors and humanists at this period.

Sculpture is frequently included in portraits by Bronzino *(Portrait of a Young Man with a Lute*, Uffizi, Florence, c. 1530) and his *Portrait of a Young Man with a Statue* (Louvre, Paris, c. 1540) was thought in the past to be the sculptor Bandinelli. Bronzino's work was known to Pencz and he may have also seen Lorenzo Lotto's *Andrea Doni* (Royal Collection, Hampton Court, 1527) when he visited Venice. Doni holds a statuette of *Diana of the Ephesians* and the portrait was already mistaken for one of a sculptor in the 17th century (Shearman 1983, pp. 144-45).

The history of Pencz's picture before its purchase is unknown. The Director of the National Gallery of Ireland, George Mulvany stated in his annual report that he bought pictures in London and Paris from April to June 1864 during a continental tour and his reticence about the vendor suggests a private sale. It was first catalogued in 1867 and described by Mulvany as 'evidently the portrait of a sculptor or silversmith bearing in his left hand a small group in silver, resembling a faun and nymph'. It was dropped from the 1875 catalogue onwards (the first under Henry Doyle's directorship) and spent nearly a century in store, unseen even by visiting scholars. Tentatively attributed to Pencz in the 1964 list catalogue it was been fully given to him since 1971. It is the last known portrait by Pencz and unique in being painted on canvas rather than his usual limewood. Small strips of paint at the top and on the right side were no doubt added when the picture was inserted in its present frame.

Pencz's first dated portraits from the 1530s already

Continued overleaf

Portrait of a Man aged twenty-eight by Georg Pencz (Cat. no. 21)

have a gravity and scale that looks more to Venetian art than the Flemish tradition passed on in Nuremberg from Michael Wolgemut to his pupil Dürer. A rare drawing by Pencz of an unknown man (Staatliches Museum, Schwerin, 1534) anticipates the Dublin picture with a half-length, strongly-lit figure set below an arch in an ill-defined space. There is a similar intensity to the work of Barthel Beham (*Ludwig X of Bayern-Landshut*, Alte Pinakothek, Munich, 1539) or the fashionable Augsburg portraitist Christoph Amberg (*Hieronymus and Felicitas Seiler*, also Munich, 1537-38), but they do not follow Pencz in developing the foil of a background room. Pencz was clearly impressed by Bronzino's work, positioning and lighting his figures in a similar way. Bronzino mastered the three-quarter length interior portrait at an earlier date (for instance *Portrait of a Young Man*, Metropolitan Museum, New York, c. 1535) but evolved flatter more emblematic images to suit his court patrons. The influence of Lotto is seen in the suggestion of compressed energy conveyed by many of Pencz's sitters. Objects such as a *vanitas* skull (*Portrait of a Young Man*, National Gallery of Ireland, Dublin, 1547) or the dividers (for designing coins) held by Jörg Herz the Nuremberg Mint Master (Staatliche Kunsthalle, Karsruhe, 1545) have a precise meaning but often Pencz imitates Lotto in trying to suggest a less definable mood (*A Man aged Seventy*, Museum of Fine Arts, Budapest, 1545). As with Lotto's *Man with a Golden Paw* (Kunsthistorisches Museum, Vienna, c. 1527) the Dublin Man wishes to convey something but the message is no longer clear.

The statuette in Pencz's portrait shows a satyr on the point of embracing a seated nude woman, whose crescent moon identifies her as Diana, the moon goddess. Though generally chaste there is a rare story that she was seduced by Pan after the gift of some wool. It originates in Virgil's *Georgics* (Book III, lines 384-93) but was better known at this date from Boccaccio's *De Genealogia Deorum* (pp. 89-90) published at Basle in 1532 and at Venice in 1547. The wool may be omitted here because of the design of these small sculptures with a more direct relationship between the figures.

The Dublin *Pan and Luna* (Fig. B) statuette derives in type from those by the Paduan sculptor and goldsmith Riccio such as *Satyr and Satyress* (Victoria and Albert Museum,

Fig. A *Abraham and Hagar surprised by Sarah*, a line engraving by Georg Pencz *circa* 1540 (Bartsch no. 6). Probably derived from the oil *Two Lovers on a Couch* by Giulio Romano (Hermitage, Leningrad).

London, 1507/16?). The Antique precursors of both are larger Hellenistic erotic marble groups (*symplegmata*) of which there is a not dis-similar *Pan with a Seated Nymph* (Vatican Museum, Rome). Radcliffe (1974) suggested that Pencz might have given a sketch of this to Georg Vischer to whom he persuasively attributed the Dublin group, noting a similar languorous sensuality and particular handling of details in Vischer's *Inkstand with a Figure of Vanitas* (Staatliche Museen, Berlin-Dahlem, 1547). The same parallels can be drawn with Pencz's prints (Fig. A) and it is not impossible that he devised the piece here himself. An engraving by his friend Hans Sebald Beham dated 1536 of *Adam and Eve* (Bartsch no. 5) also has a similar composition to the Dublin *Pan and Luna*.

ALH

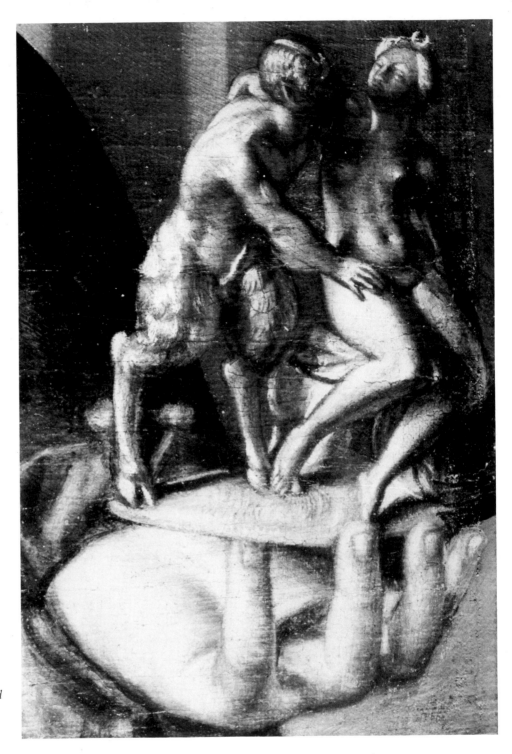

Fig. B Detail from the *Pan and Luna* statuette in *Portrait of a Man aged twenty-eight* by Georg Pencz (Cat. no. 21).

Peter Paul Rubens (Siegen 1577–Antwerp 1640)

Rubens was named a master of the Antwerp guild in 1598 having been a pupil of Verhaecht, Adam van Noort and Otto van Veen. He travelled to Italy in 1600 and was appointed Court Painter to the Duke of Mantua. This position enabled him to study contemporary painting and Antique sculpture in Rome, before returning to Antwerp in 1608. Two altarpieces for Antwerp Cathedral (1610-14) established him as the leading Flemish artist and as Court Painter to the Spanish Governors of the Netherlands, he gained equal renown as diplomat and mediator. An enormous output was made possibly by skilful deputising in his studio and an extensive use of painted modelli. He also collaborated with specialist painters of landscape or still life as on the Dublin Christ in the House of Martha and Mary.

Jan Brueghel the Younger (Antwerp 1601–Antwerp 1678)

Jan Brueghel the Younger was trained in Antwerp by his father Jan 'Velvet' Brueghel who sent him to Italy in 1611, with the son of fellow artist Joos de Momper. Jan Brueghel joined the household of his father's patron, Cardinal Federico Borromeo at Milan, but left this position without permission in order to travel. He was summoned back home after his father's death in 1625, but made a leisurely return to Antwerp via Paris, also visiting Van Dyck in Genoa. In 1626 he married Anna-Maria Janssens, a flower painter of some accomplishment. Five of their sons were artists, with still life painter Abraham the most notable. Jan Brueghel frequently collaborated with other artists such as Hendrik van Balen, Simon Vrancx, Gonzales Cocques and Abraham van Diepenbeek and his own name was only rediscovered in the 19th century.

Peter Paul Rubens with Jan Brueghel the Younger.

22 Christ in the House of Martha and Mary

EXHIBITED: 1910, Parc de Cinquantenaire, Brussels, *L'Art Belge au XVIIe Siècle*, no. 345.

PROVENANCE: Charles Alexandre de Calonne; Calonne Sale, Paris 21-30 April 1788, bought in; Calonne Sale, Skinner and Dyke, London, 26 March 1795, lot 103; Mr Bryan Sale, Coxe, Burrell and Foster, London, 18 May 1798, lot 48; Corneille Louis Reijnders Sale, Nieuwenhuys de Man, Brussels, 6 August 1821; Count Pourtalès Sale, Phillips, London, 20 May 1826, lot 104; John Smith Sale, Stanley London, 2-3 May 1828, to the auctioneer; Hon. G.J. Vernon Sale, Christie's, London, 16 April 1831, lot 34, bt. Woodin; Hugh Andrew Johnstone Munro of Novar Sale, Christie's, London, 1 July 1878, lot 90, bt. Sir Henry Page Turner Barron, by whom bequeathed to the National Gallery of Ireland 1901. Cat. no. 513.

LITERATURE: Buchanan 1824, p. 256; Smith 1830, vol. 2, p. 194; Redford 1888, vol. 1, p. 58; Rooses 1888, pp. 45-46; Hymans 1920, p. 896; Oldenbourg 1921, p. 222; Vaes 1926, p. 213; Glück 1933, p. 356; Müller-Hofstede 1968, pp. 230-31, ill. 19; Hairs 1977, p. 14 and n. 14; Ertz 1979, pp. 492-93; Hairs 1980, p. 227.

The Gospel of St Luke relates (ch. 10, vs. 38-42) that Christ visited the two sisters of Lazarus, Martha and Mary and while Martha busied herself with preparing a meal, Mary sat listening at his feet. At length Martha complained to Christ but he responded that 'Mary hath chosen the best part which shall not be taken from her'. The passage has always been taken as contrasting spiritual and material concerns. It was also seen as justification for both active and comtemplative religious orders and as giving women a wider role than the tireless housewife of the Old Testament (Proverbs 31, vs. 10-31). Mary was traditionally identified with the repentant woman who anointed Christ with oil in Simon's house and with the Mary of Magdalene who

Continued overleaf

Christ in the House of Martha and Mary by Peter Paul Rubens with Jan Brueghel the Younger (Cat. no. 22)

was cured by Christ and was present at the crucifixion and *noli me tangere* after his resurrection. Her tearful repentance is stressed in Counter-Reformation theology where she embodies penance, one of the five sacraments renounced by Luther. Today the Roman church has reverted to the view of the Orthodox church that these three are not the same person.

The theme of Christ visiting the sisters is rare in Medieval art but increasingly popular during the 16th century, with Tintoretto's picture (Alte Pinakothek, Munich) its finest treatment. The scene lends itself to an interior with often a kitchen or even a landscape view behind the main figures, a composition originating in Renaissance pictures of the birth of the Virgin Mary. The kitchen and its contents predominate in the work of Pieter Aertsen (Kunsthistorisches, Museum, Vienna, 1565) and of his nephew Joachim Bueckelaer (Musées Royaux des Beaux-Arts, Brussels, 1565) a format reflected in Spanish *bodegóns* (Velázquez, National Gallery, London, 1618). Jan Brueghel though follows his father Jan 'Velvet' Brueghel (1568-1625) in prefering an exterior setting for his religious and mythological pictures.

Christ in the House of Martha and Mary is first heard of at the 1788 sale of Charles Alexandre de Calonne. This former Prime Minister of France was dismissed from office the previous year and forced to flee to London, when the *Parlement* attempted to try him for malversation. The picture was offered again at the second Calonne sale, described as a 'capital performance' and 'invaluable' (1824). Smith's substantial provenance (1830) must be due to having recently owned it himself. He is still listed as owner in his index. At this date the picture was described as by Rubens and Brueghel (ie., Jan 'Velvet' Brueghel) but Smith adds the name of Jan van Kessel (1626-79) to whom the 1831 Vernon Sale catalogue attributes the fruit, flowers and birds, in spite of his working after 'Velvet' Brueghel's death. The picture subsequently belonged to the great Turner collector Munro of Novar. When it was acquired by Dublin, Director Sir Walter Armstrong noted in the manuscript noted in the manuscript catalogue that the architecture appeared to be by Dirk van Delen (1605-71). His name was not however added to the triumvirate of artists, which were retained until correspondence with Michael Jaffé in 1973 who described it as 'manifestly the work of Rubens and Jan Brueghel I'. Except for Glück (1933) who believed the picture to be by Brueghel and Joost van Egmont (1601-14), writers have agreed that the figurework was by Rubens, painted about 1620. A new

suggestion for his collaborator was proposed by Müller-Hofstede (1968) and further developed by Ertz (1979). They suggested the picture was by Jan Brueghel the Younger, son of 'Velvet' Brueghel and an accomplished imitator of his father. Ertz also republished the fragmentary work journal of Jan Brueghel the Younger (little known though published by Vaes in 1913).

On 3 February 1628 Brueghel recorded 'een groot stuc, Christus, Martha en Magdalena, vol wercx, de figurenkens van S. Rubens'. Ertz felt that in spite of being termed a large picture, Brueghel was indeed describing the Dublin one. Hairs had twice alluded to the journal entry (1977, 1980) but has not associated it with the Dublin picture. In his journal Brueghel noted other pictures of the same subject painted with Hendrik van Balen (1628), ? Peer de Lierner (1630-31, named as the recipient but known to have collaborated with Brueghel as a figure painter) and Gonsal (no date). None of these further pictures has been located. A painting given to the Antwerp School of the 17th century now in Bergamo (Accademia Carrara, 58 × 86 cm., $22\frac{7}{8}$ × $32\frac{7}{8}$ ins.) places Rubens' figures in a new setting but neither the landscape nor still-life detail are by Brueghel and the figures are not in van Balen's very recognisable style. A second picture (Private collection, West Germany) is a weaker reworking of the figures, now placed indoors. 'Velvet' Brueghel may have painted a *Christ in the House of Martha and Mary,* recorded at an 1868 sale (Pigler 1974, vol. 1, p. 326) but it was probably mis-attributed if Gonzales Coques (1614-84) really painted the figures as stated. A parallel development to the Dublin picture can be seen in a painting by Frans Francken II (1581-1642), (Härting 1983, cat. no. A93, plate 65, art trade, New York, dated about 1620) who collaborated on occasion with 'Velvet' Brueghel. There the space is less clearly defined with a kitchen seen behind Martha, a fireplace behind Christ and Mary (with a symbolic Sacrifice of Isaac picture over it) and the balustrade of the terrace the main figures appear to be on, seen to the right. The Dublin picture is more fluent in its composition, the sweeping gestures of the figures accentuated by the avenues of trees. Mary is also a more active participant.

Jan Brueghel the Younger incorporates several elements from his father's pictures, for instance the 17th century Château of Mariemont in the landscape. The clutter of dead birds and profusion of still life and animals reflects a shared dislike of empty space. His father composed fruit still lifes in an identical wicker basket to that seen here. The fine hound beside Martha with a turned head is another borrowed motif (as in *Travellers on a Country Road, with Cattle and Pigs,* Apsley House London, 1616, or *Dog Studies,* Kunsthistorisches Museum, Vienna, c. 1616). Jan Brueghel the Younger tends to simplify detail

to enhance the richness of his colours as with the blurred table carpet pattern or the freely painted tree foliage. An interest in architecture is evidenced by the chapel seen beyond Martha and the door behind Mary, more befitting an interior. The ape attached to a ball and chain at the centre of the picture reflects underlying symbolism in the picture. This is a familiar image of Satan (Janson 1952, pp. 245ff.) also of man's bond to the animal or material world, so very appropriate to the scene.

The peaches between its paws are symbolic of man's salvation to come and also of the virtue of silence. Given Brueghel's delight in decorative detail it would be unwise to further read the birds as images of the soul or the grapes as symbolic of Christ's blood and the communion wine. In contrast the peacock being prepared in the inner room (not a kitchen) is an established symbol of immortality, its flesh said never to decay. It echoes the contrast between the Martha and Mary in being also symbolic of pride and love of display. As a culinary delicacy it was highly praised in the classical world, and was served garnished with full plumage at medieval state banquets, tasting like turkey if properly fed. Christ's x-frame chair is of a type associated from the middle ages with rulers and popes, while the lion paw foot of Mary's seat may be a reference to Baroque imagery of a woman mounted on a lion to personify the church.

ALH

Jan Siberechts (Antwerp 1627–circa 1703 London)

Siberechts was born in Antwerp, the son of sculptor, Jan Siberechts. It is not known who trained him, but in the year 1648/49 he became a master in the Antwerp guild. Choosing to become a landscape painter he escaped the influence of Jacob Jordaens, then the dominant artistic personality in Antwerp. Cornelis de Bie, an Antwerp lawyer and collector, noted Siberechts' adeptness at borrowing the figures of Berchem and du Jardin in his 1662 notes on Flemish artists (p. 373). Fokker (op. cit.) has proposed a visit to Italy about 1650, noting the strong imprint in early pictures of Nicholas Berchem and Jan Both (both active from the 1640s), also Karel du Jardin and Adam Pynacker. Of the few that survive, the 1651 Italian Landscape *(Bode Museum, East Berlin), with its weakly drawn figures and generalised sense of place, suggests that he was learning in Antwerp at second-hand, barely influenced by the innovations of Claude in Rome. Le Château (Antwerp, Musée des Beaux-Arts) shows his new interest in the daily activities of farmers. Siberechts' style changes after 1672, when according to George Vertue (Vertue 1762-63, vol. 3, p. 188), the 2nd Duke of Buckingham persuaded him to come to England. Vertue in fact states that this took place during the Duke's Embassy to Paris in 1670, but since Siberechts is recorded in Antwerp in March 1672, with the Duke visiting there on another Embassy in July, it may well have happened then. In England, Siberechts became a topographical artist, unrivalled in his combination of detail with delicate lighting. For the most part he painted Country houses, although* The Coach and Six *(Squerryes Court, 1674) is an attempt to adapt his Flemish pictures to England. The* View of Longleat *(Government Picture collection, 1676 on loan to Tate Gallery) is what his patrons preferred. Here Siberechts reveals an acute eye for describing the material possessions of the nobility. Fields, trees and shrubs are recorded with exactitude, the whole seen from an exaggerated aerial perspective.* Hunters Near Longleat *(Private collection, 1684) is a reminder that he could still paint nature and animals with sensitivity; a few surviving watercolours (examples in the British Museum) anticipate English work of the 18th century. Siberechts' last dated picture is from 1696, but his exact date of death is not known. He does not seem to have had pupils and had been forgotten when landscape painting was revived by Gavin Lambert and John Wootton.*

23 The Farm Cart

Oil on canvas, 73.5 × 86 cm. (28½ × 33⅝ ins.)
Signed on the shaft of the cart: *J. Siberechts. en. Amvers 1671.*
EXHIBITED: 1930, Musée Royal des Beaux-Arts, Antwerp, *Exposition Internationale, Coloniale, Maritime et d'Art Flamand Ancien;* 1939, Pavilion no. 1, Liège, *Grand Saison Internationale de l'Eau,* no. 900.
PROVENANCE: Comtesse de Rouzat (Fokker); Christie's, London, 22 December 1927, where purchased by Captain Robert Langton Douglas, from whom purchased by the National Gallery of Ireland 1928. Cat. no. 900.
LITERATURE: Fokker 1931, pp. 92-93.

The Farm Cart is a fine example of Siberechts' Antwerp period, painted the year before he left for England. He frequently used this setting of a flooded road with farmers and livestock returning from market. Fokker (1931) titled the picture *Le Cheval Lachant son Eau (The Horse Relieving itself)* after the central incident. It was exhibited as *Un Gué (a Ford)* in 1939. A close variant was in the Wigger collection (Fokker p. 93) and another at Christie's in 1976 (2 July, lot 74). The boy and horse were repeated in another picture seen by Fokker (pp. 89-90) in the Brussels sales rooms (Chasles sale, Fiévez, 16 December 1929). The cart equally reoccurs, being loaded with produce at *La Ferme de Maraichers* (Musées Royaux des Beaux-Arts, Brussels, 1664) or with a different boy and more aged peasant woman in *A Cowherd Passing a Horse and Cart in a Stream* (National Gallery, London, 1658?). This motif of a laden cart turning a bend on a flooded road is strikingly close to the farm cart in Rubens' *An Autumn Landscape with a View of Het Steen* (National Gallery, London, 1636?), even to the frieze of trees behind it and the water it traverses. Siberechts however depicts an enclosed unhurried world, far from the busy, expansive view of country life on Rubens' estate. Although large, the figures have simplified expressions and do not invite curiosity or sympathy. The peasant woman is typically rather placid, the charming boy insecurely placed on his horse, but there is a compelling precision of detail in the market produce, foliage and effects of movement on the water. The whole is painted in vivid tones of blue, grey and green.

ALH

The Farm Cart by Jan Siberechts (Cat. no. 23)

Rembrandt van Rijn (Leiden 1606–1669 Amsterdam)

Rembrandt, the son of a miller, was born in Leiden where he was brought up and where, according to one biographer, he briefly attended the University. His first teacher was the Leiden artist Jacob van Swanenburgh with whom he studied for three years and then, about 1624, he went to study with Pieter Lastman in Amsterdam for a period of six months. According to Houbraken Rembrandt also studied with Jacob Pynas in Amsterdam before returning to Leiden about 1625 where he possibly shared a studio with Jan Lievens. At this time he took as his pupil Gerard Dou and Willem de Poorter may also have studied with him during these years. He gained a reputation as a history and portrait painter and about 1631/32 moved to Amsterdam where he remained for the rest of his life. In his first year in Amsterdam he painted the Anatomy Lesson of Dr Tulp *a group portrait of the Guild of Surgeons in Amsterdam; and the success of this work brought him many commissions. In 1634 he married Saskia van Uylenburgh the daughter of a wealthy and prominent Frisian family, and from that date until her death in 1642, the same year as he painted* The Night Watch, *success followed on success. During these years he had several pupils including Gerbrandt van den Eeckhout (q.v.). From about 1642, however, Rembrandt's business declined and he was declared bankrupt in 1656. From the late 1640s he lived with Hendrickje Stoeffels and on his bankruptcy, she and his son Titus formed a partnership to employ him in order to protect him from further financial losses.*

From as early as 1629 until his death in 1669 Rembrandt painted portraits of himself and this extensive series of self-portraits record the artist in every mood. Apart from portraits he also painted religious subjects, landscapes, history subjects and indeed, unlike most of his contemporaries was proficient in all genres. He was also gifted as a draughtsman and an etcher.

24 Landscape with the Rest on the Flight into Egypt

Oil on panel, 34 × 48 cm. (13⅞ × 18¾ ins.)
Signed and dated, bottom left: *Rembrandt f. 1647*
EXHIBITED: 1870, Royal Academy, London, *Old Masters* no. 29; 1894, Royal Academy, London, *Old Masters* no. 91; 1899, Royal Academy, London, *Rembrandt* no. 51; 1929, Royal Academy, London, *Dutch Art 1450-1900* no. 140; 1932, Rijksmuseum, Amsterdam, *Rembrandt* no. 22; 1956, Rijksmuseum, Amsterdam, Museum Boymans, Rotterdam, *Rembrandt* no. 57; 1969, Rijksmuseum, Amsterdam, *Rembrandt* no. 8.
PROVENANCE: Henry Hoare, Esq., Stourhead, Wiltshire by 1752; thence by descent; Stourhead Heirlooms sale, Christie's, London, 2 June 1883 lot 68 where purchased by the National Gallery of Ireland. Cat. no. 215.
LITERATURE: Walpole 1762, p. 42; Smith 1836, vol. 7, no. 603; Waagen 1854, vol. 3, p. 172; Dutuit 1883/85 no. 55, p. 45; Bode 1883, no. 261, p. 592; Wurzbach 1886, no. 197; Michel 1893, pp. 366 & 555; Bode/Hofstede de Groot 1897/1905, no. 342; Valentiner 1909, p. 290; Hofstede de Groot 1916, vol. 6, no. 88; Bredius 1935, no. 576; Bauch 1966, no. 80; Gerson 1968, no. 220, p. 324; Arpino/Lecaldano 1969, no. 278; Bredius 1969, no. 576, p. 609. (Note: *as the painting is included in almost all the literature on the artist, the bibliography is very extensive. An attempt is made here to list as completely as possible the major monographs up to Bredius (1935): thereafter the literature cited is selective.*
ENGRAVED: by J. Wood in 1752 and reissued by Boydell in 1779: a 1752 impression is in the National Gallery of Ireland, cat. no. 11,427; also, according to Waagen engraved by P-C Canot (c.1710-77) a French engraver who worked in England; anonymous engraving published in *Gems of Ancient Art. . . .* (London, 1827).

The painting, which is untitled in Wood's engraving of 1752, was called *A Nightpiece* by Horace Walpole in 1762 (Walpole 1762, p. 42). It was called *Two gypsies by moonlight* by Waagen (1854) and described by Smith (1836) as 'a company of travellers at the base of a hill'. It was apparently Bode (1883) who first referred to it as *The Rest on the Flight into Egypt* and all authorities have called it that since his time.

It was also Bode (1883) who first drew attention to the fact that the composition is derived from Elsheimer's *Rest on the Flight into Egypt* painted in 1609 (Alte Pinakothek, Munich) where the scene is also shown taking place at night. Elsheimer's picture was engraved by Hendrick Goudt in 1613 (Fig. B) and all authorities are agreed that Rembrandt must have known the engraving if not the original picture itself. Elsheimer shows a group of figures illuminated by a blazing fire among trees and uses the detail of a kneeling boy tending the fire that was also used by Rembrandt. The fire is reflected in a pool and a dark mass of trees, forming a diagonal across the picture as in the Dublin Rembrandt, is silhouetted by moonlight. *The Rest on the Flight into Egypt* is not the only instance of Rembrandt's interest in Elsheimer: a version of the latter's *Tobias and the Angel* (National Gallery, London) was also engraved by Goudt, and this engraving formed the basis of an etching by Hercules Seghers. Using Segher's actual copper plate, Rembrandt reworked it by substituting

Continued overleaf

Landscape with the Rest on the Flight into Egypt by Rembrandt (Cat. no. 24)

figures for a flight into Egypt in place of Tobias and the Angel.

Rembrandt painted the subject of *The Flight into Egypt* on at least two other occasions (Bredius 1969, nos 532A & 552A), but his treatment of the theme in both of those pictures has little relevance to our painting. He also made etchings of the subject, and one of those (Fig. A), dating from 1645 (Bartsch 58) shows the Holy Family grouped in a composition somewhat similar to the Dublin painting. Although he painted several dark storm landscapes, there is no obvious comparison between any of these and *The Rest on the Flight into Egypt*. Gerson (Bredius 1969, p. 609) suggests that some of the background details recall the vigorously painted trees in *A Landscape* in the Louvre (Bredius 1969, no. 450); but as far as the painting may be compared with any other in Rembrandt's *oeuvre* it is perhaps most appropriate to consider it in the context of his small interior scenes.

The engraving of the painting made by Wood in 1752 (Fig. C) shows clearly many details which are difficult to decipher on account of the dark tonality. A herd is visible on the left (of the engraving) leading his cattle; and the water is seen to stretch fully along the foreground. It has been remarked (Yale 1983, p. 55) that the print was published at a time when English taste in landscape was almost entirely concentrated on Italian pictures; and indeed it is only in the print that one notices fully how Italianate such a detail as the Claudian building on the hilltop is, or, for that matter, how much the composition as a whole owes to Italian sources. In this respect it is worth recalling that Rembrandt may have studied in his early years in Amsterdam with Jacob Pynas, an artist who had worked in Rome at the beginning of the century.

HP

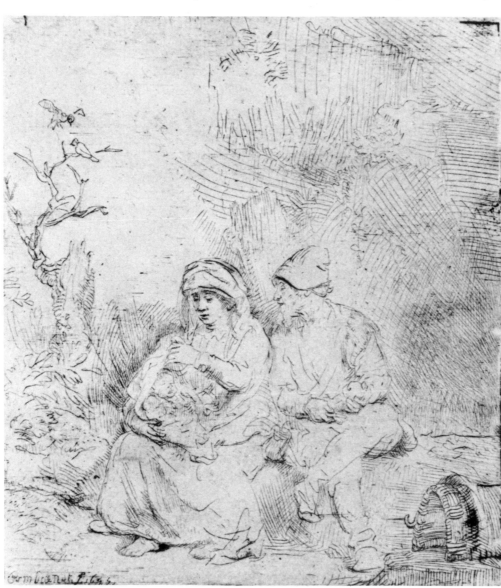

Fig. A *The Rest on the Flight into Egypt.* Etching by Rembrandt signed and dated 1645.

Fig. B *The Rest on the Flight into Egypt.* Engraving by Hendrick Goudt dated 1613 after the painting by Adam Elsheimer dated 1609 now in the Alte Pinakothek, Munich.

Fig. C *The Rest on the Flight into Egypt.* Engraving by J. Wood after Rembrandt's original painting then in the collection of Henry Hoare. Dated October 1752.

School of Rembrandt c.1630

25 Interior with figures

Oil on panel, 21 × 27 cm. (8¼ × 10½ ins.)
PROVENANCE: Horace Buttery, London from whom purchased by the National Gallery of Ireland, 1896. Cat. no. 439.
LITERATURE: Collins Baker 1926, p. 42; Benesch 1940, p. 2; Potterton 1982, p. 105; Brown 1984, pp. 205 & 211.

The subject was identified by Walter Armstrong in 1904 (Dublin 1904) as *Playing La Main Chaude.* Since that time the picture has always been so called at Dublin and recently published by Brown (1984, pp. 205 & 211) as such. That game is played by placing one's head in the lap of a seated woman and one's hand behind one's back. The object of the game is to guess which of the other players has touched one's hand and at the same time smacked one's bottom. Although so patently foolish, the game was very popular in seventeenth century Holland and was depicted by a number of painters, including Cornelis de Man in a painting in the National Gallery, London. Little in the Dublin painting would suggest that the figures are playing *La Main Chaude.* The solemnity of their expressions, in spite of the music from the violinist on the stairs at the right, would indicate fairly strongly that they are not playing a game at all; and indeed one is at a loss to propose any parlour-game that is played exclusively by adult males.

The painting was purchased by the National Gallery of Ireland in 1896 as Willem de Poorter and catalogued by Armstrong in 1898 as 'Ascribed to de Poorter' (Dublin 1898). In a later catalogue (Dublin 1904) he retained the attribution to de Poorter but described the painting as 'greatly superior to the average work of de Poorter'. In 1914 he catalogued it as 'Rembrandt' (Dublin 1914) and more recently it has been referred to in Dublin as 'School of Rembrandt'. The picture was published by Collins Baker in 1926 as Gerard Dou (Collins Baker 1926, p. 42) and by Benesch in 1940 as Rembrandt (Benesch 1940, p. 2). It was ascribed to Gerard Dou by Potterton (1982, p. 106) and called 'Leiden School' by Brown (1984 p. 205). In attributing the painting to Rembrandt, Benesch (1940) compared it in style and manner to that painter's *The Foot Operation* (Bredius 1969, no. 422); but the attribution of that painting to Rembrandt has been disputed and it has been proposed as Lievens (Reznicek 1964, no. 61). Benesch also drew attention to the similarity of the background in the Dublin painting to that in Dou's *Rembrandt in his studio* (Martin 1913, p. 57) which also has a column on the right and an oval portrait on the background wall. Benesch compared the composition of the group of figures on the left with a similar group in a drawing in the Musée Bonnat, Bayonne which he attributed to Rembrandt. A comparison might also be made with

Fig. A X-ray photograph of *Interior with figures* (Cat. no. 25). The photograph shows the portrait head of a man which is painted underneath the composition.

Rembrandt's *The Risen Christ at Emmaus* (Bredius 1969, no. 539) of about 1628-29 which shows Christ seated in profile and silhouetted dramatically against a background wall in a manner very similar to the figure on the left in our painting. Otto Naumann, who has examined a photograph of our painting, has compared it with Rembrandt's *Artist in his studio* in Boston (Bredius 1969, no. 419) and has written (1983) that the Dublin painting has 'a chance as a Rembrandt'. Seymour Slive, again on the basis of a photograph, has related the painting to *Christ washing the feet of his disciples* in Chicago which carries a disputed attribution to Lievens (Schneider 1973, p. 356); and in a letter in 1983 he has tentatively proposed early Lievens as a possible attribution for our painting.

Radiographs of the Dublin painting (Fig. A) show that it was painted over an earlier composition: a portrait head of a man wearing a headdress. That picture was an upright composition, the top of which is the left-hand side of the painting in its present state. The portrait is somewhat similar in style to Rembrandt's self-portraits of the late 1620's and early 1630's.

The painting is here catalogued as Rembrandt School meaning that it was painted in Leiden by an artist very closely associated with Rembrandt and probably painted about 1630.

HP

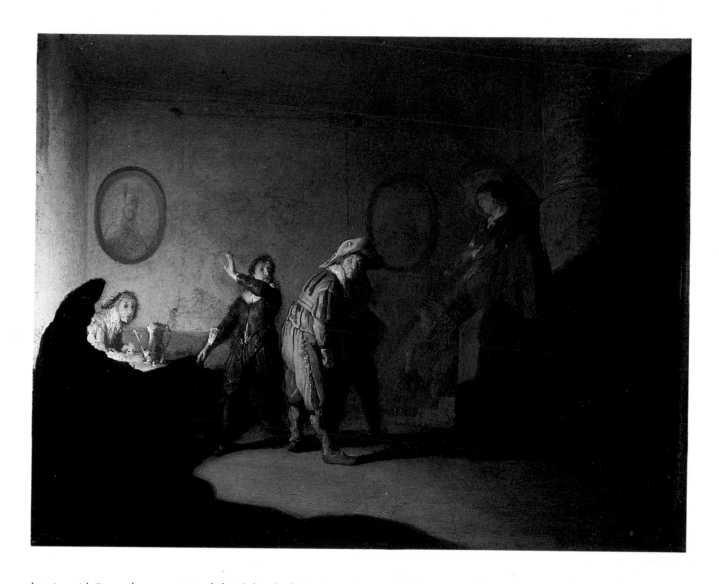

Interior with figures by an artist of the School of Rembrandt, c.1630 (Cat. no. 25)

Gerbrandt van den Eeckhout (Amsterdam 1621–1674 Amsterdam)

van den Eeckhout was born in Amsterdam on 16 August 1621 the son of a goldsmith, Jan Pietersz. van den Eeckhout. According to Houbraken he was Rembrandt's best-loved pupil and also a great friend of Rembrandt. It is not known when exactly he was apprenticed to Rembrandt but it is thought to have been from about 1635. His earliest dated work is of 1641, a Moses and Aaron *the present whereabouts of which is unknown. He was primarily a history-painter but also painted portraits and genre scenes. His style was greatly influenced by that of his master and also by that of Rembrandt's own teacher, Pieter Lastman. There are some one hundred and fifty known paintings by him as well as numerous drawings.*

26 Christ at the Synagogue in Nazareth

Oil on canvas, 61 × 79 cm. (24⅛ × 31 ins.)
Signed and dated on the pavement, bottom right: *G. V Eeckhout. Fe. A° 1658*
EXHIBITED: 1884, Royal Academy, London, *Old Masters* no. 65.
PROVENANCE: S. Herman de Zoete, 1884; his sale, Christie's, London, 9 May 1885 lot 223 where purchased by the National Gallery of Ireland. Cat. no. 253.
LITERATURE: Roy 1972, no. 58, p. 219; Nystad 1975, p. 147; Potterton 1982, p. 104; Sumowski 1983, vol. 2, no. 428, pp. 733 & 791.

The picture has always been catalogued in Dublin as *Christ in the Temple* or *Christ preaching in the Temple* and was called by Roy (1972) *Christ and the Scribes.* Its true subject was identified by Nystad (1975) as *Christ preaching at the Synagogue in Nazareth* (Luke, ch.4, vs.16-21). In referring to drawings and etchings by Rembrandt, Nystad has explained the composition of the picture as representing the *sjoel* or study-room which was at the entrance to a synagogue, but built at a lower level to the entrance. The bench to the right of Christ is typical furnishing for a *sjoel* and was used to separate the room from the entrance to the synagogue. The entrance to the synagogue is in the background, left.

The composition of the painting, particularly with regard to the placing of Christ is related in a general way to Rembrandt's etching of *Christ Preaching (La Petite Tombe)* of about 1652, (Bartsch no. 72) and also to Rembrandt's *Hundred Guilder Print* (Bartsch no. 74) of about 1639-49. A closer comparison for the left-hand side of the painting is with Rembrandt's etched *Tribute Money* (Bartsch no. 68) of about 1635 which includes in the background a loggia with figures and other figures poring over a book. Within van den Eeckhout's own *oeuvre* the composition comes closest to *Christ among the Doctors* of 1662 in Munich, and an undated *Presentation in the Temple* in Dresden.

Although always given to van den Eeckhout, the attribution was only fully confirmed in 1981 when overpainting of the signature and date was removed.

HP

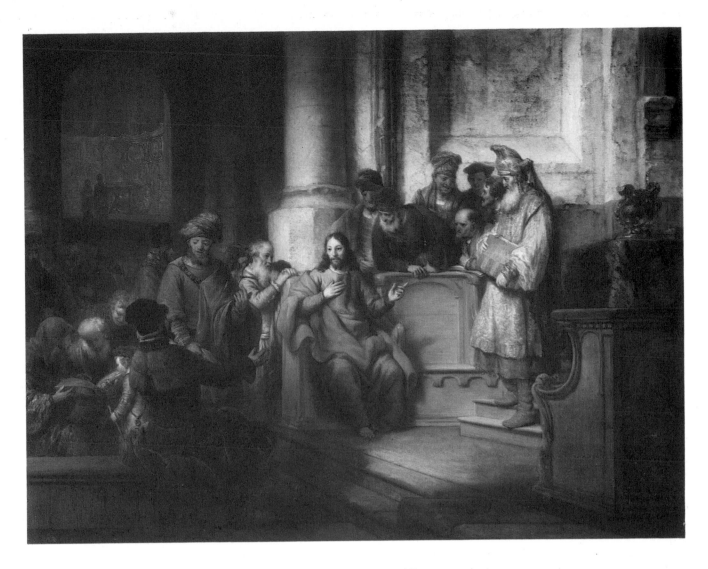

Christ at the Synagogue in Nazareth by Gerbrandt van den Eeckhout (Cat. no. 26)

Salomon van Ruysdael (Naarden 1600/03–1670 Haarlem)

Ruysdael was born, Salomon de Gooyer, in Naarden (Gooiland) sometime between 1600 and 1603 and enrolled in the Guild of St. Luke in Haarlem under that name in 1623. By 1628 he was already known as Ruysdael (or Ruijsdael or Ruyesdael) and in that year was praised as a landscape painter by Samuel Amzing in his Beschryvinge ende lof der stad Haerlem. *He served the Guild of St. Luke as overseer in 1647 and 1669 and as dean in 1648. It is not certain who was his teacher but he was influenced in his early years by Esias van de Velde who was working in Haarlem between 1610 and 1618. Until the mid 1640's his development paralleled that of Jan van Goyen and he achieved effect in his painting by the use of tone. His later paintings are more dramatic with sharper contrasts of light and dark and greater variety of colour. His son Jacob Salomonsz. van Ruysdael was also a painter and he was the uncle of Jacob van Ruisdael.*

27 The Halt

Oil on canvas, 135 × 100 cm. (53⅛ × 39⅜ ins.)
Signed and dated on the back of the carriage on the right: *SVR* (in monogram) *1661*
EXHIBITED: 1952-53, Royal Academy, London, *Dutch Art* no. 282.
PROVENANCE: Prince Demidoff sale, San Donato, Florence, 15 March 1880 lot 1123; Charles William Harrison Pickering sale, Christie's, London, 11 June 1881 lot 158, bt. Sir Henry Page Turner Barron by whom bequeathed to the National Gallery of Ireland, 1901. Cat. no. 507.
LITERATURE: Stechow 1975, no. 164, p. 93.

The composition is of a type, a halt of carriages before an inn, which Ruysdael made his own; so much so that Stechow (1975), in categorising the paintings of the artist, uses the type as a specific category and lists thereunder over thirty paintings. The earliest of these (Stechow 1975 no. 145, present whereabouts un-known) is dated 1635 and Ruysdael continued with the subject until the 1660's. The inn in the Dublin painting is depicted with minor variation of details in several paintings including one in the Norton Simon Museum, Pasadena which is dated 1643 (Stechow 1975, no. 147) and two paintings in the Rijksmuseum, Amsterdam dated 1655 and 1660 (Stechow 1975, nos. 155 & 158). In the case of the 1660 painting, which is considerably smaller than the Dublin picture, the landscape and other details are also similar.

The Dublin picture is one of the largest and finest of all Ruysdael's paintings of this subject. The date, which is clearly 1661, has always been misread as 1667: a date that would make the picture uncomfortably late in his career. The correct date of 1661 means that our picture is a year later than the Rijksmuseum painting with which it compares so aptly.

HP

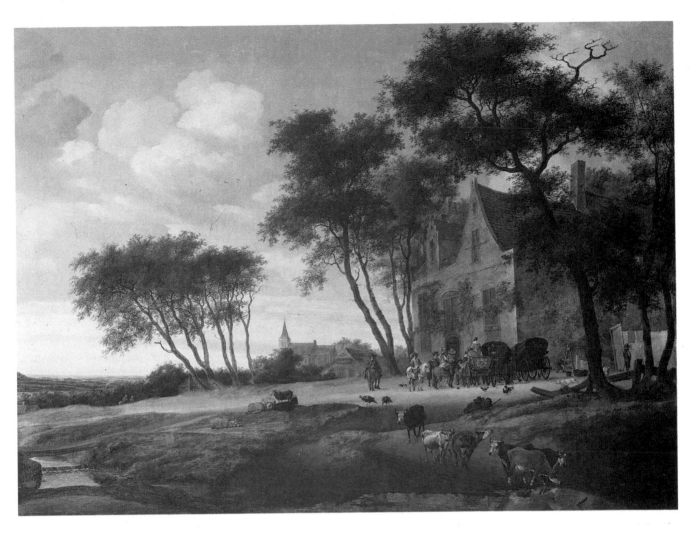

The Halt by Salomon van Ruysdael (Cat. no. 27)

Frans Post (Haarlem 1612–1680 Haarlem 1680))

Post was the son of the Leiden glass-painter Jan Jansz. Post and younger brother of the architect and painter, Pieter Post, who was probably also his teacher. In 1636, when the West Indies Company appointed Count Johan Maurits van Nassau-Siegen Governor-General of Brazil, he took with him a personal suite of painters, naturalists and cartographers including the young Frans Post; and Post stayed in Brazil until Johan Maurits himself returned to Holland in 1644. On his return Post settled in Haarlem and became a member of the Guild of St. Luke there in 1646. Only six paintings, later presented to Louis XIV of France, and one drawing survive from Post's work executed in Brazil; but nevertheless, throughout his life, he continued to paint only Brazilian scenes.

Post's distinctive use of colour, with vivid blues and greens, reflects early Dutch and Flemish painting; and his exotic subject matter gives his pictures an appearance of naivety. Although the composition of his later paintings reflect contemporary developments in Dutch landscape painting, Post's overall style was unique in seventeenth century Holland.

28 A Brazilian Landscape

Oil on panel, 48 × 62 cm. (19 × 24¾ ins.)
Signed, bottom right: *F. Post*
EXHIBITED: 1952-53, Royal Academy, London, *Dutch Painting* no. 337.
PROVENANCE: Robert Langton Douglas, by whom presented to the National Gallery of Ireland, 1923. Cat. no. 847.
LITERATURE: De Sousa-Leão 1948, no. 82; Guimarães 1957, no. 175; Larsen 1962, no. 96; De Sousa-Leão 1973, no. 72.

As the picture was probably painted some twenty years after Post returned to Haarlem from Brazil, the view is not real but uses elements of landscape and buildings typical of the Brazilian countryside. The wide well-watered terrain was especially suited to the cultivation of sugar cane and is similar to that shown in many of Post's paintings of both real and imaginary views. Dotted through the landscape on the far side of the river are several sugar plantations; and part of one is shown in detail on the right. On the extreme right is the furnace house where negroes are shown fuelling the wood-fired boilers. To the left of the furnace is the drying platform with other negroes laying out the cane, which is being brought to them in a chest. The oxen-cart in the foreground would have been used for transporting the sugar chests. The building on the left is similar to chapel buildings in many of Post's paintings; but as there is no cross this is not likely. Nor is it likely to be the plantation master's house as in a plantation that was usually built at some short distance away from the main plantation buildings. The man and woman walking towards the river are probably intended as the master and his wife. On the extreme left is a papaya tree, next to it a macaúba palm, then a coco palm, with towards the centre other palms and trees. In the foreground vegetation are a crocodile, armadillos, anteaters, a monkey, a snake, herons and other animals and birds.

The composition of our painting is of a type categorised by Stechow (1966) as 'one wing panorama'. It is of a format used by Post throughout his career; but the one wing in his later landscapes is more densely foliated and its inhabitants are generally more exotic and more numerous than in his earlier landscapes. In his later paintings Post also stratifies the colour more intensely into green, green-blue and blue zones. The Dublin painting may be dated to the first half of the 1660's on stylistic grounds and compared with, for example, the *Landscape with a Church* in Detroit which is dated 1665 (De Sousa-Leão 1973, no. 48).

HP

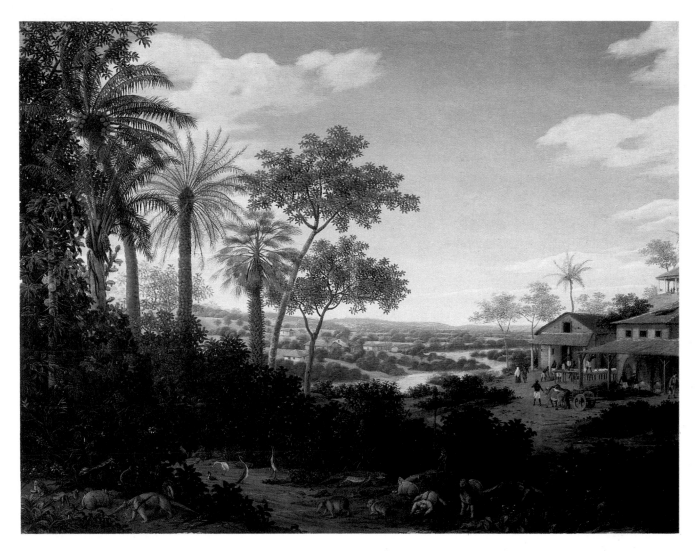

A Brazilian Landscape by Frans Post (Cat. no. 28)

Anthonie De Lorme (Doornik c.1605–1673 Rotterdam)

De Lorme's date of birth is unknown and he is first recorded in Rotterdam in 1627 when he acted as a witness for his teacher, Jan van Vucht. He married in Rotterdam in 1647 and died there in 1673. His earliest known picture dates from 1639 and depicts a church interior that is derived from, although not identical with, the St. Laurenskerk in Rotterdam. Throughout the 1640's he painted only imaginary church interiors and in these he was influenced by the work of his teacher van Vucht and also by Bartholomeus van Bassen. About 1652 De Lorme painted his first real view of the interior of the St. Laurenskerk and, thereafter, his oeuvre consists almost entirely of paintings of that church. While he was influenced by the Delft painters of church interiors, Gerard Houckgeest and Hendrick van Vliet, the example of Saenredam was of paramount importance to him throughout his life.

29 Interior of the St. Laurenskerk, Rotterdam

Oil on canvas, 87 × 74 cm. (34⅜ × 29 ins.)

EXHIBITED: 1895, Guildhall Art Gallery, London, *Loan Collection of Pictures* no. 117.

PROVENANCE: Lord Northwick, Thirlestane House by 1846; Thirlestane House sale (Phillips') 26-30 July 1859 lot 241 bt. Agnew; E. A. Leatham, Misarden Park, Cirencester, 1895; Anon sale, Christie's, London, 20 June 1903 lot 155 bt. Patterson; W. B. Patterson, London from whom purchased, by the National Gallery of Ireland, 1903. Cat. no. 558.

LITERATURE: Thirlestane Cat. 1846, no. 478; Waagen 1854, vol. 3, p. 209.

The painting was described by Waagen (1854) as 'Delorme, *Interior of a church*; of a transparancy and effect approaching de Witt *(sic)*. The figures by Lingelbach are very skilful'; and exhibited in 1895 as the *Porch of Antwerp Cathedral*, painted by J. Lingelbach with figures by Adrian van de Velde. It has always been catalogued at Dublin, correctly, as the *Interior of the St. Laurenskerk (Grote Kerk) Rotterdam* bv De Lorme. The view is looking east along the southern ambulatory; the choir is on the left. The church is a Gothic building dating from 1409-1525. It was badly bombed in the Second World War and, although now restored, none of the memorials visible in the Dublin painting are still in existence.

De Lorme painted many views of the interior of the St. Laurenskerk of which thirteen are listed by Jantzen (1979, p. 226-27). The French nobleman, Balthasar de Monconys who travelled in Holland in the 1660's wrote of De Lorme in 1663, '(Il) ne fait que l'Eglise de Rotterdam en diverses veues, mais il les fait bien'

(Liedtke 1982, p. 69). Liedtke (1982, p. 69 ff.) has drawn attention to the fact that De Lorme, having previously painted imaginary church interiors, only turned to painting real views about 1652 and used as his subject matter his local church. In this development he was influenced by contemporary architectural painting in nearby Delft, notably the work of Gerard Houckgeest and Hendrick van Vliet, although neither of these painters actually painted in Rotterdam. Throughout his career De Lorme also seems to have been aware of the work of Saenredam and it is the latter's influence, rather than that of the Delft painters, that is most apparent in the present picture.

It is generally recognised that many paintings of church interiors in seventeenth century Holland have *vanitas* overtones. The chronicler Dirck van Bleyswyck, writing in Delft in 1667, urged his readers to visit tombs every day to contemplate death and the vanities of life (Wheelock 1975/76, p. 181); and the visitors to the St. Laurenskerk in De Lorme's painting are doing just that. It would seem very unlikely that these figures were painted by Lingelbach who is, however, known to have painted figures in paintings by a number of different artists. As he worked in Amsterdam a collaboration with De Lorme is not very likely.

In his earliest paintings of the St. Laurenskerk, dating from 1652-53, De Lorme uses a close vantage point and emphasises the fall of light. In a late painting of 1669 in Rotterdam the view is more distant and the composition simplified. A date some time in the early 1660's might be suggested for the present picture.

HP

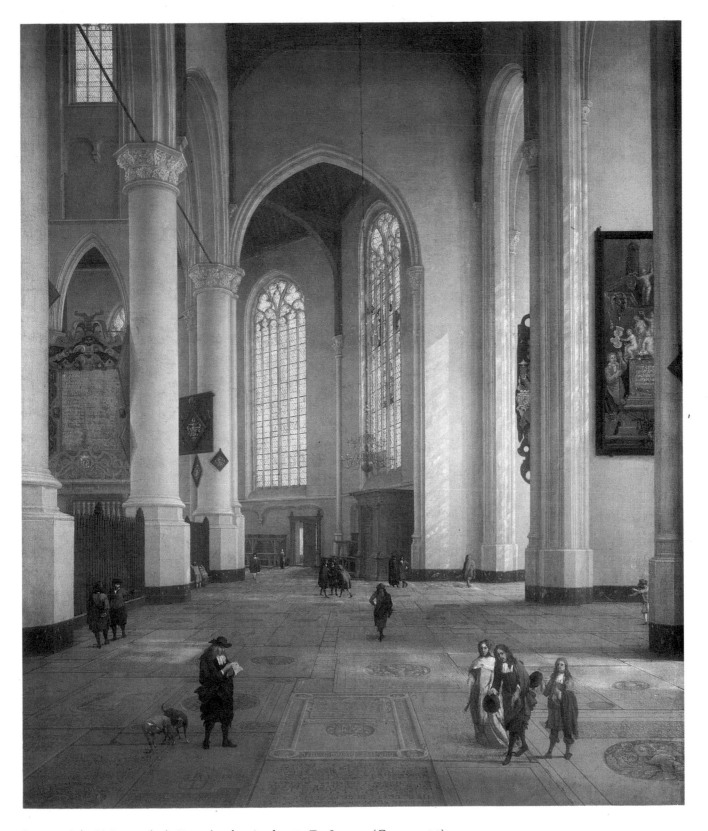

Interior of the St. Laurenskerk, Rotterdam by Anthonie De Lorme (Cat. no. 29)

Nicolaes de Gyselaer (Dordrecht 1583–before 1659 ?Amsterdam)

Gyselaer is generally cited as having been born in Leiden about 1592 (Thieme-Becker; Bernt 1962, vol. 4 no. 115) although the Rijksmuseum, Amsterdam gives Dordrecht in 1583 (Amsterdam 1976, p. 243). He became a member of the Guild of St. Luke in Utrecht in 1616 or 1617 and was married in Amsterdam in 1616. He is recorded in Utrecht in 1644 and 1654 and died sometime before 1659, probably in Amsterdam. He painted, exclusively, architectural interiors somewhat in the style of Bartholomeus van Bassen and his work is sometimes confused with Pieter Neeffs. There are very few signed works.

30 Interior with figures

Oil on panel, 36 × 56 cm. (13⅝ × 22⅛ ins.)
Signed on the buffet-gast, right: *N D Giselaer. F.*
PROVENANCE: S. T. Smith, Duke Street, London from whom purchased by the National Gallery of Ireland, 1893. Cat. no. 327.
LITERATURE: Jantzen 1979, no. 160d.

The subject of the painting is not easily identifiable. Pictures by the artist, which are rare, depict exclusively such architectural interiors; and these are often peopled with Old Testament subjects such as *Joseph and Potiphar's Wife*, *Haman and Mordecai* and *David and Bathsheba*. In the Dublin painting, whatever the exact subject matter may be, it seems likely that some contrast is intended between the principal pair of figures and the pair of figures in the background. The latter are seated at a table on which is placed bread and wine on a white napkin. It would be difficult not to find some religious significance in this detail and the couple themselves are notably sober in their appearance. Equally it is made clear that the other couple are advancing towards each other with amorous intent. Gyselaer's style is not sufficiently well known for one to draw definite conclusions as to whether the meaning that may be attached to several of the details in the painting are intended. For example a dog is a well-known symbol of marital fidelity. The standing woman holds her left hand in a position that can also be interpreted as signifying fidelity in marriage: it is for example identical with the gesture of Giovanna Cenami in Van Eyck's *Arnolfini Marriage*. On the right hand side of the composition, that is on the same side as the bed, hangs a seascape; and seascapes can be shown in Dutch seventeenth century paintings in order to suggest that love is as hazardous as a journey by sea. The winged figures on the chimneypiece are cupids. The item of furniture on the extreme right is a *buffet-gast* which was usually placed in a dining room and used for storing and displaying silver and china.

The room shown in the Dublin painting is imaginary and there were no such interiors in seventeenth century Holland. Somewhat similar rooms are found in other paintings by the artist, for example the painting signed and dated 1621 in the Fitzwilliam Museum, Cambridge; and an *Interior with Joseph and Potiphar's wife* (Sotheby's 12 April 1978, lot 19) shows a very similar room indeed. In painting his pictures, Gyselaer like other architectural painters such as Pieter Neeffs, Sebastian Vrancx, Anton Gheringh and van Bassen, probably looked at the architectural patterns books of Jan Vredeman de Vries and others. In our painting the room could be inspired in a general way by some of the plates in de Vries's *Scenographiae*; while the detail of the chimneypiece could have an Italian source in Serlio's *Architettura*, Book IV.

The Dublin painting compares stylistically with a *Joseph and Potiphar's Wife* signed and dated 1625 (Sotheby's New York, 12 June 1975, lot 96) and may be dated to about that time.

HP

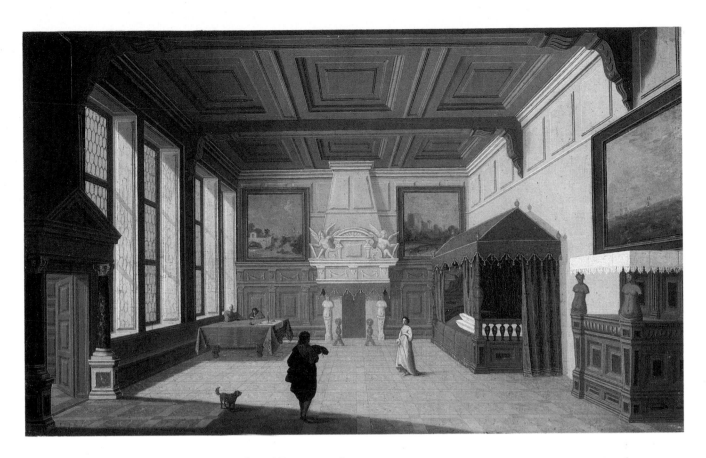

Interior with figures by Nicolaes de Gyselaer (Cat. no. 30)

Jacob Duck (Utrecht c.1600–1667 Utrecht)

Duck is thought to have been a pupil in Utrecht of Joost Cornelisz. Droochsloot (1586-1666) who depicted low-life scenes. He is recorded as an apprentice portrait painter in the Utrecht Guild of St. Luke in 1621 and may have been enrolled as a master in the Guild by 1626: he was certainly a master by 1630-32. For some time around 1636 he lived in Haarlem and from 1656-60 he was in The Hague. He painted guardroom and merry company scenes in the manner of the Amsterdam painters Willem Cornelisz. Duyster and Pieter Codde.

31 Interior with a woman sleeping

Oil on panel, 27 × 24 cm. (10¾ × 9⅜ ins.)
Signed bottom right: *J Duck* (the *J D* in monogram)
PROVENANCE: Sir Walter Armstrong, from whom purchased by the National Gallery of Ireland, 1891. Cat. no. 335.

The subject of the painting is not clear, but in the context of other paintings by Duck, it is most likely that it is intended to convey some moral rather than represent some specific subject from, for example, literature. Duck painted any number of pictures of sleeping figures, both male and female, and, in general he incorporated in these paintings some other action which had specific sexual implications. In a painting in the Alte Pinacothek, Munich an older woman, overcome by drink and tobacco smoking, is shown asleep in the foreground, while in the background a younger woman enjoys the attentions of a young soldier. In another painting by the artist (coll. Lord Lichfield) a sleeping woman is about to be awakened by a soldier who is making a very lewd gesture. The woman in the Dublin painting keeps company with soldiers: she is leaning on a drum, an instrument that may be associated with the military. On the drum are coins, a gold chain, pearls and on open jewel casket. The soldier in the centre background appears to be about to add to the jewels and coins that are on the drum. Duck, like other painters of his time such as W. C. Duyster, painted several pictures of soldiers plundering jewels. In paintings by him in the Louvre and the Hermitage, Leningrad, the soldiers offer their plunder to women of easy virtue. In the context of these pictures the subject of our painting might simply be explained as a prostitute whose procuress is the woman in the background doorway.

The panel on which the picture is painted has been extended at the top and the extension is clearly visible on the surface. It would not be unusual for Duck to paint a picture horizontal in format as the Dublin picture would be without the addition. A pair of paintings in the Groeningen Museum are so shaped. It would also be usual for him to have painted a picture in the format of our painting as it now appears. The very thin painting of the addition, with the grain of the wood showing through is a similar technique to that found in the Groeningen paintings; and it is probable that the addition to the panel is original.

Duck's style of the 1650's and 1660's has been summed up (*Dutch Genre* 1984, p. 193) as 'use of strong local colour, the choice of an upright format, and the depiction of an interior limited to only a few figures'. A date in the late 1650's may be proposed for our painting. The woman in the picture is repeated almost exactly in a different composition in the Landesmuseum Ferdinandeum, Innsbruck.

HP

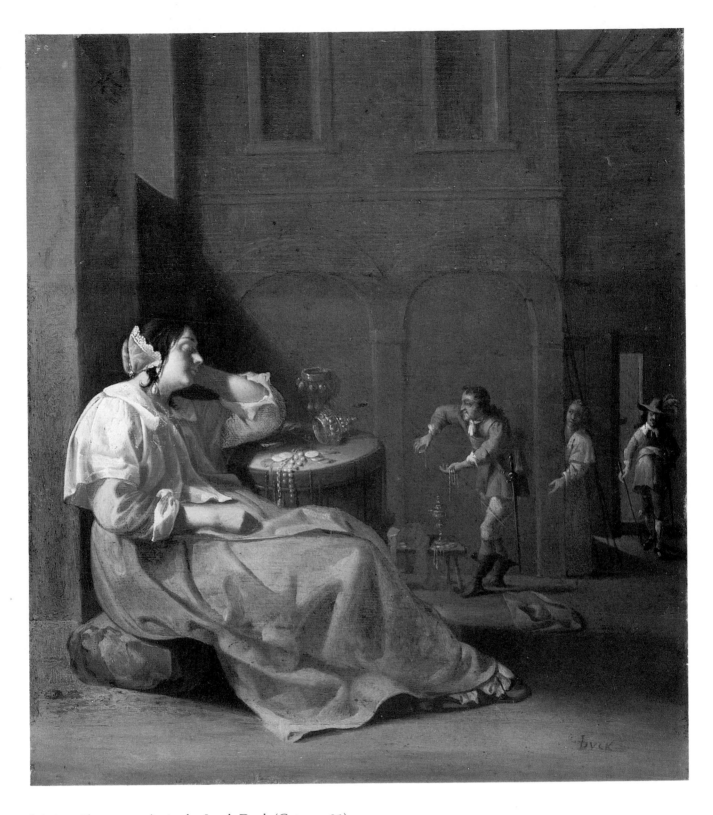

Interior with a woman sleeping by Jacob Duck (Cat. no. 31)

Jacob Gerritsz. van Hasselt (Utrecht c.1597–c.1674 Utrecht)

van Hasselt was born about 1597 or 1598 in Utrecht the son of a decorative painter, Gerrit Jacobsz. van Hasselt. He is mentioned as a Master in the Guild of St. Luke in Utrecht in the years 1616-17. He married Anna Dareth of Utrecht and by her had three children between 1641 and 1643. He died about 1674. A painting of A Marriage Feast *showing the members of his own family, signed and dated 1636, is in the Centraal Museum, Utrecht. In 1638 he presented a painting* The unbelieving Centurion who came to Christ *to the St. Job's Hospital at Utrecht. Wurzbach (1906-11) refers to a landscape painter of this name mentioned at Utrecht about 1638 and 1643 and stated to have worked in Rome; although there is no reference to a painter of this name in the published lists of Dutch painters in Rome (Hoogewerff 1942 and Bodart 1970).*

32 View from the Bishop's throne, west from the nave, towards the staircase tower in Utrecht Cathedral

Oil on panel, 55 × 38 cm. (21½ × 15⅛ ins.)
Signed on the cartouche, left: *J. (?G) V Hasse(lt) A° 1659*
Inscribed above the doorway: *Si quid cum qu Tecum qu...* (the remainder indecipherable).
EXHIBITED: 1912, Rijksmuseum, Amsterdam (on loan from H. Pfungst).
PROVENANCE: Alexandre Dumont sale, Cambrai, 30 September 1878 lot 74; Malherbe sale, Valenciennes, 17-18 October 1883 lot 78; Foucart sale, Valenciennes, 12 October 1898 lot 116; H. Pfungst, London, 1912; Durlacher, London, 1921; L(ippmann) de Londres sale, Amsterdam (Muller), 27 October 1927 lot 5 where purchased by Durlacher for the National Gallery of Ireland. Cat. no. 897.
LITERATURE: Borenius 1921, p. 143; Swillens 1946, p. 133.

The subject of the picture was incorrectly identified in the Dumont and Foucart sales catalogues as a beggar seated at the door of the Hospice of the Cloister St. Agatha at Delft. Borenius (1921) referred to it as a Roman beggar seated outside the vaulted gate of a building. Its true subject was identified by Swillens (1946) as a *View from the Bishop's throne, west from the nave, towards the staircase tower in Utrecht Cathedral*. While this is indeed the view represented it seems likely that the picture has some further meaning and the positioning of the lady on the staircase may be relevant. A somewhat similar composition is the painting attributed to Egbert van der Poel in the Rijksmuseum, Amsterdam which shows a man descending the stairway tower of the Prinsenhof in Delft; and that picture represents the moment before the assassination of William the Silent. The inscription over the doorway is largely indecipherable. If understood it is probable that it would explain the meaning of the picture although in the opinion of Professor Julian Brown of the Department of Palaeography, King's College, London (who has examined a photograph of the inscription) it is possibly pretend writing.

The picture was attributed to Vermeer in the Dumont Sale catalogue of 1878; to J. C. van Desselt *(sic)* in the Malherbe sale of 1883; and in the Foucart Sale of 1898 it was said to be signed on the cartouche *V.de M., Delft fecit a° 1659.* (i.e. Vermeer). Van Hasselt's signature was uncovered by the time the painting was lent to the Rijksmuseum, Amsterdam in 1912. It was there shown as Van Hasselt, and so attributed ever since although erroneously catalogued in Dublin (Dublin 1981) as Izaak van Hasselt.

HP

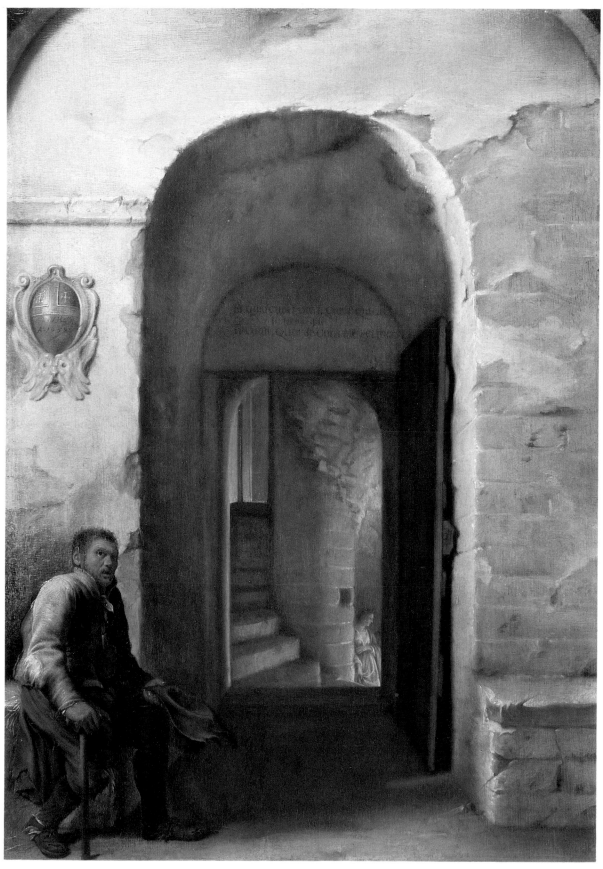

View from the Bishop's throne, west from the nave, towards the staircase tower in Utrecht Cathedral by Jacob Gerritsz. van Hasselt (Cat. no. 32)

Jan Mytens (The Hague c.1614–1670 The Hague)

Mytens was the nephew and pupil of Daniel Mytens the Elder and father and teacher of Daniel Mytens the Younger. In 1639 he became a member of the Guild of St. Luke in The Hague and in 1656 one of the founders of 'La Pictura' a company of painters in The Hague.

He was the most fashionable portraitist working in the capital city of Holland in the mid-seventeenth century and was patronised by the Court, Government officials and the newly rich burghers. His style was influenced by his uncle and teacher, Daniel Mytens the Elder who himself had worked at the Court of Charles I in England. Although Mytens the Elder was in England long before the arrival of Van Dyck in 1632, his style of painting was very much influenced by Rubens and Van Dyck; and he passed on to his pupil Jan Mytens the elegance one associates with those two great Flemish portraitists.

33 A Lady playing a Lute

Oil on canvas: 80 × 65 cm. (31½ × 25⅜ ins.)
Signed and dated, top right: *Mytens pincxit 1648*
EXHIBITED: 1857, Manchester, *Art Treasures Exhibition*, no. 618 (definitive catalogue); 1882, Worcester, *Worcestershire Exhibition* no. 358; 1969, Galerie des Beaux Arts, Bordeaux, *L'Art et la Musique*, no. 51.
PROVENANCE: Acquired between 1827 and 1835 by Joseph Strutt of Derby; thence by descent to Howard Galton of Hadzor by 1854; thence by descent to Hubert Galton; his sale (Hadzor Sale) Christie's, London, 22 June, 1889, lot 51 where purchased by the National Gallery of Ireland. Cat. no. 150.
LITERATURE: Waagen 1854, vol. 3, p. 222.

The painting was exhibited in Worcester in 1882 as a *Portrait of the Countess of Derby*, and sold in 1889 as *Charlotte de la Tremouille, Countess of Derby playing a guitar*. Waagen (1854) referred to it as 'Mytens — a female portrait with a guitar'. The lady in fact plays a theorbod lute typical of the mid-seventeenth century and known in England as a French lute. (Information from Dr Barra Boydell). The lute has two distinct pegboxes. In the painting the number of strings does not correspond to the number of pegs, and the pegs are painted at random. There seems to be no evidence to support the identification of the sitter as Charlotte de la Tremouille, Countess of Derby: that Lady Derby (d.1663/64) was the daughter of the Duke of Thouars and granddaughter of William of Nassau, Prince of Orange. Her portrait, together with her husband and daughter, by Van Dyck is in the Frick Collection and shows a lady who bears no physical resemblance to the lady in our picture. A signed and dated painting of 1652 by Gerrit Honthorst (sold at Christie's, 4-5 June, 1984, lot 471) shows a lady as Minerva, and that portrait bears an inscription identifying the sitter as Charlotte de la Tremouille; but the lady as Minerva does not appear to be one and the same as the lady in our portrait.

The composition of the painting would indicate fairly strongly that it was painted as one of a pair of portraits, and its pendant would have shown the lady's husband. While music is in general regarded as the accompaniment of love, the lute in particular was used to denote harmony. (*Tot Lering en Vermaak* 1976, p. 105 ff.) The lute was therefore appropriate to paintings of married couples. An emblem by Jacob Cats, first published in 1618, shows a man tuning a lute with a second lute on a table beside him, and he remarks that the strings of one lute resound to the tuning of the other. According to the emblem this resonance demonstrates that 'two hearts resound in one tone'. That the lute was specifically associated with marital harmony in seventeenth century Northern painting is demonstrated in a painting by Theodoor van Thulden in Brussels. In that picture a lady playing a lute is crowned by Hymen, God of Marriage.

Mytens painted a great number of pair portraits of married couples and often included some form of allegory. He was also familiar with the emblem literature of the period, in particular that of Jacob Cats.

HP

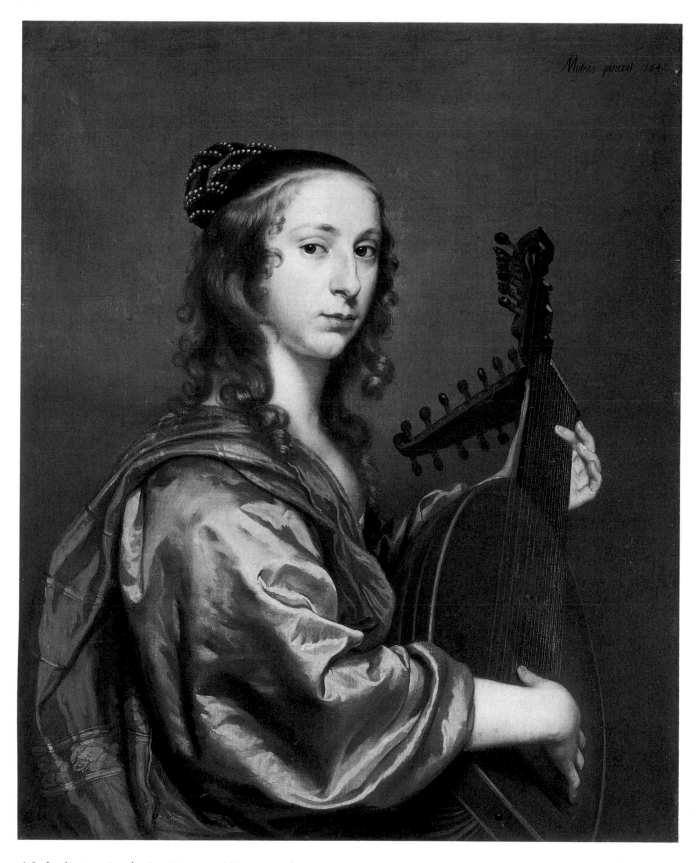

A Lady playing a Lute by Jan Mytens (Cat. no. 33)

Cornelis Troost (Amsterdam 1696–1750 Amsterdam)

He was the son of an Amsterdam goldsmith, Johannes Troost and sometime between 1710 and 1720, for a period of two years, was a pupil of Arnold Boonen, then the most sought-after portrait painter in Amsterdam. He married Susanna Maria van Duyn, the daughter of an acrtress and singer, in Zwolle in 1720; and he himself is recorded as an actor in Amsterdam in 1718 and again in the 1720's. Troost was a master of portraiture in all its forms: both single and double portraits, group portraits and conversation pieces. He also painted stage sets and several pictures which show scenes from plays. There are some outdoor scenes by him which are somewhat, although not exactly, in the fête-champetre tradition; and at least one room decorated by him survives. He was as skilled as a draughtsman as he was as a painter in oils; and he particularly excelled when working in pastel.

34 Portrait of Jeronimus Tonneman and his son, Jeronimus: 'The Dilettanti'

Oil on panel, 68 × 58 cm. (26¾ × 22¾ ins.)
Signed and dated on the skirting board beneath the statue: *C. Troost 1736*
EXHIBITED: 1894, Utrecht, *Oude schilderkunst* no. 440; 1946, Museum Boymans-van Beuningen, Rotterdam, *Cornelis Troost en zijn tijd* no. 106; 1952, Rijksmuseum, Amsterdam, *Drie Eeuwen Portret in Nederland* no. 169; 1954-5, Royal Academy, London, *European Masters of the eighteenth century* no. 113; 1971-2, Institute of Arts, Minneapolis, Museum of Art, Toledo, Museum of Art, Philadelphia, *Dutch Masterpieces from the eighteenth century* no. 89.
PROVENANCE: Jeronimus Tonneman the Younger; by descent to his daughter Mrs. P. H. de la Court; thence by descent; coll. Douaire De la Court-Ram, Utrecht, 1894; Anon. sale, Christie's, London, 12 June 1899 lot 78 bt. Dowdeswell; coll. Ward, London; S. Richards, London from whom purchased by the National Gallery of Ireland, 1909. Cat. no. 497.
LITERATURE: Knoef 1947a, p. 20; Knoef 1947b, p. 14; Staring 1956, p. 110; Niemeijer 1973, no. 136S, p. 204.

The sitters, who had traditionally been called Allard de la Court and his son-in-law, Jeronimus Beeldsnijder were correctly identified by Knoef (1947b) as Jeronimus Tonneman and his son, also Jeronimus. The father was christened in Amsterdam on 19 October 1687 and died there on 26 March 1750. His wife, Adriana van Assenburg, whom he married in 1711, died four years after their marriage. Their son's date of birth is unknown but he must have been between twenty-five and twenty-eight at the time the picture was painted in 1736. In 1742 the Tonneman family lived on the Keizersgracht adjacent to Utrechtse straat in Amsterdam.

Jeronimus Tonneman the Elder was one of Troost's most important patrons: he owned the artist's self-portrait now in the Rijksmuseum Amsterdam (cat. no. A4225) and also his major conversation-piece, *The Spendthrift* (Rijksmuseum Amsterdam, cat. no. A4209). He also owned a number of drawings by Troost and a set of twelve stage scenes in pastel.

The interior shown in the Dublin painting is not real, but idealised and in general reflects a French idiom (Staring 1956). On the table is Van Mander's *Het Schilderboeck* first published in 1604 and the most important source book on the lives of Dutch painters. The younger Tonneman plays a standard one-keyed flute contemporary for the period. The stucco relief on the background wall shows *Time revealing Truth and banishing Slander* and above the chimneypiece a stucco relief in a roundel shows *Mercury killing Argus*. According to Ovid (*Metamorphoses* 1:668-721) Mercury did this by first of all lulling Argus to sleep with piped music; but in Van Mander's *Wtleggingh op den Metamorphosis Pub. Ovidii Nasonis* published in 1604, and a copy of which is known to have been in Tonneman's library, Van Mander links the episode of Mercury killing Argus with the human trait of being lured by desire toward wealth and idle fame, the consequence of which is that reason, justice and virtue are destroyed. The plaster statue in the niche on the right is modelled from Duquesnoy's *St. Susanna*, a saint whose story is generally taken as illustrating the triumph of virtue over vice.

The choice of subject matter for the plaster reliefs and statue can hardly have been accidental and it is probable that the elder Tonneman wished to have himself depicted not just as a connoisseur and patron, but one who was aware of the vanity of such a role. By a curious irony, the year after the picture was painted the younger Tonneman is recorded in the diary of Jacob Bicker Raye (Bicker Raye 1732-72) as having stabbed his mistress, who had borne him a child, with a pair of scissors and shortly thereafter left Holland as a midshipman on a voyage to the East Indies.

A possible preparatory drawing for the painting was sold in Amsterdam on 20 November 1899 lot. 663. Described as 'Jeronimus Tonneman. Art Lover, friend of Cornelis Troost. Half-length seated in front of a table', its present whereabouts is unknown.

HP

84

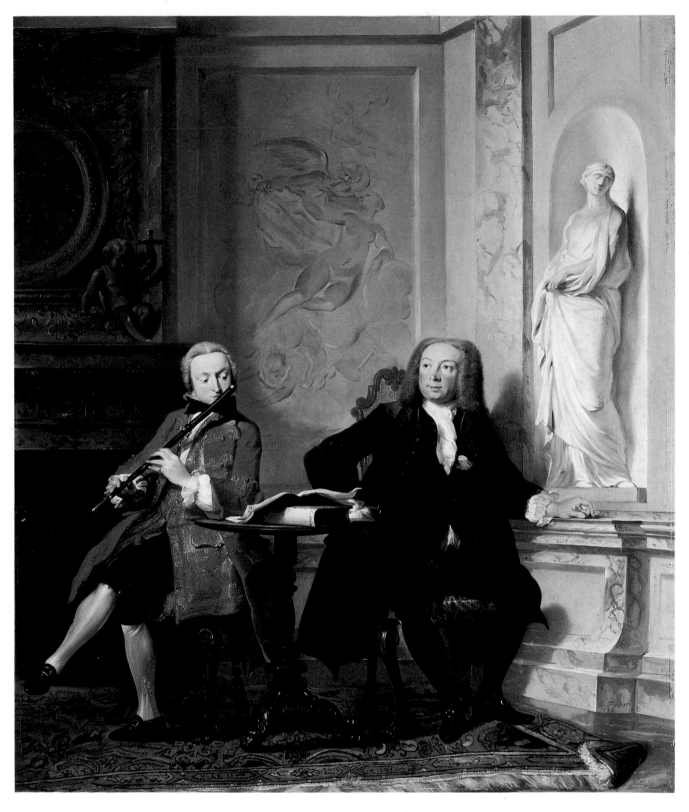

Portrait of Jeronimus Tonneman and his son, Jeronimus: 'The Dilettanti' by Cornelis Troost (Cat. no. 34)

Emil Nolde (Nolde 1867–1956 Seebüll)

Nolde was born in a small village of that name near the German border with Denmark. He adopted Nolde as his surname about 1901. His early training and occupation was as a wood carver and furniture maker, which he taught from 1892-98 at St Gallen in Switzerland. The success of animated picture postcards of mountains enabled him to study painting in Munich; at Dachau with the mystic Adolf Hölzel and for nine months during 1899 at the Académie Julian in Paris. Nolde admired Daumier and the more figurative Impressionists, but also copied Titian and Rubens in the Louvre. He returned to Germany in 1900 and although working in isolation now saw pictures by Van Gogh, Gauguin, Munch and Ensor which influenced his work. During 1906-7 he joined Die Brücke artists, who admired his 'colour tempests'. From 1909-15 Nolde painted a series of religious pictures whose unsettling violence and distortion of form are a personal interpretation of the bible the equal of Rembrandt's and masterpieces of German Expressionism. In 1913 Nolde joined a scientific expedition in order to study at first hand the Primitive art he had seen in the Berlin Ethnographic museum and travelled through Russia to Japan and the South Seas. This work was confiscated by the British at the outbreak of war in 1914, but recovered in 1921. Nolde was given a major 50th birthday retrospective at Dresden in 1927 but within a decade was denounced as a degenerate artist by the Nazis and 1,052 works confiscated from German museums to be sold or burnt. He protested to Dr Goebbels (who like Albert Speer owned pictures by him) but was forced to resign from the Berlin Academy and following the 1937 Munich 'Degenerate Art' exhibition, even forbidden to paint. This resulted in his 'unpainted pictures', landscape and figurative watercolours hidden until later. In spite of losses, more than 1,100 paintings, innumerable watercolours, also etchings, woodcuts and lithographs by Nolde survive. At each of his three major homes (Alsen, Utenwalf and Seebüll) he created magnificent gardens, which he painted.

35 Women in the Garden (Frauen im Garten)

Oil on canvas, 73 × 88 cm. (28¾ × 34 ⅝ ins.).
Signed on stretcher: *Emil Nolde „Frauen im Garten"*
EXHIBITED: 1917, Kunstsalon Ludwig Schames, Frankfurt-am-Main, *Emil Nolde*, no. 26; 1918, Kestner-Gesellschaft, Hannover, *Emil Nolde*, no. 43; 1918, Kunstsalon Ludwig Schames, Frankfurt-am-Main, *Emil Nolde*, no. 25.
PROVENANCE: Lüders, Hamburg; Kowarzik collection; acquired by the Städelsches Kunstinstitut/Städtische Galerie in 1926; confiscated by the government in 1937/38 as *Entartete Kunst* (degenerate art) and sold in 1938; Private collection, Munich; Roman Norbert Ketterer, Campione d'Italia near Lugano, in 1967; Private collection, Brazil; Sotheby's, London, 26 June, 1984, lot 36, where purchased by the National Gallery of Ireland. Cat. no. 4490.

This darkened garden with two women contemplating each other was painted in 1915, according to Nolde's notes. He follows his usual practice of signing and titling the picture on the stretcher. We are grateful to Martin Urban of the Nolde Stiftung at Seebüll for this information, also for identifying the right hand figure as Nolde's wife Ada. Nolde had a home on the island of Alsen from 1903-16 and spent most of 1915 there. He painted his first garden at Alsen in 1906, attracted by the glowing, pure colours of the flowers and moved by thoughts of their eventual destruction once picked for human pleasure (Urban 1966, p. 7). In 1909 he stopped painting these "little garden scenes which the public liked because of their bright, fresh colours. I could have painted myself into an artistic corner, if this small success had become my goal and fulfilment' (Urban 1966, p. 20).

Women in the Garden shows him returning to the theme after a six year interval reflecting the mood of his 'difficult and spiritual religious pictures', being composed 'more profoundly and substantially and filled with more melancholy' (Nolde 1958, p. 191). Nolde's normally fiery yellows and reds are here tempered, with pink the strongest colour, balanced by tones of violet and green. A suggestion of intense stillness is achieved through the dense colouring and the bands of flowers and trees depicted with swirling impasto paint. Nolde consciously disregarded conventional perspective and more usual landscape colours. The foreground blooms have an almost surreal quality against the large simplified figures, which are more dominant than the figures of *Blumengarten A* (Nationalgalerie, Berlin, 1915). Nolde emphasised the importance of dualism in his work with contrasts of male and female, emotional states, colours, tones and values. Here the figures are not clearly differentiated, but the picture fits his working method, beginning analytically but finding that 'after a colour or chord was achieved naturally, one colour determined another, finding the way entirely with feeling and without thought in the full range of the beautiful colours of the palette, in pure sensual devotion and creative pleasure' (Nolde 1958, p. 185).

ALH

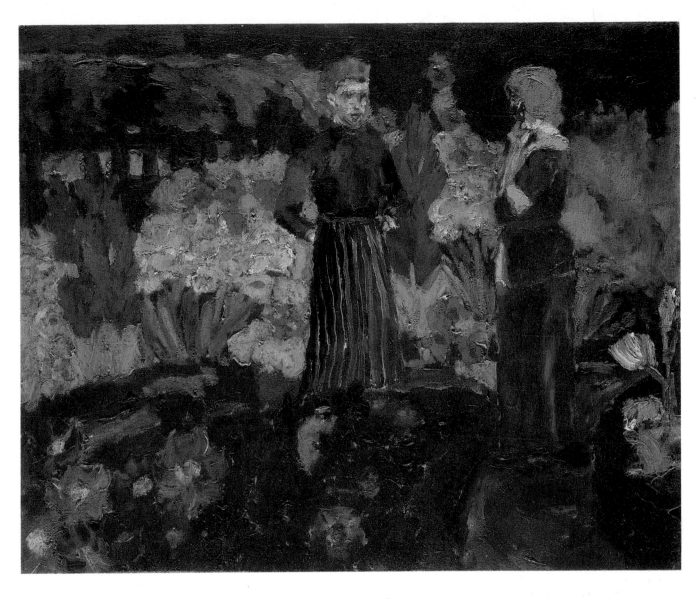

Women in the Garden (Frauen im Garten) by Emil Nolde (Cat. no. 35)

Bibliography

All the paintings in the collection of the National Gallery of Ireland are listed and illustrated in the *National Gallery of Ireland, Illustrated Summary Catalogue of Paintings* (1981). Drawings and watercolours are in the companion *National Gallery of Ireland, Illustrated Summary Catalogue of Drawings, Watercolours and Miniatures* (1983). Sculptures and Prints are similarly catalogued in the *National Gallery of Ireland, Illustrated Summary Catalogue of Sculptures and Prints* (to be published 1985). Catalogues of new acquisitions have been published in 1981, 1982 and 1984.

Text catalogues of the collection were published regularly in the early years of the National Gallery of Ireland, most of them simply reprints of previous catalogues with new acquisitions inserted. Those published in 1864, 1867, 1868, 1871 and 1874 were prepared by George Mulvany; those in 1875, 1879, 1882, 1884, 1885, 1886, 1887 and 1890 by Henry Doyle. The first catalogue prepared by Walter Armstrong and published in 1898 included a great number of revised attributions and new opinions. His subsequent catalogues in 1904, 1908 and 1914 (published during Sir Hugh Lane's brief Directorship) continued to update scholarly information on the collection. Selective catalogues were published in 1920, 1928 and 1932 but thereafter there were no further text catalogues until a catalogue of the Italian paintings in 1956 by Thomas McGreevy.

Check-lists of the paintings were published in 1964 and 1971. The catalogues referred to above are abbreviated with the prefix 'Dublin' and the date of publication in this catalogue.

de l'Ain 1970
G. Girod de l'Ain, *Joseph Bonaparte, le Roi malgré lui* (Paris 1970)

Amsterdam 1976
All the paintings of the Rijksmuseum in Amsterdam: a completely illustrated catalogue (Amsterdam & Maarssen 1976)

Andresen 1863
A. Andresen, *Nicolas Poussin, Verzeichnis der nach seinen Gemälden gefertigten gleichzeitigen und späteren Kupferstiche* (Leipzig 1863), reprinted, *Gazette des Beaux-Arts*, vol. 2 (1962), p. 139

de Angelis 1974
R. de Angelis, *L'opera pittorica completa di Goya* (Milan 1974)

Anon 1781
Anon., *Exposition des ouvrages . . .* (1781)

Anon 1824
Anon., *Notice sur la vie et les ouvrages de M.-J.-L. David* (Paris 1824)

Ansaldi 1955
G. R. Ansaldi, 'Ritratti inediti di Wicar, *Bollettino dei Musei Communali di Roma*, nos. 3-4 (1955)

Arpino/Lecaldano 1969
G. Arpino & P. Lecaldano, *L'Opera Pittorico Completa di Rembrandt* (Milan 1969)

Auerbach 1937
E. Auerbach, 'Conrad Faber, or The Master of the Holzhausen Portraits', *Burlington Magazine*, vol. 70 (1937), p. 14

de Bachaumont 1777-89
L. Petit de Bachaumont, *Memoires secrets pour servir a l'histoire de la republique des lettres en France, depuis MDCCLXII jusqua nos jours; ou Journal d'un Observateur*, 31 vols. (London 1777-89)

Badt 1969
K. Badt, *Die Kunst des Nicolas Poussin* (Cologne 1969)

Bartsch
A. Bartsch, *Le Peintre Graveur*, (22 vols., 1808-54, reprinted edition Nieuwkoop & Hildesheim 1970)

Bauch 1966
K. Bauch, *Rembrandt Gemälde* (Berlin 1966)

Bean 1964
J. Bean, *100 European Drawings in the Metropolitan Museum of Art* (New York 1964)

Bellonci/Garavaglia 1967
M. Bellonci & N. Garavaglia, *L'opera completa del Mantegna* (Milan 1967)

Benesch 1940
O. Benesch, 'An early portrait drawing by Rembrandt' *Art Quarterly*, vol. 3 (1940), p. 2

Berenson 1901-16
B. Berenson, *The Study and Criticism of Italian Art*, 3 vols. (London 1901-16)

Berenson 1910
B. Berenson, *North Italian Painters* (New York & London 1910)

Berenson 1931
B. Berenson, *Italian Pictures of the Renaissance* (Oxford 1931)

Berenson 1932
B. Berenson, *Italian Pictures of the Renaissance* (Oxford 1932)

Berenson 1957
B. Berenson, *Italian Pictures of the Renaissance: Venetian School* (London 1957)

Berenson 1958
B. Berenson, *Pitture italiane del Rinascimento: la scuolo veneta* (London & Florence 1958)

Berenson 1968
B. Berenson, *Italian Pictures of the Renaissance: Central Italian Schools and North Italian Schools* (London 1968)

Bernt 1962
W. Bernt, *Die niederländischen Maler des 17. Jahrhunderts*, vol. 4 (Munich 1962)

Bertin 1893
G. Bertin, *Joseph Bonaparte en Amerique* (Paris 1893)

Bicker Raye 1732-72
Fr. Beyerinck & M.G. de Boer (eds.) *Het dagboek van Jacob Bicker Raye 1732-1772* (Amsterdam n.d.)

de Bie 1662
C. de Bie, *Het Gulden Cabinet van de edele vry Schilder-Const ontsloten door den lanck ghewenschten vrede tusschen de twede croonen van Spagnien en Vrancryck* (Antwerp 1662)

Blunt 1950
A. Blunt, 'Poussin Studies IV: Two rediscovered late works' *Burlington Magazine*, vol. 92 (1950), p. 38

Blunt 1954
A. Blunt, *The Drawings of G.B. Castiglione and Stefano della Bella in the Collection of Her Majesty the Queen at Windsor Castle* (London 1954)

Blunt 1966
A. Blunt, *The Paintings of Nicolas Poussin, a critical catalogue* (London 1966)

Bodart 1970
D. Bodart, *Les Peintres des Pays-Bas Méridionaux et de la Principauté de Liège à Rome au XVIIeme Siècle* (Brussels & Rome 1970)

Bode 1883
W. Bode, *Studien zur Geschichte der Holländischen Malerei* (Braunschweig 1883)

Bode/Hofstede de Groot 1897-1905
W. Bode & C. Hofstede de Groot, *The Complete Work of Rembrandt* (1897-1905)

Bodkin 1932
T. Bodkin, 'Nicolas Poussin in the National Gallery, Dublin', *Burlington Magazine*, vol. 60 (1932), p. 174

Bodkin 1956
T. Bodkin, *Hugh Lane and his Pictures* (Dublin 1956)

Borenius 1921
T. Borenius, 'Claesz Hals—II', *Burlington Magazine*, vol. 38 (1921), p. 143

Bortolatto 1975
L. R. Bortolatto, *Tout L'Oeuvre peint de Delacroix* (Paris 1975)

Braham 1981
H. Braham, *The Princes Gate Collection* (London 1981)

Bredius 1935
A. Bredius, *Rembrandt: samtliche gemälde* (Vienna 1935)

Bredius 1969
A. Bredius, *Rembrandt: the complete edition of the paintings*, revised by H. Gerson (London 1969)

Brookner 1980
A. Brookner, *Jacques-Louis David* (London 1980)

Brown 1984
C. Brown, *Scenes of Everyday Life: Dutch Genre Painting of the Seventeenth Century* (London & Boston 1984)

Brücker 1965
W. Brücker, *Conrad Faber von Creuznach* (Frankfurt-am-Main 1965)

Buchanan 1824
W. Buchanan, *Memoirs of Painting etc.* (London 1824)

Cagli/Valcanover 1969
C. Cagli & F. Valcanover, *L'opera completa di Tiziano* (Milan 1969)

Caliari 1909
P. Caliari, *Paolo Caliari, sua vita e sue opere* (Rome 1909)

Camón Aznar 1950
J. Camón Aznar, *Domenico Greco* (Madrid 1950)

Camón Aznar 1980
J. Camón Aznar, *Goya* (Paris 1980)

Cantinelli 1930
R. Cantinelli, *Jacques-Louis David 1748-1825* (Paris & Brussels 1930)

del Caso 1972
J. del Caso 'Jacques-Louis David and the style *All'antica*', *Burlington Magazine*, vol. 114 (1972), p. 686

Cipriani 1956
R. Cipriani, *Tutta la Pittura del Mantegna* (Milan 1956)

Cipriani 1962
R. Cipriani, *Tutta la Pittura del Mantegna* (Milan 1962)

Collins Baker 1920
C.H. Collins Baker, 'Notes on Syon House Pictures, Part II', *The Connoisseur*, vol. 17 (1920), p. 194

Collins Baker 1926
C.H. Collins Baker, 'Rembrandt's painter in his studio', *Burlington Magazine*, vol. 48 (1926), p. 42

Constans 1980
C. Constans, *Musée national du château de Versailles: Catalogue des Peintures* (Paris 1980)

Cossío 1908
M.B. Cossío, *El Greco* (Madrid 1908)

Cossío 1972
M.B. Cossío, *El Greco* (Madrid 1972)

Coupin 1827
M.P.A. Coupin, *Essai sur J.L. David peintre d'histoire, ancien membre de l'Institut, officier de la Legion d'Honneur* (Paris 1827)

Crookshank 1964
A. Crookshank, 'Two Signatures of Giovanni Battista Passeri', *Burlington Magazine*, vol. 106 (1964), p. 179

Crosato Larcher 1968
L. Crosato Larcher, 'L'opera completa del Veronese', *Arte Veneta*, vol. 22 (1968), p. 220

Crowe/Cavalcaselle 1912
J.A. Crowe & G.B. Cavalcaselle, *A History of Painting in North Italy*, ed. T. Borenius (London 1912)

David 1867
J.L. David, *Notice sur le Marat de Louis David Suivie de la Liste de ses Tableaux dressée par lui-même* (Paris 1867)

David 1880
J.L. David, *Le peintre Louis David 1748-1825, Souvenirs et Documents, inedits* (Paris 1880)

David 1948
Exhibition catalogue, *David* (Orangerie, Paris 1948)

Davies 1906-07
R. Davies, 'An Inventory of the Duke of Buckingham's Pictures, etc. at York House in 1635', *Burlington Magazine*, vol. 10 (1906-07), p. 376

Davies, 1961
M. Davies, *National Gallery Catalogue: The Earlier Italian Schools* (2nd ed., London 1961)

Della Chiesa 1967
A.D. Della Chiesa, *Accademia Carrara* (Bergamo 1967)

Delogu 1928
G. Delogu, *G.B. Castiglione detto il Grechetto* (Bologna 1928)

Dessins 1974-75
Exhibition catalogue, *Le Néo-Classicisme français: dessins des Musées de Province* (Grand Palais, Paris, 1974-75)

Dresden 1979
Gemäldegalerie Alte Meister Dresden (Dresden 1979)

Duncan 1906-07
E. Duncan, 'The National Gallery of Ireland', *Burlington Magazine*, vol. 10 (1906-07), p. 7

Dutch Genre 1984
Exhibition catalogue, *Masters of Seventeenth Century Dutch Genre Painting*. (Philadelphia Museum of Art, Gemäldegalerie, Berlin, Royal Academy, London 1984)

Dutuit 1883/85
E. Dutuit, *L'oeuvre complet de Rembrandt . . . Supplément. Tableaux et dessins de Rembrandt: catalogue historique et descriptif* (Paris 1883/85)

Emiliani 1958
A. Emiliani, 'Orazio Gentileschi: nuove proposte per il viaggio marchigiano', *Paragone*, no. 103 (1958), p. 38

Ertz 1979
K. Ertz, *Jan Brueghel der Altere, die gemälde mit kritischem oeuvrekatalog* (Cologne 1979)

Escholier 1929
R. Escholier, *Delacroix, peintre, graveur, écrivain* (Paris 1929)

Fiocco 1937
G. Fiocco, *Mantegna* (Milan 1937)

Fiocco 1959
G. Fiocco, *L'Arte di Andrea Mantegna* (Venice 1959)

Fischer 1977
M.R. Fischer, *Titian's Assistants during the Later Years*, Dissertation (New York & London 1977)

Fokker 1931
T.H. Fokker, *Jan Siberechts, peintre de la paysanne Flamande* (Brussels & Paris 1931)

Fonti 1971
Fonti per la storia della Pittura. 1 Serie Documentaria. Lettere e altri documenti intorno alla Storia della Pittura. Giovanni Benedetto Castiglione detto il Grechetto, Giovanni Francesco Castiglione, Salvatore Castiglione (Genoa 1971)

Friedlaender 1914
W. Friedlaender, *Nicolas Poussin. Die Entwicklung seiner Kunst* (Munich 1914)

Friedlaender/Blunt 1939-74
W. Friedlaender & A. Blunt, *The Drawings of Nicolas Poussin: A catalogue raisonné*, 5 vols. (London 1939-74)

Friedlander 1913
M.J. Friedlander, 'Conrad Faber — Painter of the Patricians of Frankfort in the second quarter of the sixteenth century', *Art in America*, vol. 1 (1913), p. 142

Gamond 1826
A. Thomé de Gamond, *Vie de David* (Paris 1826)

Gassier/Wilson 1971
P. Gassier & J. Wilson, *Goya: His Life and Work, with a catalogue raisonné of the paintings, drawings and engravings* (London 1971)

Gaya Nuño 1958
J.A. Gaya Nuño, *La Pintura Española fuera de España L'Historia y Catálogo* (Madrid 1958)

Gérard 1852-57
H. Gérard, *L'Oeuvre du Baron Gérard 1789-1836*, 3 vols. (Paris 1852-57)

Gérard 1886
Baron Gérard, ed., *Lettres addressées au Baron François Gérard, peintre d'histoire par les artistes et les personnages célèbres de son temps, deuxième édition publiée par le Baron Gérard, son neveu et précédée d'une notice sur la vie et les oeuvres de François Gérard et d'un récit d'Aléxandre Gérard, son frère* (Paris 1886)

Gerson 1968
H. Gerson, *Rembrandt Paintings* (Amsterdam 1968)

Gilbert 1962
C. Gilbert, 'The Mantegna Exhibition', *Burlington Magazine*, vol. 54 (1962), p. 6

Glendinning 1980
N. Glendinning, 'The Mystery of Goya', *Apollo*, vol. 112 (1980), p. 356

Glück 1933
G. Glück, *Rubens, Van Dyck und ihr Kreis* (Vienna 1933)

Gmelin 1966
H. Gmelin, 'Georg Pencz als Maler', *Münchner Jahrbuch der Bildenden Kunst*, vol. 17 (Munich 1966), p. 49

Gore 1955
St. John Gore, 'An "Ecce Homo" in Dublin', *Burlington Magazine*, vol. 97 (1955), p. 218

Grautoff 1914
O. Grautoff, *Nicolas Poussin: sein Werk und sein Leben* (London 1914)

Graves 1921
A. Graves *Art Sales* (London 1921)

Gregory 1973
Lady A. Gregory, *Sir Hugh Lane: His Life and Legacy* (Gerrards Cross 1973)

Gudiol 1962
J. Gudiol, 'Iconography and chronology in El Greco's paintings of St. Francis', *Art Bulletin*, vol. 44 (1962), p. 195

Gudiol 1970
J. Gudiol, *Goya 1746-1828* (Paris 1970)

Guimarães 1957
A. Guimarães, 'Na Holanda com Frans Post', *Revista do Instituto Histórico e Geográfico Brasileiro*, Vol. 235 (1957)

von Hadeln 1978
D. von Hadeln, *Paolo Veronese* (Florence 1978)

Haftmann 1959
W. Haftmann, *Emil Nolde*, trans. N. Guterman (London 1959)

Hairs 1977
M.L. Hairs, *Dans le Sillage de Rubens, les peintres d'histoire d'auversois au XVIIe siècle* (Liège 1977)

Hairs 1980
M.L. Hairs, Exhibition catalogue, *Brueghel une dynastie de peintres*, 'Jean Brueghel le Jeune' essay (Palais des Beaux-Arts, Brussels, 1980)

Härting 1983
U.A. Härting, *Studien zur Kabinettbildmalerei des Frans Francken II* (Hildesheim, Zurich & New York 1983)

Haskell 1958
F. Haskell, 'Review of Zeri, Pittura e Contoriforma', *Burlington Magazine*, vol. 100 (1958), p. 396

Hautecoeur 1954
L. Hautecoeur: *Louis David* (Paris 1954)

Heinemann 1980
F. Heinemann, 'La Bottega di Tiziano' *Tiziano e Venezia* (Convengo Internazionale di Studi, Venezia, 1969), (Vicenza, 1980), p. 433

Hempel 1965
E. Hempel, *Baroque Art and Architecture in Central Europe* (Harmondsworth 1965)

Hind 1910
A.M. Hind, *Catalogue of Early Italian Engravings Preserved in the Department of Prints and Drawings in the British Museum* (London 1910)

Hirst 1981
M. Hirst, *Sebastiano del Piombo* (Oxford 1981)

Hofstede de Groot 1907-27
C. Hofstede de Groot, *A Catalogue raisonné of the works of the Most Eminent Dutch Painters of the Seventeenth Century*, 8 vols., trs. and ed. E.G. Hawke (London 1916)

Holma 1940
K. Holma, *David, son évolution et son style* (Paris 1940)

Hoogewerff 1942
Nederlandsche Kunstenaars te Rome (1600-1725) (The Hague 1942)

Howard 1975
S. Howard, *Sacrifice of the Hero: The Roman years, A Classical Frieze by Jacques-Louis David* (Sacramento 1975)

Hugelsdorfer 1939
W. Hugelsdorfer, 'Gemälde Deutsche Meister in der National Gallery of Ireland in Dublin', *Pantheon*, vol. 23 (1939), p. 19

Huyghe 1963
R. Huyghe, *Delacroix* (Paris 1963)

Hymans 1920
H. Hymans, *Oeuvres* (Brussels 1920)

Janson 1952
H.W. Janson, *Apes and ape lore in the Middle Ages and the Renaissance* (London 1952)

Jantzen 1979
H. Jantzen, *Das Niederländische Architekturbild* (Braunschweig 1979)

Jones 1981
L. Jones, 'Peace, Prosperity and Politics in Tiepolo's Glory of the Spanish Monarchy', *Apollo*, vol. 114 (1981), p. 220

Jonescu 1960
T. Jonescu, 'Un "Ecce Homo" di Tiziano al Museo Brukenthal', *Paragone*, no. 129 (1960), p. 38

Jullian 1956
R. Jullian, '"L'Enfance de Cyrus" par G.B. Castiglione', *Bulletin des musées lyonnais*, no. 2 (1956), p. 25

Kalnein & Levey 1972
W.G. Kalnein & M. Levey, *Art and Architecture of the 18th century in France* (Harmondsworth 1972)

Knapp 1910
I. Knapp, *Mantegna. Klassiker der Kunst* (Stuttgart & Leipzig 1910)

Knoef 1947a
J. Knoef, *Cornelis Troost* (Amsterdam 1947)

Knoef 1947b
J. Knoef, 'Een portret van Tonneman?' *Kunthistorische mededelingen*, vol. 2 (1947), p. 14

Kozakiewicz 1972
S. Kozakiewicz, *Bernardo Bellotto* (Recklinghausen 1972)

Kristeller 1901
P. Kristeller, *Andrea Mantegna* (London, New York & Bombay 1901)

Lacambre 1973
J. Lacambre, 'I Funerali de Patroclo: Gamelin e David', *Arte Illustrata*', vol. 6 (1973), p. 302

Lafond 1913
P. Lafond, *Le Greco* (Paris 1913)

Lapauze 1924
H. Lapauze, *Histoire de l'Académie de France à Rome* (Paris 1924)

de Laroque 1872
L. de Laroque, *Biographie Montpelliéraine, Peintres, Sculpteurs, et Architectes* (Montpellier 1872)

Larsen 1962
E. Larsen, *Frans Post, interprète du Brésil* (Amsterdam & Rio de Janiero 1962)

Laver 1969
J. Laver, *A Concise History of Fashion* (London 1969)

Legendre/Hartmann 1937
M. Legendre & A. Hartmann, *Domenikos Theotocopoulus called El Greco* (London 1937)

Lenormant 1847
C. Lenormant, *Francois Gérard, peintre d'histoire, essai de biographie et de critique*, 2nd edition (Paris 1847)

Von Lersner 1706
A.A. Von Lersner, *Chronica der Welt-Beruhmten Freyen Reichs-Wahl und Handels-Staat Frankfort-am-Main* (Frankfurt 1706)

Licht 1954
F.S. Licht, *Die Entwicklung der Landschaft in den Werken von Nicolas Poussin* (Basle & Stuttgart 1954)

Liedtke 1982
W.A. Liedtke, *Architectural Painting in Delft* (Doornspijk 1982)

Litaniae 1576
'Litaniae deiparae Virginis ex Sacra Scriptura depromptae quae in alma Domo lauretana omnibus diebus Sabbathi, Vigiliarum et Festorum decantari solent' in C. Bernardino, *Trattato sopra l'historia della Santa Chiesa et Casa della gloriosa Madonna Maria Vergine di Loreto* (Macerata 1576), p. 103

Longhi 1943
R. Longhi, 'Ultimi studi sul Caravaggio e la sua cerchia' *Proporzioni*, vol. 1 (1943), p. 5

McGreevy 1956
T. McGreevy, *National Gallery of Ireland: Catalogue of Pictures of the Italian Schools* (Dublin 1956)

Magne 1914
E. Magne, *Nicolas Poussin, premier peintre du roi, 1594-1665* (Brussels & Paris 1914)

Mahon 1960
D. Mahon, 'Poussin's early development: an alternative hypothesis', *Burlington Magazine*, vol. 102 (1960), p. 228

Mahon 1962
D. Mahon, 'Poussiniana: after thoughts arising from the exhibition', *Gazette des Beaux-Arts*, vol. 60 (1962), p. 1

Malmaison 1968
Exhibition catalogue, *Souvenirs de la famille imperiale de Napoleon 1 à Napoleon III* (Orangerie du château de Bois-Préau, Musée National de Malmaison, Reuil Malmaison, 1968)

Manzini/Frati 1969
G. Manzini & T. Frati, *L'opera conpleta del Greco* (Milan 1969)

Marini 1968
R. Marini, *L'Opera completa del Paolo Veronese* (Milan 1968)

Marini 1974
M. Marini, *Io Michelangelo da Caravaggio* (Rome 1974)

Martin 1913
W. Martin, *Gerard Dou: des Meisters Gemälde. Klassiker der Kunst* (Stuttgart & Berlin, 1913)

Martin/Feigenbraum 1979
J.R. Martin & G. Feigenbaum, Exhibition catalogue, *Van Dyck as Religious Artist* (The Art Museum, Princeton University, 1979)

Mason Rinaldi 1984
S. Mason Rinaldi, *Palma Giovane, L'Opera Completa* (Milan 1984)

Mayer 1916
A.L. Mayer, *El Greco* (Munich 1916)

Mayer 1925
A.L. Mayer, *Francisco de Goya* (Barcelona & Buenos Aires 1925)

Mayer 1926
A.L. Mayer, *Domenico Theotocopuli – El Greco* (Munich 1926)

Meroni 1978
U. Meroni (ed.), *Fonti per la Storia della Pittura e della scultura antica. VIII Serie documentaria. Lettere e altri documenti intorno alla Storia della Pittura. Giovanni Benedetto Castiglione detto il Grechetto, Salvator Rosa, Gian Lorenzo Bernini* (Monzambano 1978)

Michel 1893
E. Michel, *Rembrandt, sa vie, son oeuvre et son temps* (Paris 1893)

Missale 1951
Missale Romanum (Rome, Tournai & Paris 1951)

Moir 1976
A. Moir, *Caravaggio and his Copyists* (New York 1976)

de Montaiglon 1875-92
 A. de Montaiglon: *Procès-Verbaux de l'Académie Royale de Peinture et de Sculpture, 1648-1792...*, 10 vols. (Paris 1872-95)
de Montaiglon/Guiffrey 1887-1912
 A. de Montaiglon & J. Guiffrey (eds.), *Correspondance des Directeurs de l'Académie de France à Rome avec les Surintendants des Bâtiments, 1774-1779, publiée d'après les manuscrits des archives nationales*, 17 vols. (Paris 1887-1912)
Moreau 1873
 A. Moreau, *E. Delacroix et son oeuvre* (Paris 1873)
Moreau-Nelaton 1916
 E. Moreau-Nelaton, *Delacroix raconté par lui-même* (Paris 1916)
Morassi 1962
 A. Morassi, *A Complete Catalogue of the Paintings of G.B. Tiepolo* (London 1962)
Mulcahy 1984
 R. Mulcahy, 'Spanish Masterpieces in Dublin', *Irish Arts Review*, vol. 1, no. 3 (1984), p. 29
Müller-Hofstede 1968
 J. Müller-Hofstede, 'Rubens und Jan Brueghel: Diana und ihre Nymphen', *Jahrbuch der Berliner Museen*, vol. 10 (1968), p. 200
Müller-Rostock 1922
 J. Müller-Rostock, 'Ein Verzeichnis von Bildern aus dem Besitze des Van Dyck', *Zeitschrift fur Bildende Kunst*, vol. 33 (1922), p. 22
Munich 1983
 Munich, Alte Pinakothek, Erläuterungen zu den ausgestellten Gemälden (Munich 1983)
Nicolson/Wright 1974
 B. Nicolson and C. Wright, *Georges de La Tour* (London 1974)
Niemeijer 1973
 J.W. Niemeijer, *Cornelis Troost 1696-1750* (Assen 1973)
Nolde 1958
 E. Nolde, *Jahre der Kämpfe, 1902-1914* (Flensburg, 1958)
Nolde 1965
 E. Nolde, *Welt und Heimat 1913-1918* (Cologne 1965)
Nystad 1975
 S. Nystad, 'Joseph and Mary find their son among the doctors', *Burlington Magazine*, vol. 107 (1975), p. 147
Oberhuber 1973
 K. Oberhuber, J.A. Levenson & J.L. Sheehan, Exhibition catalogue, *Early Italian Engravings from the National Gallery of Art* (National Gallery of Art, Washington, 1973)
Oldenbourg 1921
 R. Oldenbourg, *P.P. Rubens. Klassiker der Kunst* (Stuttgart & Berlin 1921)
Osmond 1927
 P.H. Osmond, *Paolo Veronese: his career and work* (London 1927)
Paccagnini 1961
 G. Paccagnini, Exhibition catalogue, *Andrea Mantegna* (Palazzo Ducale, Mantua 1961)
Pallucchini 1968
 A. Pallucchini, *L'Opera completa di Giambattista Tiepolo* (Milan 1968)
Pallucchini 1969
 R. Pallucchini, *Tiziano* (Florence 1969)
Passeri 1772
 G.B. Passeri, *Vite de' Pittori, Scultori, et Architetti che anno lavorato in Roma, morti dal 1641 fino al 1673* (Rome 1772)
Pérat é 1909-10
 A. Pérat é, 'Les esquisses de Gérard', *L'Art et les Artistes*, vol. 10 (1909-10), p. 7
Pérez Sànchez 1980
 A.E. Pérez Sànchez, 'Diego Polo, Imitador Espanol de Tiziano', *Tiziano e Venezia* (Convengo Internationale di Studi, Venezia, 1976), (Vicenza, 1980), p. 351
Percy 1971
 A. Percy, Exhibition catalogue, *Giovanni Benedetto Castiglione* (Philadelphia Museum of Art, 1971)
Pigler 1974
 A. Pigler, *Barock-Themen* (Budapest 1974)
Pignatti 1976
 T. Pignatti, *Veronese* (Venice 1976)
Pilkington 1829
 M. Pilkington, *A General Dictionary of Painters* (London 1829)
Piovene/Marini 1981
 G. Piovene & R. Marini, *L'Opera completa del Veronese* (Milan 1981)
Potterton 1982
 H. Potterton, 'Recently-cleaned Dutch pictures in the National Gallery of Ireland', *Apollo*, vol. 115 (1982), p. 104
Prado 1963
 Museo del Prado. Catalogo de las Pinturas (Madrid 1963)
Radcliffe 1974
 A. Radcliffe, 'A Portrait of Georg Vischer', *Apollo*, vol. 99 (1974), p. 46
Rearick 1980
 W.R. Rearick, 'Tiziano e Jacopo Bassano', *Tiziano e Venezia* (Convegno Internazionale di Studi, Venezia, 1976) (Vicenza 1980), p. 369
Redford 1888
 G. Redford, *Art Sales* (London 1888)
Reznicek 1964
 E.K.J. Reznicek, Exhibition catalogue, *Mostra di disegni fiamminghi e olandesi* (Gabinetto dei Disegni e della Stampe, Uffizi, Florence 1964)
Richter/Morelli 1960
 J.P. Richter & G. Morelli, *Italienische Malerei der Renaissance im Briefwechsel* (1876-91, ed. G. Richter, Baden-Baden 1960)
Ridolfi 1914/24
 C. Ridolfi, *Le Maraviglie dell'Arte overe le vita de gl'illustri pittori veneti ...* (1648, ed. in 2 vols. by D. von Hadeln, Berlin 1914/24)
Ripa 1611
 C. Ripa, *Iconologia, overo Descrittione d'Imagini delle Virtù, Vitij, Affetti, Passioni humane, Corpi celesti, Mondo e sue parti*, 2nd illustrated edition (Padua 1611)
Rittinger 1979
 B. Rittinger, 'Führichs Wiener Kreuzweg', *Zeitschrift für Kunstgeschichte*, vol. 42 (1979), p. 166
Rizzi 1971
 A. Rizzi, Exhibition catalogue, *Mostra del Tiepolo; Disegni e acqueforti* (Villa Manin di Passariano, Udine, 1971)
Robaut 1885
 A. Robaut, *L'Oeuvre complet de Eugène Delacroix* (Paris 1885)
Rooses 1888
 M. Rooses, *L'Oeuvre de P.P. Rubens* (Antwerp 1888)
Rosenberg 1964
 J. Rosenberg, *Rembrandt* (Cambridge, Mass. 1964)
Rosenberg 1970
 P. Rosenberg, 'Twenty French drawings in Sacramento', *Master Drawings*, vol. 8 (1970), p. 31
Rosenberg 1972-73
 P. Rosenberg, Exhibition catalogue, *Dessins français du 17ᵉ et du 18ᵉ siècle des collections americaines* (Toronto, Ottawa, San Francisco, New York, 1972-73)
Rosenberg 1973
 P. Rosenberg: 'Disegni francesi dal 1750—al 1825 nelle collezioni de Louvre; il neo-classicismo, Parigi, 1972', *Arte Illustrata*, vol. 6 (1973), p. 78

Rosenberg 1977
P. Rosenberg, Exhibition catalogue, *Nicolas Poussin 1594-1665* (Academia di Francia a Roma, Villa Medici, Rome, 1977)

Rosenberg 1983
P. Rosenberg, 'Tableaux français du XVIIe siècle', *La Revue du Louvre*, vol. 33 (1983), p. 350

Rosenblum 1973
Rosenblum, 'David's Funeral of Patroclus', *Burlington Magazine*, vol. 115 (1973), p. 567

Roy 1972
R. Roy, *Studien zu Gerbrandt van den Eeckhout*, Dissertation (Vienna 1972)

Rutter 1930
F. Rutter, *El Greco 1541-1614* (London 1930)

Schnapper 1974
A. Schnapper: 'Les académies peintes et le 'Christ en Croix' de David', *La Revue du Louvre*, vol. 24 (1974), p. 381

Schnapper 1980
A. Schnapper, *David, témoin de son temps* (Fribourg 1980)

Schneider 1973
H. Schneider, *Jan Lievens sein leben und seine werke* (Amsterdam 1973)

Seilern 1969
A. Seilern, *Italian Paintings and Drawings at 56, Princes Gate, London SW7: Addenda* (London 1969)

Sérullaz 1972a
A. Sérullaz, Exhibition catalogue, *The Age of Neo-Classicism*, 'David' essay (Royal Academy of Arts & the Victoria & Albert Museum, London 1972)

Sérullaz 1972b
A. Sérullaz, Exhibition catalogue, *Dessins français de 1750 à 1825 dans les collections du musée du Louvré, le néo-classicisme* (Cabinet des Dessins, The Louvre, Paris 1972)

Sérullaz 1973
M. Sérullaz, 'Delacroix et la Peinture Liberée, *La Revue du Louvre*, vol. 23 (1973), p. 361

Sérullaz 1974
A. Sérullaz, in the Exhibition catalogue *Le Néo-Classicisme Français: Dessins des Musées de Province* (Grand Palais, Paris 1974-75)

Seznec/Adhémar 1967
J. Seznac & J. Adhémar, *Diderot, Salons* (Oxford 1967)

Shapley 1979
F.R. Shapley, *Catalogue of the Italian Paintings in the National Gallery of Art, Washington* (Washington 1979)

Shearman 1983
J. Shearman, *The Pictures in the Collection of Her Majesty the Queen. The Early Italian Pictures* (Cambridge, New York & Melbourne 1983)

Smith 1830 and 1836
J. Smith, *A catalogue raisonné of the works of the most eminent Dutch, Flemish, and French painters*, 9 vols. (London 1829-42)

Smith 1981
A. Smith, Exhibition catalogue, *Second Sight: Mantegna: Samson and Delilah. Degas: Beach Scene* (The National Gallery, London 1981)

De Sousa-Leão 1948
J. De Sousa-Leão, *Frans Post* (Rio de Janeiro 1948)

De Sousa-Leão 1973
J. De Sousa-Leão, *Frans Post, 1612-80* (Amsterdam 1973)

Speculum Humanae Salvationis
Medieval text, reprinted and discussed in A. Wilson & J.L. Wilson, *A Medieval Mirror, Speculum Humanae Salvationis 1324-1500* (Berkeley & London 1985)

Spike 1980
J. Spike, Exhibition catalogue, *Italian Baroque Paintings from New York Private Collections* (The Art Museum, Princeton University, 1980)

Staring 1956
A. Staring, *De Hollanders thuis* (The Hague 1956)

Stechow 1966
W. Stechow, *Dutch Landscape Painting of the 17th Century* (London 1966)

Stechow 1975
W. Stechow, *Salomon van Ruysdael* (Berlin 1975)

Sue 1793
J.J. Sue, 'Rapport sur les tableaux de David lu à la séance publique du 5 Mai', *L'Esprit des Journaux Francois et etrangers par une société de gens de lettres* (Paris, VIII, agosto, 1793), p. 275

Suida 1959-60
W. Suida, 'Miscellanea Tizianesca IV', *Arte Veneta*, vol. 13-14 (1959-60), p. 62

Sumowski 1983
W. Sumowski, *Gemälde der Rembrandt-Schüler*, vol. 2 (Landau 1983)

Swillens 1946
P.T.A. Swillens, 'Jacob van Hasselt', *Oud Holland*, vol. 61 (1946), p. 133

Thieme-Becker 1907-50
U. Thieme & F. Becker, *Allgemeines Lexikon der bildenden Künstler von der Antike bis zur Gegenwart*, 37 vols. (Leipzig 1907-50)

Thirlestane 1846
Anon, *Hours in the Picture Gallery at Thirlestane House, Cheltenham* (Cheltenham & London 1846)

Thullier 1974
J. Thullier, *L'opera completa di Poussin* (Milan 1974)

Tietze-Conrat 1955
E. Tietze-Conrat, *Mantegna: Paintings, Drawings, Engravings* (London 1955)

Torriti 1967
P. Torriti, *La Galleria del Palazzo Durazzo Pallavicini a Genova* (Genoa 1967)

Tot Lering en Vermaak 1976
Exhibition catalogue, *Tot Lering en Vermaak* (Rijksmuseum, Amsterdam 1976)

Trapp 1971
P.A. Trapp, *The Attainment of Delacroix* (Baltimore 1971)

Urban 1966
M. Urban, *Emil Nolde, Flowers and Animals – watercolours and drawings*, trans. B. Berg (London 1966)

Vaes 1926-27
M. Vaes, 'Le Journal de Jean Brueghel II', *Bulletin de L'Institut Belge de Rome* (1926-27)

Valentiner 1909
W.R. Valentiner, *Rembrandt: Des Meisters Gemälde, Klassiker der Kunst* (Stuttgart & Berlin 1909)

Valynseele 1954
J. Valynseele, *Le sang des Bonaparte* (Paris 1954)

Venturi 1901-39
A. Venturi, *Storia dell'Arte Italiana*, 11 vols. (1901-39)

Verbraeken 1973
R. Verbraeken: *Jacques-Louis David jugé par ses contemporains et par la posterité* (Paris 1973)

Vertue 1762-63
G. Vertue, *Anecdotes of Painting in England*, published by H. Walpole, 3 vols. (London 1762-63)

Vienna 1966
Exhibition catalogue, *Die Kunst der Graphik, III, Renaissance in Italien, 16 Jahrhundert* (Albertina, Vienna 1966)

de Villars 1850
M. de Villars, *Memoires de David, Peintre et Député à la Convention* (Paris 1850)

Viniegra 1902
 S. Viniegra, Exhibition catalogue, *Exposición de las obras del Greco* (Museo Nacional de Pintura, Madrid 1902)
Waagen 1854-57
 G.F. Waagen, *Art Treasures in Great Britain*, 3 vols. and supplement, trans. Lady Eastlake (London 1854-57)
Walpole 1762
 H. Walpole (P. Toynbee, ed.), 'Horace Walpole's Journals of Visits to Country Seats 1762', *Walpole Society*, vol. 16 (1928), p. 42
Wethey 1962
 H.E. Wethey, *El Greco and his School* (Princeton 1962)
Wethey 1969
 H.E. Wethey, *The Paintings of Titian, vol. 1, The Religious Paintings* (London 1969)
Wheelock 1975-76
 A.K. Wheelock Jr., 'Gerard Houckgeest and Emanuel de Witte: architectural painting in Delft around 1650' *Simiolus*, vol. 7 (1975-76), p. 167
Whistler 1985
 C. Whistler, 'A Modello for Tiepolo's Final Commission: The Allegory of the Immaculate Conception', *Apollo*, vol. 121 (1985), p. 172
White 1974
 J. White, 'Sir Hugh Lane as a Collector', *Apollo*, vol. 109 (1974), p. 112
Wild 1962
 D. Wild, 'L'Adoration des Bergers de Poussin à Munich et ses tableaux religieux des années cinquante', *Gazette des Beaux-Arts*, vol. 60 (1962), p. 223

Wild 1980
 D. Wild, *Nicolas Poussin* (Zurich 1980)
Wildenstein 1955
 G. Wildenstein, 'Les Gravures de Poussin au XVIIᵉ siècle' *Gazette des Beaux-Arts*, vol. 46 (1955), p. 75
Wildenstein 1973
 D. & G. Wildenstein, *Documents complementaires au catalogue de l'oeuvre du Louis David* (Paris 1973)
Witt 1915
 R.C. Witt, 'Recent Additions to the Dublin Gallery—1', *Burlington Magazine*, vol. 27 (1915), p. 56
Wittkower 1973
 R. Wittkower, *Art and Architecture in Italy 1600-1750*, 3rd ed. (Harmondsworth 1973)
von Wurzbach 1886
 A. von Wurzbach, *Rembrandt Galerei* (Stuttgart 1886)
von Wurzbach 1906-11
 A. von Wurzbach, *Niederländisches Künstler-Lexikon*, 3 vols. (Leipzig & Vienna 1906-11)
Wynne 1980
 M. Wynne, 'Una Vista de Aranjuez por Joli redescubierta' in *Archivo Español de Arte*, vol. 53 (1980), p. 382
Yale 1983
 Exhibition catalogue, *Rembrandt in eighteenth century England*. (Yale Center for British Art, 1983)
Yriarte 1901
 C. Yriarte, *Mantegna* (Paris 1901)
Zeri 1974
 F. Zeri, 'Major and Minor Italian Artists at Dublin', *Apollo*, vol. 99 (1974), p. 88

Index

Names of collectors who have previously owned paintings now in the National Gallery of Ireland, have the suffix (coll.)

Accademia, Venice, 16, 18
Accademia Carrara, Bergamo, 58
Acton Family (coll.), 38
Adam, Pierre, 42
Aducci, Signor, xii
Aertsen, Pieter, 58
Albrecht I of Königsberg, 52
Allnutt (coll.), xiv
Altdorfer, Albrecht, 50, 52
Alte Pinakothek, Munich, 32, 48, 54, 62, 65, 78
Amberg, Christoph, 54
Amzing, Samuel, 70
Andrea, Zoan, 6
Andrieux, François, 42
Angerstein Collection, ix
Apsley House, London, 58
d'Argenville, Dézallier, 34
Armstrong, Sir Walter, xiii, xvi, xix-xxi, 8, 58, 66, 78 (coll.)
Art Institute of Chicago, 50
Asper, Hans, 46, 50

Badile, Antonio, 10
Bähr, George, 22, 24
van Balen, Hendrik, 56, 58
Baltimore Museum of Art, 30
Barron, Sir Henry Page Turner (coll.), xx, xxi, 56, 70
Basont, M. (coll.), xxii
van Bassen, Bartholomeus, 74, 76
Bossière, Samuel (coll.), 32
Bayeau, Francesco, 30
Beckett-Denison, Christopher (coll.), 46, 48
Beham, Bartel and Hans Sebald, 52, 54
Bellini, Gentile and Giovanni, 4, 7
Bellotto, Bernardo, **22-25**
Berchem, Nicolaes, 60
Berlin Ethnographic Museum, 86
Bicker Raye, Jacob, 84
de Bie, Cornelis, 60
van Bleyswyck, Dirck, 74
Boccaccio, 54
Bode Museum, Berlin, 18, 60
Bodkin, Thomas, xxvi
Bonaparte, Cardinal Lucien, 8, 42 (coll.)
Bonaparte, Joseph (coll.), 42
Bonington, Richard Parks, 44
Boonen, Arnold, 84
Bossière, Samuel, 32
Both, Jan, 60
Botticelli, xiii
Boucher, François, xxvii, 34, 38
Bout, Adriaan (coll.), 32
Boydell, John, 16, 19, 62
Breton, Jules, xxvii
British Government Picture Collection, 60
British Museum, London, xxii, 44, 60
Bronzino, 52, 54, 55
Brueghel, Jan 'Velvet', 56, 58
Brueghel the Younger, Jan, **56-59**
Brukenthal Museum, Sibiu, 8

Bryan, Mr (coll.), 56
Buckingham, Duke of (coll.), 10
Bueckelaer, Joachim, 58
Bürhle Collection, Zurich, 44
Buttery, Horace (coll.), 66

de Calonne, Charles Alexandre (coll.), 56
Canaletto, 22
Canino, Princess Zénaïde of (coll.), 42
Canot, P.C., 62
Caravaggio, Michelangelo da, 12, 14
Carlin (coll.), 44
Carlsberg Glyptotek, Copenhagen, 44
Carriera, Rosalba, 36
Cars, Laurent, 36
Castiglione, Francesco, 18
Castiglione, Giovanni Benedetto, xxv, **16-19**
Cats, Jacob, 82
Cavendish Bentick, G.A.F. (coll.), 26
da Celano, Tommaso, 28
Centraal Museum, Utrecht, 80
Cerezo, Matteo, 8
Cézanne, Paul, xxvii
Chardin, Jean Baptiste Siméon, xvi, xix, 36
Charles IV of Spain, 30
Chatsworth, Devonshire Collection, 6
Chester Beatty, Sir Alfred (coll.), xxvi-xxvii
le Chevalier de Knieff, M. (coll.), 44
Chiaveri, Gaetano, 22, 24
City Art Gallery, Birmingham, 8
Claude, xxii, xxiv, 60
Clovio, Giulio, 28
Cochin the Elder, Nicolas, 36
Cocques, Gonzales, 56, 58
Codde, Pieter, 78
Constable, John, xviii, 44
Corot, Jean-Baptiste, xxv
Costa, Lorenzo, xiii
Cottingham, A.D.A. (coll.), 34
de la Court, Mrs. P.H. (coll.), 84
de la Court-Ram, Douaire (coll.), 84
Cranach, Lucas, 46
E.B. Crocker Museum, Sacramento, 40

Dargan, William, xi
Daumier, Honoré, 86
David, Jacques-Louis, xxvii, **38-42**
Degas, Edgar, xxv
De Gree, Peter, ix
Delacroix, Eugène, **44-45**
de Deleitosa, Marqués (coll.), 24
van Delen, Dirk, 58
De Lorme, Anthonie, **74-75**
Demidoff, Prince (coll.), 70
Desportes, Alexandre Francois, xxiii
Devonshire, Duke of (coll.), 6
Diderot, 40
van Diepenbeek, Abraham, 56
Domenichino, 20

Donatello, 4
Douglas, Robert Langton (coll.), 60, 72
Dowdeswell (coll.), 84
Doyle, Henry, xiv, xv, xvi-xix, 52
Droochsloot, Joost Cornelisz., 78
Dou, Gerard, 62, 66
Drey, F.A. (coll.), 14
Duck, Jacob, **78-79**
Dumont, Alexandre (coll.), 80
Dunne, the Misses (coll.), 34
Duquesnoy, Francois, 84
Dürer, Albrecht, 48, 50, 52, 54
Dussel, Abbé, 32
Duyster, Willem Cornelisz., 78
Van Dyck, Anthony, xxiv, 1, 7, 8 (coll.), 12, 34, 56, 82 (coll.)

Eastlake, Charles, xiii
van den Eeckhout, Gerbrandt, 62, **68-69**
van den Eeckhout, Jan Pietersz., 68
van Egmont, Joost, 58
Elsheimer, Adam, 62, 65
Ensor, James, 86
Ercole de'Roberti, xiii
d'Este, Alfonso, 7
van Eyck, Jan, 48, 76

Faber, Conrad, **46-51**
Farnese Family, 7
Farrer, Henry (coll.), 50
de' Ferrari, Giovanni Andrea, 16
Fesch, Cardinal (coll.), viii, xii
Feselen, Melchior, 46
Fitzwilliam Museum, Cambridge, 76
Fontanel, M. (coll.), 38
Foucart (coll.), 80
Fowke, Francis, xi
Fra Angelico, xii, xviii
Fragonard, Jean Honoré, xxvii
Francia, Francesco, xiii
Francken II, Frans, 58
Frick Collection, New York, 82
Fyoll, Hans, 46

Gainsborough, Thomas, xxi, xxiii, xxiv
Galleria Borghese, Rome, 12
Galton, Howard (coll.), 82
Galton, Hubert (coll.), 82
Gamelin, Jacques, 38, 40
Gauguin, Paul, 86
Gemäldegalerie, Berlin-Dahlem, 46, 50, 52
Gemäldegalerie, Dresden, 22, 24, 52
Gentileschi, Orazio, xxv, **12-13**
Gérard, François-Pascal-Simon, xxvii, **42-43**
Germanisches National-Museum, Nuremberg, 48, 52
Gheringh, Anton, 76
Giambologna, xx, xxi
Giorgione, 7
Giulio Romano, 10
Godefroid, Eléonore, 42
de Godoy, Manuel, 30
van Gogh, Vincent, 86
Gonsal, 58
Gonzaga family, 4, 7, 16
Gonzaga, Ludovico, 4
Goubaud, Antoine, 34
Goudt, Hendrick, 62, 65
Goya, Francisco de, xix, xxiv, xxvii, **30-31**, 36

van Goyen, Jan, 70
Graham (coll.), xii
El Greco, xxiii, **28-29**
Groeningen Museum, Bruges, 78
Grünewald, Mathias, 46
Guardi, Gian Antonio, xviii
Guerin, Baron, 44
de Gyselaer, Nicolaes, **76-77**

Hals, Frans, xv, xviii
Hamilton, 12th Duke of (coll.), 32, 46
Hamilton, Hugh Douglas, xxiv
Hamilton, Sir William (coll.), 32
Harris, Tomás (coll.), 12
Harrison Pickering, Charles William (coll.), 70
van Hasselt, Isaak, 80
van Hasselt, Gerrit Jacobsz., 80
van Hasselt, Jacob Gerritsz., **80-81**
de Heem, Jan Davidsz., 34
Herman de Zoete, S. (coll.), 68
Hermitage, Leningrad, 18, 52, 54, 78
Herodotus, 18
Historisches Museum, Frankfurt, 46
Hoare, Henry, (coll.), 62, 65
Hogarth, William, xxiii, xxiv
Holbein the Younger, Hans, 46
Homer, 38
Hölzel, Adolf, 86
Honthorst, Gerrit, 82
Houbraken, 62, 68
Houckgeest, Gerard, 74
Huber, Wolf, 50

Ibáñez, Antonio Raimundo, 30

James (coll.), xx
Jamnitzer, Albrecht, 52
du Jardin, Karel, 60
Jordaens, Jacob, x, xiv, 60
Joyce, James, xxviii

van Kessel, Jan, 58
Ketterer, Roman Norbert, 86
Kibble, Thomas (coll.), 10
Knighton, Sir William (coll.), 7
Kowarzik (coll.), 86
Kunsthistorisches Museum, Vienna, 4, 12, 54, 58

Lambert, Gavin, 60
Landesmuseum Ferdinandeum, Innsbruck, 78
Lane, Sir Hugh (coll.), xxi-xxvi, 28
Lanfranco, Giovanni, xi, xiii
Langton Douglas, Captain Robert, xxv, 60, 72 (coll.)
Largillière, Nicolas, **34-35**
Lastman, Pieter, 62, 68
de La Tour, George, 14
de La Tour, Maurice Quentin, 36
Lawrence, Thomas, xxiv
Leatham, E.A. (coll.), 74
Le Brun, Charles, 34
Le Clerc, Jean, 14
Lely, Peter, 34
Lichfield, Lord (coll.), 78
de Lierner, Peer, 58
Lievens, Jan, 62, 66
Lincoln, Earl of (coll.), 16
Lincoln, the 9th Earl of (coll.), 16
Lingelbach, Johannes, 74

Lippi, Filippino, xiii
Lippmann de Londres (coll.), 80
Lomi, Aurelio, 12
Lomi, Bacci, 12
Lotto, Lorenzo, 52, 54
Louis XIV of France, 72
Louvre, Paris, xi, 4, 34, 38, 40, 41, 52, 64, 78, 86

McGreevy, Thomas, 8
Malcolm of Poltalloch, John (coll.), 4
Malcolm of Poltalloch, Lord (coll.), 4
Malherbe (coll.), 80
de Man, Cornelis, 66
van Mander, Karel, 84
Mantegna, Andrea, xix, **4-5**
Mantua, Dukes of (coll.), 16, 56
Maratti, Carlo, (coll.), viii
Mariette, P.J., 34
Martyn, Edward (coll.), xxvi
Mauritz, Johan, 72
Memling, Hans, 46
Metropolitan Museum, New York, 28, 32, 54
van der Meulen, Adam Frans, 34
Michelangelo, 32, 52
Millet, Jean François, xxvii
Milltown (coll.), xix-xxi
Mocetto, Girolamo, 6
de Momper, Joos, 56
de Monconys, Balthasar, 74
Monet, Claude, xxv
Morris Browne, Lord Terence (coll.), 14
Mulvany, George, xiii, xvii, xviii, 52
Munch, Edvard, 86
Munro of Novar, Hugh Andrew Johnstone (coll.), 56
Murillo, Bartolomé Estebán, xxvii
Musée des Beaux-Arts, Antwerp, 60
Musée des Beaux-Arts, Lyons, 18
Musée Bonnat, Bayonne, 66
Musée de la Chartreuse, Douai, 14
Musée de Dijon, 16, 18
Musée Eugène Boudin, Honfleur, 38, 40
Musée de Narbonne, 38
Musée National de Malmaison, 42
Musée National du Château de Versailles, 42
Musées Royaux des Beaux-Arts, Brussels, 58, 60
Museo di Capodimonte, Naples, 42
Museo Civico, Viterbo, 32
Museo Napoleonico, Rome, 42
Museum of Art, Raleigh, North Carolina, 22
Museum of Fine Arts, Budapest, 54
Mytens Elder and Younger, Daniel, 82
Mytens, Jan, **82-83**

Naryschkin, M.B. (coll.), 22, 24
Nationalgalerie, Berlin, 86
National Gallery, London, ix, xiii, xvi, xviii, 4, 32, 58, 60, 62, 66
National Gallery, Washington, 4, 6
Natoire, Charles, 36
Nattier, Jean Marc, xxvii, 34, 36
Natural History Museum, Dublin, xi
Neeffs, Pieter, 76
Nolde, Emil, **86-87**
Nolde Stiftung, Seebüll, 86
van Noort, Adam, 56
Northumberland, Duke of (coll.), 48
Northwick, Lord (coll.), 74
Norton Simon Museum, Pasadena, 70

Ovid, 84

P, M. (coll.), 44
Pajou, Augustin, 42
Palma Giovane, 8
Pantoja de la Cruz, xxv
Parmigianino, 10
Passeri, Giovanni Battista, **20-21**
Patinir, Joachim, 50
Patterson, Mr W.B. (coll.), 74
Pencz, Georg, xiv, **52-55**
Pensionante del Saraceni, **14-15**
Perronneau, Jean-Baptiste, xxv, **36-37**
Perugino, xxvi
Pesne, Jean, 32
Peterzano, 7
Petit, Francis (coll.), 44
Peyronnet Browne, Lady Isabel Mary (coll.), 14
Pfungst, H. (coll.), 80
de Pidal, Marqués (coll.), 28
Pigalle, Jean-Baptiste, 36
van der Poel, Egbert, 80
de Poorter, Willem, 62, 66
Poggi, Giovanni Battista, 16
Pointel (coll.), 32
Poldi Pezzoli Museum, 8
Pöppelmann, Daniel, 22, 24
Post, Frans, **72-73**
Post, Pieter, 72
Pourtalès, Count (coll.), 56
Poussin, Nicolas, xviii, xxi, xxiv, **32-33**
Procaccini, Giulio Cesare, viii, xii
Prado, Madrid, 50
Pynacker, Adam, 60
Pynas, Jacob, 62, 64

de Quinto, Ricardo Pascual (coll.), 28

Racine, 42
Raffaellino del Garbo, xiii
Raimondi, Marcantonio, 32
Raphael, 32
Reijnders, Corneille Louis (coll.), 56
Rembrandt, xviii, **62-65**
Rembrandt, School of, xix, **66-67**
Renoir, Pierre Auguste, xxii
Reynolds, Joshua, xviii, xix, xxii
Ricci, Sebastiano, 26
Riccio, 54
Richards, S. (coll.), 84
Rigaud, Henri (coll.), 44
Rigaud, Hyacinthe, 34
Rijksmuseum, Amsterdam, 70, 76, 80, 84
Ringling Museum, Sarasota, 7
di Roccagiovine, Marchese Julie (coll.), 42
de Rouzat, Comtesse (coll.), 60
della Rovere family, 7
de Rosset, Pierre Fulcrand, 36
Royal Collection, 12, 16, 32, 52
Rubens, Peter Paul, xix, xxi, 34, **56-59**
van Ruisdael, Jacob, 70
van Ruysdael, Jacob Salomonsz., 70
van Ruysdael, Salomon, xxi, **70-71**

Saenredam, Pieter, 74
Saraceni, Carlo, 14

Sebastiano del Piombo, 32
Seghers, Hercules, 62
Serlio, 76
Serra, Duca del Cardinale (coll.), 38
Shaw, George Bernard, xxvii
Siberechts, Jan, xxv, **60-61**
Sligo, Marquess of (coll.), 14
Ska Kyrka, Farentuna Harad, Sweden, 32
Smith, John (coll.), 56
Smith, William (coll.), xx
Solario, Andrea, 8
South Kensington Museum, London, xi
Squarcione, Francesco, 4
Squerryes Court, 60
Staatliche Kunsthalle, Karsruhe, 54
Staatiiche Museen, Berlin-Dahlem, 22, 24, 52, 54
Staatliches Museum, Schwerin, 54
Städelsches Kunstinstitut, Frankfurt, 46, 48
Steen, Jan, xiv, xviii
Stroganoff Collection, Count, 32
Strutt of Derby, Joseph (coll.), 82
Suida Manning, Robert & Bertina (coll.),
Surugue, Jean-Baptiste, xvi
van Swanenburgh, Jacob, 62

Tacca, Ferdinando, xx
Tassi, Agostino, 12
Tate Gallery, London, 60
Taylor, George Archibald (coll.), xx
Tchelitchev, Pavel, xxviii
Terzi, Count (coll.), 14
Thoré, Theophile, 44
van Thulden, Theodore, 82
Tiepelo, Giovanni Battista, **26-27**
Tiepelo, Lorenzo, 26
Tintoretto, 58
Titian, xviii, xxiv, **7-9,** 10, 28
Tonneman the Younger, Jeronimus (coll.), 84
Troost, Cornelis, xix, **84-85**
Tura, Cosima, xiii
Turner, Joseph Mallord William, xviii

Uffizi, Florence, xxvi, 6, 50, 52
Ulster Museum, Belfast, 20

Vatican Museums, Rome, 14, 44
Van Heek Collection, S'Heerenberg, 48
van Veen, Otto, 56
Vasallo, 18
Vaughan, Henry (coll.), xviii, xx
de la Vega Inclán, Marqués (coll.), 30
Velázquez, Diego, xvii, 58
van de Velde, Adrian, 74
van de Velde, Esias, 70
Verhaecht, 56
Vermeer, Jan, 80
Vernon, Hon. G.J. (coll.), 56
Veronese, xviii, xxiii, **10-11,** 44
Verrio, Antonio, 34
Vertue, George, 60
Victoria & Albert Museum, London, 54
Vien, Joseph Marie, 38
Virgil, 42
Vischer, Georg, 52, 54
van Vliet, Hendrick, 74
Vorsterman, Lucas, 7, 8
Vrancx, Sebastian, 76
Vrancx, Simon, 56
de Vries, Jan Vredeman, 76
van Vucht, Jan, 74

Walpole, Horace, 62
Ward (coll.), 84
Watteau, Jean Antoine, xvii, xx
Wertimger, Manuel, 48
Wicar, Jean-Baptiste, 42
Wigger Collection, 60
Wingfield, Hon. Lewis (coll.), 4
de Witte, Emanuel, 74
Wolgemut, Michael, 54
Wood, John, 62, 64, 65
Wootton, John, 60

Zuccatti, Sebastiano, 7